the Forth Naturalist and Historian

Volume 30 2007

Published by the Forth Naturalist and Historian, University of Stirling – charity SCO 13270.

ISSN 0309-7560

ISBN 1-898008-64-7

Supported by INEOS and Scottish Natural Heritage.

Cover: front– Comma Butterfly. *Roy Sexton.*
 back– Souvenir Programme, Stirling and Bridge of Allan Amateur Operatic Society. *Smith Art Gallery and Museum Collection.*

Printed by Meigle Colour Printers Ltd., Tweedbank Industrial Estate, Galashiels.
Set in Zapf Calligraphic on Amber 100 gsm and cover 300 gsm Satin.

THE FORTH NATURALIST AND HISTORIAN

The Forth Naturalist and Historian (FNH) is an informal enterprise of Stirling University. It was set up in 1975 by several University and Central Regional Council staff to provide a focus for interests, activities and publications of environmental, heritage and historical studies for the Forth area, comprising now local authority areas Stirling, Falkirk and Clackmannanshire.

Since then the organisation of an annual environment/heritage symposium called *Man and the Landscape* has been an important feature.

The annual *Forth Naturalist and Historian* has published numerous papers, many being authoritative and significant in their field, and includes annual reports of the weather, and of birds in the locality, plus book reviews and notes. These volumes provide a valuable successor to that basic resource *The Transactions of the Stirling Field and Archaeological Society*, 1878-1939. Four year contents/indexes are available, and selected papers are published in pamphlet form, while others are available as reprints.

In addition a 230 page book *Central Scotland – Land, Wildlife, People,* a natural history and heritage survey, was produced in 1994 and is available in the form of a CD-Rom, *Heart of Scotland's Environment* (HSE).

Other FNH and associated publications still in print include – *Mines and Minerals of the Ochils, Airthrey and Bridge of Allan, Woollen Mills of the Hillfoots, The Ochil Hills* – landscape, wildlife, heritage – an introduction with walks, *Alloa Tower and the Erskines of Mar,* and the *Lure of Loch Lomond* a journey round the shores and islands. Several of these are in association with Clackmannanshire Field Studies Society.

FNH publications are listed on the internet British Library (BLPC) and by booksellers e.g. Amazon, Bol, Barnes and Noble.

Offers of papers/notes for publication, and of presentations for symposia are ever welcome.

Honorary Secretary Marilyn Scott,
Computer Services, University of Stirling, FK9 4LA.
E-mail: fnh@stir.ac.uk
Web: http://www.fnh.stir.ac.uk

Lindsay Corbett, 1923 - 2007

Lindsay was born and brought up in Glasgow, beginning his career in the Mitchell Library. He moved to London, working in the Library of the Institute of Mining and Metallurgy before moving to the Atomic Weapons Research Establishment at Aldermaston. In 1973 he was appointed Depute Librarian to Stirling University and settled in Alloa.

Lindsay was a founder member and a keen supporter of the Clackmannanshire Field Studies Society. This interest was followed by his early involvement in a joint venture between Stirling University and Central Regional Council Education Department to raise interest in the natural and historical environment of the Central Region. Supported by Robert Innes, Director of Extra-Mural Education at Stirling University and Ian Collie, Director of Education of Central region, a group of University and Council staff began to work informally in 1975 and eventually set up the Forth Naturalist and Historian Editorial Board.

Lindsay was one of the prime movers on the Board, holding the joint posts of Secretary, Treasurer, Editor and salesperson for over thirty years. He guided the group through its early years, helping to establish an annual symposium and the publication of an annual journal. In addition, his expertise in editing and publishing enabled the Board to support local groups, individuals and businesses in publishing books, pamphlets, postcards and maps. Lindsay has also held the post of chairperson of the Board and was instrumental in gaining charitable status. He was key to gaining the support of British Petroleum who have helped finance the Forth Naturalist and Historian journal for over thirty

years. Lindsay was also deeply involved in fieldwork and research on numerous local projects including the work of the Clackmannanshire Field Studies Society, mining in the Ochils, the restoration of Alloa Tower and the Woodland Trust, to name but a few.

The University of Stirling recognised his commitment and achievement in 1995, awarding him the honorary degree of Master of Arts. The members of the Forth Naturalist and Historian Editorial Board acknowledged his Herculean efforts on their behalf in 2003, electing him as their first Honorary President. Lindsay will be sadly missed by all who knew him. The success of his efforts will continue to bear testament to his lengthy and deep commitment to promoting interest in the natural and historical environment of his local area.

Lindsay is survived by his widow, Nancy, and two sons to whom we extend our sincere sympathy.

ROBERT DICK OF TULLIBODY:
BAKER, AMATEUR NATURALIST AND VICTORIAN ICON
People of the Forth (15)

Margaret Mercer and Roy Sexton

Samuel Smiles and Robert Dick

Samuel Smiles was born in Haddington in 1812, one of eleven children. In spite of his humble origins he obtained a medical degree eventually becoming the village doctor. After a career as a political reformer he was propelled to international fame by the publication of *Self Help* in 1859. This book which preached industry, thrift and self-improvement became an instant success selling more than 250,000 copies including translations into many languages (Wintle, 1982). Although *Self Help* was a practical guide the key to Smiles' success was to turn the biographies of celebrated men into an inspirational medium that awakened in readers their own potential and instilled in them the desire to succeed. One such icon was Robert Dick of Tullibody.

In *Self Help* Smiles only refers to him briefly:

> *Not long ago, Sir Roderick Murchison (President of the British Association and the Royal Geographical Society) discovered at Thurso, in the far north of Scotland, a profound geologist, in the person of a baker there, named Robert Dick. When Sir Roderick called upon him at the bakehouse in which he baked and earned his bread, Robert Dick delineated to him, by means of flour upon a board, the geographical features and geological phenomena of his native county, pointing out the imperfections in the existing maps, which he had ascertained by travelling over the country in his leisure hours. On further inquiry, Sir Roderick ascertained that the humble individual before him was not only a capital baker and geologist, but a first-rate botanist. "I found," said the Director-General of the Geographical Society, "to my great humiliation, that this baker knew infinitely more of botanical science, ay, ten times more, than I did and that there were only some twenty or thirty specimens of flowers (from the British flora) which he had not collected."* Smiles continued *"It is the glory of our country that men such as these so abound …. And even in the lowliest calling the true worker may win the very loftiest rewards"*.

The entry is short because Sir Roderick Murchison's address to the British Association in 1858 which drew attention "To the man I am proud to call a distinguished friend" was only made just before the publication of *Self Help*. Smiles subsequently selected a few examples from *Self Help* for more detailed biographies; amongst these were George Stevenson (1875), Josiah Wedgwood (1894), James Nasmyth (1885), Boulton and Watt (1865) and Robert Dick (1878).

Dick was an unassuming man with an aversion to recognition. He was happy for others to use his plant and fossil finds without attribution. It was only at the insistence of Professor Balfour of Edinburgh University that he wrote up his discovery of Holy Grass (*Hierochloe odorata L.*). As a consequence

we are almost entirely indebted to the industry of Samuel Smiles who in the 12 years after Dick's death recovered hundreds of letters from his sisters and scientific associates. Without him there would be little trace of Dick's accomplishments.

Robert Dick's Formative Years in Tullibody

Robert Dick is said to have been born in January 1811 the second of four children born to Thomas and Margaret Dick (nee Gilchrist) an excise officer at Knox's Cambus brewery. The couple were married in 1807 at Cupar in Fife and their first child Nancy (Agnes) was born and christened in Tullibody later that year. However neither Robert nor his younger sister Jane's births are recorded in Alloa Parish records though the last born James b 1815 is included. The family lived at 24, Main Street, Tullibody (Figure 2) which was demolished in 1958 during the village's redevelopment. According to the Rev Thom (1907) it was a plain two storey building which originally had a pantiled roof but was not embellished with ornamentation as illustrated in Smiles' book. Robert attended the Tullibody Barony school which was partly maintained by the Abercromby family. The two storey building had a lower school room with the teacher's quarters above and an unenclosed play area on the roadside. Robert was picked out by his tutor Mr Macintyre as a very able student and according to the Rev. Crouther Gordon his father like all good Scots of his day aspired to see his laddie "college bred". In later life Robert wrote fondly of his "auld dominie" recalling that "every morning before the business of the day began he used to pray that teachers and scholars might all be taught and that discipline might be followed with obedience".

Sadly Robert's life was to change dramatically when at the age of seven his mother died and two years later in 1820 his father remarried Margaret Knox the Brewery owner's daughter. Excise regulations did not allow the inspection of a relative's business and so his father was transferred to Mr Dall's Distillery (later Glenochil distillery) at Menstrie. The family moved into a house just north of the works, on the east bank of the Damsburn and on the south side of the old Hillfoots road (Morris, 1908). Robert attended the subscription school at Menstrie which comprised a school room and master's house in two cottages which were taken down in 1875 to make way for a new school's playground. According to Smiles' account Robert made little progress under his new teacher Mr Morrison who had only one arm and was disparagingly described as "not having the limbs to fit him for anything else". This contrasts with an ex-pupil's description of Morrison as "a strict disciplinarian who was much respected" (Morris, 1908).

Robert and his siblings did not get on well with their new mother who soon had a family of her own. She was very hard on her step-children and Robert never forgot how she beat his younger brother until he could not stand. To keep away from the house he roamed the hills developing an interest in the natural world making collections of minerals and plants. Even then he was persecuted for wearing out his boots and was forced to walk bare foot. Later he

was to confide in Charles Peach about this unhappy period. "...All my naturally youthful spirits were broken ... to this day I feel the effects ... it is this that makes me shrink from the world".

At the age of thirteen instead of being sent to college he was apprenticed to Mr Aikman a prosperous baker in Tullibody. The shop with chimney and ovens behind occupied the corner site where the Post Office now stands and there was a grain store across the road. When the shop was renovated in 1950-2 the sandstone blocks from the coal fired ovens were used to help build the foundation for the garage at 2, Ochil Street.

Mr Aikman was a kindly man who was to remain in contact with his apprentice throughout his life. He provided the flour for Robert to set up business in Thurso and later hinted that he might like to return to Tullibody to take over the bakery when he retired. Apprentices lived over the bakehouse and worked for their keep. Robert was charged with getting up at 3 am to light the three ovens and once he was strong enough to carry the basket of loaves, he was sent on deliveries to Blairlogie, Bridge of Allan and Lipney. Using borrowed books he developed an interest in the natural history of the surrounding area. One biographer (Morris 1918) suggested that while making his deliveries to Drumbrae and Bridge of Allan "his quick eyes would spy out ... the chickweed wintergreen *Trientalis europaea* and petty whin *Genista anglica*". A century later these plants can still be found along the path near the Cocksburn reservoir. Later in life when attempting to collect all the flora of the British Isles he asked his sister to send him water crowfoot *Ranunculus aquatilis* which he recalled grew in the Devon river.

Thomas Dick and family left Cambus in 1926 when appointed Supervisor of Excise in Thurso. Robert remained and upon the completion of his apprenticeship took a boat from Alloa to Leith finding work as a journeyman baker before transferring to similar positions in Glasgow and Greenock. At his father's suggestion he travelled north in 1830 to start a business in Thurso which only had one baker at the time. After the construction of an oven he set up shop in Wilson's Lane opposite his father's house. Bread was very much a luxury in these parts and initially Robert specialised in biscuit making aided by Annie MacKay his lifelong housekeeper. His sister Jane helped in the shop and after the family moved away to Haddington he corresponded with her for the rest of her life. Fortunately she kept all these letters which form the basis of much of Smiles' account. Robert was never to return to Tullibody though he kept in touch through correspondence both with Agnes who returned to the village and his father who eventually died at "Dovecot" in Cambus. In Peach's obituary in the John O'Groat Journal he states that Robert helped rear the families of his sisters who became widowed. He was also elected a "corresponding member" of the Alloa Archeological Society in 1863.

Botany and the Discovery of Holy Grass

Robert bought his flour from a merchant in Leith who was persuaded to send him books and a microscope packed in the centre of the bags. These

included the *Gardener's Dictionary* and the British Flora. He had plenty of leisure time and after his bread was ready he left the sales to his housekeeper spending the rest of the day reading and wandering. He took up botany in a most resolute way spending the spring and summer in excursions finding and documenting the local flora, particularly the ferns and mosses. Robert mapped out the county into districts and resolved to examine them all. This required great dedication and involved walking massive distances. In a letter to his sister he described one such excursion to Morven Hill on which he was to find alpine ladies mantle (*Alchemilla alpina*). He set off at 2 am to cover the 32 miles from Thurso (of which only 18 were by road) crossing many bogs and moors until he eventually reached the top of Morven by 11 am. The return journey was started at 2 pm and was not completed until 3 am the next morning.

Dick's chief botanical contribution was the re-discovery of *Hierochloe odorata* (*H. borealis*) the Northern Holy Grass. This plant had originally been included in the *British Flora* on the authority of George Don (1764-1814) who added more new species to the list of Scottish plants than anybody since. Don too has a local connection having botanized during his apprenticeship as a clock maker in Dunblane (Morris, 1908). Eventually he took up gardening and became head gardener at the Royal Botanic Gardens Edinburgh (RBGE) writing *Herbarium Britannicum* in 1804. He kept a large collection of wild plants in a "Systematic Garden" associated with his house in Forfar. Unfortunately he had a disconcerting habit of mixing up garden (alien) and indigenous wild plants. After his death a number of Don's claims could not be substantiated and in Sir Joseph Hooker's popular *Students Flora,* 43 of his "reputed discoveries" were relegated to the appendix (Morris, 1908; Butler, 1981). Dick's discovery of holy grass growing on the banks of the Thurso river helped rescue Don from calumny. Although surprised by the discovery Robert was too bashful to rush to print. It was about 20 years later that a young botany student noticed it in Dick's herbarium and reported the discovery to Professor Balfour at Edinburgh. Although initially sceptical Balfour was convinced as soon as he received a specimen and the record was published in the *Annals of Natural History, Edinburgh* 1854.

Holy grass has since been found in a number of wetland sites in both Scotland and Northern Ireland. There is a local colony on Vane Farm SSSI on Loch Leven in Kinross. The name is thought to have been derived from the practice of strewing it on the floors of Nordic churches where it perfused the atmosphere with its attractive scent. It is interesting that according to the *Atlas of the British Flora* all the recently discovered sites in Orkney are near old Norse churches.

According to Morris' (1908) account of *Noteworthy Local (Stirling) Botanists,* Dick set out to collect all the wild plants of Caithness. In achieving this he found a number of rarities including pyramidal bugle, (*Ajuga pyrimidalis*), Scottish primrose (*Primula scotica*), Baltic rush (*Juncus balticus*) and shady horsetail (*Equisetum pratense*). Not content he tried to extend his herbarium further to all the British native plants. English species were obtained by

exchanging Caithness plants for southern species collected by many of the famous botanists of the period. The RBGE has many herbarium sheets of *Hierochloe odorata* attributed to Dick which had been supplied under this exchange scheme. Dick wrote he had 3000 different specimens altogether and Morris reported in 1904 that they were still well preserved and kept in a case provided by public subscription. The herbarium has survived and will form part of a commemorative display in the new Caithness Horizons visitor centre.

Fossil Fish and Hugh Miller

Dick first became interested in fossils in the old red sandstone rocks around Thurso in 1835. Apparently he had attended three lectures given by a Mr Keir in Thurso (Williamson, 1967) and then read Mantell's *Wonders of Geology*. However his enthusiasm was really fired by the purchase of Hugh Miller's *Old Red Sandstone* (1841) with its descriptions of the Scottish fossil fish which abound in the Thurso area.

Hugh Miller was the son of a sea captain born in Cromarty in 1802. Although very successful at school his master boxed him about the ears once too often and he left to become a journeyman stone mason. As a result he developed an interest in the winged fossil fish he found in the rocks and what at the time were thought to be turtles but were later shown to be heavily armoured fish. In his famous book *Old Red Sandstone* he wrote of his finds *"creatures whose very type is lost, fantastic and uncouth, and which puzzle the naturalist to assign them even their class; boat-like animals, furnished with oars and a rudder; fish plated over, like the tortoise, above and below, with a strong armour of bone, and furnished with but one solitary rudder-like fin; other fish less equivocal in their form, but with the membranes of their fins thickly covered with scales; creatures bristling over with thorns; others glistening in an enamelled coat, as if beautifully japanned. All the forms testify of a remote antiquity – of a period whose fashions have passed away."*

Ill health caused by 10 years inhaling silica dust led Miller to change career to banking. His book *Scenes and Legends of the North of Scotland*, was a big success. Sir Roderick Murchison founder of the Geological Society read the geology chapter and soon the two were correspondents. Miller moved to Edinburgh where he had a prominent role in the founding of the Free Church during "The Disruption". He became the editor of *The Witness* newspaper which did much to swing political opinion against the current rights of patronage. Miller started to write articles about fossil fish in *The Witness* and these formed the basis of *Old Red Sandstone*. He became the leading populariser of geology during a period in which there was intense public interest and geology books outsold novels 5:1. In 1834 Louis Agassiz the leading Swiss authority on fish fossils addressed the British Association meeting in Edinburgh. Sir Roderick Murchison introduced Miller's fossils to the great man, some of which were quite new to Agassiz and he later named them for either himself or for Miller.

Robert Dick was one of the many inspired by Miller's book and once again he started walking the length and breadth of Caithness in pursuit of fossils.

This time he was encumbered with "a 3 lb of iron chisels in his pockets, a 4 lb hammer in one hand and a 14 lb smiddy hammer in the other". He sent the first of hundreds of letters and specimens to Miller on the Union Steamer from Thurso to Leith in March 1845. Some of these first discoveries were valued by Miller who began to modify his accounts and reconstructions as more complete fossils were found. Robert could be quite critical and wrote "Your Edinburgh Professors can put on their spectacles next time they travel North. If they wish to be respected they must be more particular". In the third edition of *Old Red Sandstone* (1846) the evidence for the "development theory" that there was a gradual progression in fish size and complexity from the Silurian through the ORS to the Carboniferous had to be amended because Dick found a massive *Homosteus* (then called *Asterolepis*, Saxon, 1967) in the oldest ORS beds. Agassiz calculated it was 12 feet 5 inches long.

The two were to eventually meet in Caithness in 1845 and their excursions together with other information provided by Dick were documented in Miller's articles and *The Cruise of the Betsy*. One such account is preceded by the following introduction: "Let us accompany Mr Dick in one of his exploratory rambles. The various organisms which he disinterred I shall describe from specimens before me, which I owe to his kindness,—the localities in which he found them, from a minute and interesting description, for which I am indebted to his pen".

Robert shunned publicity and in a note with a dozen more specimens wrote "Be a good man and do not speak about me by name. I am a quiet creature and do not like to see myself in print at all". Most of his best specimens were sent to Miller who later wrote "he robbed himself to do me service".

Coccosteus was amongst the fossils sent to Miller. It belonged to the group of fishes known as Placoderms whose head and thorax were covered by articulated armoured plates. *Homosteus milleri* (called Asterolepis by Dick and Miller) had a massive skull the size of a horse and bones up to one inch in thickness (Saxon, 1967). Placoderms were the first jawed fish and became extinct by the end of the Devonian. *Osteolepis* and *Holoptychius* were fossil lobed finned fish or Sarcopterygians which are thought to be ancestral to the first land tetrapods and modern amphibians. They had primitive lungs that allowed them to survive in stagnant water. Their paired lobed fins contained rod shaped bones surrounded by muscle allowing them to walk underwater. Dick also found fossil *Dipterus,* an extinct genus of lungfish.

While "the young men of Thurso who are interested in the improvement of their minds" were encouraged by the John O' Groat Journal to visit Holburn Head to observe Mr Dick's fossil beds, the uneducated seem to have thought Dick very odd and rather simple. A newspaper article in March 1851 ridicules them. It had been reported that a fire burned in the centre of Loch of Calder (probably a Will o' the Wisp) for several minutes which according to Brawlbin superstitions predicted an unusual calamity. Apparently Robert Dick who had been collecting in the vicinity was warned by the locals who "thought this individual is *no vera wise*". This was "because he is seen hammering at stones

and rocks, and because he sometimes tells … that he is taking out of the stones what was thousands of years ago alive and swimming about in water, in the shape of fish".

Glaciation and boulder clay

Agassiz revisited Scotland in 1840 this time to address the Glasgow meeting of the British Association. With him he brought the revolutionary proposal of Venetz and de Charpentier that the glaciers of the Alps had once been more extensive and their movement accounted for the spread of the crystalline rocks from the Central Alps across the great Swiss plain to the flanks of the Jura mountains (Geikie, 1905). It was suggested that landforms in northern latitudes were shaped by the actions of ice rather than cataclysmic floods. During his visit Agassiz recognized features in the Scottish landscape which were also consistent with glaciations and proposed that "not only glaciers existed in the British islands but that large sheets of ice covered the entire surface". At first his conclusions were regarded as rank heresy by the older conservative geologists who could hardly contain their contempt for this youthful observer (Giekie, 1905). The theory proposed that the erratic rocks perched on mountain sides, often far from their original strata and the large boulder clay deposits which covered much of Scotland were carried there by glaciers. Lyell had earlier proposed an alternative "drift" theory that envisaged that the land had been inundated during long periods of subsidence and the clay sediments and sea shells were deposited from it. The large erratic boulders (like Samson's Button in Tullibody) were carried by icebergs that floated over the land dropping rocks picked up from the icebound edges of frozen continents.

Miller had seen sea shells in the boulder clays at Wick while travelling to Orkney but lacked time to collect them. He realized their significance and mobilized Dick to cast light on the controversy (Williamson, 1967). Once again Robert undertook long treks (two of over 50 miles) constantly driven by his compelling curiosity. Details of the marine shells, scored rocks and polished stones were described in a series of letters to Miller which he in turn wrote up in *The Witness*. Robert had previously collected shells from the Caithness coast and realized that those he found in the boulder clay were living species from deeper water. The proximity of the deposits to the current shore line raised the prospect that sea birds had carried them there and he continually sought new sites that were higher and further inland. His observations proved to be ambiguous. For instance at Freswick besides abundant broken shells he found "a considerable variety of stones in the clay section that were all rubbed, grooved or scratched"… "they included pieces of flint, and chalk, granite, quartz, greenstone, together with a belemnite fossil". While the shells were consistent with a marine origin both they and the small stones were worn and scored which Dick believed was evidence of a glacial origin. Miller provided the following explanation: "*The agent which produced such effects could not have been simply water whether impelled by currents or waves. No force of water could have scarred such distinct well marked lines on such small stones. The blacksmith, let him use what strength of arm he may, can not bring his file to bear on a minute pin or nail,*

until he has locked it fast in his vice … the smaller stones must have been fastened (in ice) ere they could have been scratched".

In 1880 Dick's observations on the Caithness shelly boulder clay together with those of his friend Charles Peach (see below) were reinvestigated by the Scottish Geological Survey. They discovered that the score lines or striae on the basal rocks of eastern Caithness and the direction of transport of local erratics were both in a SE to NW direction. As a consequence they proposed that the shells, chalk, flints and fossils were scoured from the bed of the North Sea by an ice sheet which moved onto land from the Moray Firth and deposited the material across the plain of Caithness. They suggested that glaciers which originated on land to the south of Caithness initially moved east into the Moray Firth but were then deflected northwestwards by the greater force of the ice sheets they met radiating from Scandinavia. The lack of banding in the clay itself also suggested it was derived from land based glacial action and not deposition from some past sea which covered the landscape (Peach and Horne, 1881).

Miller's suicide

The discovery of fossils of extinct fish as well as failure to find living species fossilized in the sandstone beds raised questions about accuracy of the biblical account of the creation. Miller as a prominent member of the Free Church found himself in a difficult position and had to concede that the account in Genesis was symbolic. He believed, as did many scientists of the time, that the fossil record represented a series of separate special creations and subsequent mass extinctions. He interpreted the six days of creation as being synonymous with geological periods which had been sublimed into representative visions of the progress of creation. Miller famously shot himself after correcting the proofs of *The Testimony of the Rocks* on Christmas Eve 1856, leaving a scribbled note for his wife and children. Robert was devastated and wrote to his sister "I thought it was the end of all things. I am more shocked than I can tell. I can not look on a stone without thinking of him". He believed that his friend's insanity resulted from the conflict between meeting the exigencies created by his position as both a scientist and religious journalist. However several of Miller's biographers believe that he was comfortable with the borderline he trod between the biblical literalists and those geologists who saw no role for God (Knell and Taylor, 2006). Dick's own views were remarkable for their time. In a letter to his sister commenting on *The Testimony of the Rocks* he wrote "Of one thing you may be sure, the earth as we have it was not made in six ordinary days. The earth is making yet. It is still in the course of creation" . Unlike Miller, Dick lived long enough to be confronted by Darwin's theory of evolution. He appears unimpressed "I have no wish to meddle with Mr Darwin's notions". Later he confessed he "might have spoken rashly for in truth I have never read one of his books and the reviewers of them may have twisted his meaning to suit their purposes".

The question of the importance of Dick's contribution to Miller's reputation as a geologist has never been authoritatively researched. It is particularly

difficult because of Dick's requests for anonymity. Some of Miller's biographers do not mention him though there is plenty of evidence from Miller's own hand that this is a serious oversight. Perhaps the best placed to make the judgment are the palaeontologists who can evaluate the importance of Dick's fossil finds. In 1963 a genus of fossil fish was named Dickosteus *"after the Thurso baker whose early geological explorations of Caithness greatly promoted the study of Devonian fishes"* (Miles and Westoll, 1963).

Charles Peach

During the latter stages of his life Robert struck up a friendship with a kindred spirit Charles Peach. The two had much in common. Peach had humble origins as a revenue coastguard whose job was to stop smuggling. This occupation resulted in him being moved periodically round the coast from Norfolk to Dorset to Cornwall and finally to Wick. Peach's obsession was rock pool invertebrate zoology and his expertise soon came to the attention of men of learning. In contrast to Dick, Peach was not a retiring character and whilst working in Cornwall he went to a British Association meeting at Plymouth to present a paper. This was astonishing not only because of his position but because he had only attended one formal lecture in his life. In the presentation he showed that the rocks of Cornwall contained fossils, contrary to the opinion of experts like Murchison and Pryce. Subsequently he presented his studies at a series of BA meetings building scientific respect and acquaintances.

Peach relates that Dick "was a household name to him in Cornwall" and in 1853 upon taking up a position in Wick he sought him out in his bakehouse at Thurso "as he felt assured he was a man after his own heart". The two clearly enjoyed one another's company and had long discussions "in front of the fiery furnace" and many outings together sharing their common interests and broadening one another's range of knowledge.

Peach made some remarkable fossil discoveries in the Durness limestone and Sir Roderick Murchison Director General of the Geological Survey journeyed north to investigate. While in Thurso he sought information about the location of fossil beds from Dick but unfortunately Robert was unable to leave his ovens to see him. Murchison was more successful on his next trip to Caithness and accompanied by Peach spent a fascinating day discussing the local geology with Dick. It was during this meeting that Robert made the model of Caithness in flour to explain its geology which so impressed Murchison. At the 1858 BA meeting in Leeds Sir Roderick spoke about "The results of researches among the older rocks of the Scottish Highlands" referring to both Peach's and Dick's finds. He subsequently addressed a public meeting in Leeds Town Hall which really turned into a eulogy of Dick and led Samuel Smiles to include him as an example in *Self Help*. Peach sent Dick the newspaper reports of the lecture and in reply he received a few scribbled stanzas which have become known as the *Song of a Geologist*. It was widely sung at geological meetings and has recently been republished (Edinburgh Geologist, 2004). The following verses are an extract:

Hammers an' chisels an' a'
Chisels an' fossils an' a'
Resurrection's our trade; by raising the dead
We've grandeur an' honour an' a'

Hammers an' chisels an' a'
Chisels an' fossils an' a'
The deeper we go, the more we shall know
Of the past an' the recent and a'

This publicity was not welcomed by Dick and he was bothered by increasing numbers of callers at his bakery. The merely curious were turned away while the scientists like Wyville Thompson were granted access to the inner sanctum ... the bakehouse. His attitude clearly upset the townsfolk and the following is an extract of his obituary in the *Northern Ensign* newspaper "For it was not everybody that Mr Dick would honour with the sight (of his collection) or even with conversations. Retiring to a degree and even at times repulsive in manners, Mr Dick was considered extremely antisocial ... and not a few who visited Thurso solely to see his collections left without their object, including a member of the reigning dynasty of France".

The next year Peach attempted by letter to get Dick to present some of his findings at the Aberdeen meeting of the BA his reply was "when you go to Aberdeen I hope you will not speak of me at all. People bothered me so much last year after Sir Roderick made his speech that I have no desire for a repetition".

Throughout this period Robert suffered both a decline in health and in trade. When he went to Thurso there was only one other baker but by 1862 there were six and there was not the trade to support them. His position was not helped by the impression in the general populace that this reclusive man who walked the moors collecting mosses and stones at night was mad. Others avoided his shop because he desecrated the Sabbath, collecting his fossils rather than attending the Kirk. Ironically he was too moral for business. He declined the offer of supplying the wealthier houses whose occupants were becoming acquainted with his fame because he knew it would cause hardship to other bakers. He confided in a letter to his sister Jane in May "I have lost much and am still loosing and what is worse I am loosing my health. I have not had a days health since last February and goodness knows that if I had to take to my bed all would be over". He regretted not giving up his shop and taking up some other occupation. His sister had suggested he might return to Bannockburn to set up business there but he declared he had a dread of weaving places ... "Weavers often suffer great misery and the stoppage of trade is clear ruin". Besides the situation of bakers in the Stirling area appeared no better and in one letter he refers to a newspaper sent by his sister describing the suicide of a baker's wife from Alva.

Debts, Death and Memorials

In the last three years of his life Robert increasingly suffered from crippling rheumatism, failing eyesight and a bad chest. For significant periods these prevented him from pursuing his passion. When the rheumatism abated he was still able to walk 30 miles in search of herbarium specimens and fossils for the collections of Wyville Thompson and Sir Roderick Murchison. His letters to his sister reveal periods of intense depression when his failing business and poor health got the better of him.

On March 9th 1863 a steamer the Prince Consort with £45 worth of Robert's flour in her hold struck the quay in Aberdeen harbour. After the passengers were removed she broke her back as the tide receded and the flour was soaked. Because the negligence of the crew could not be proved the cargo was uninsured and Robert was responsible for the payment. He attempted to sift the sand out of the flour but this resulted in further loss of trade. He wrote to his sister "I am injured for ever. I'll never make an extra farthing from my trade here. The bakers are in swarms now. I am old and my strength and sight fail me. Before I had hardships quite enough but this crowns everything. I am stupid with grief". As a result of this plea Jane lent him £20. Initially he seems to have successfully concealed his plight from his friends but eventually he approached John Miller a native of Thurso who spent most of his time in London asking him to offer Sir Roderick Murchison "in quiet way" his fossil collection so he could pay off the debt. He wrote "those drunken blackguards of the steamer have ruined me, I am a beggar, not in word but in fact". Miller offered to give him the money but Dick did not want charity so his friend bought the fossils himself. These were later kept at Burgo House, Bridge of Allan but eventually on John Miller's death they joined the fossils Dick had given to Hugh Miller in the National Museum of Scotland.

For a brief period "the vengeance" abated and Robert set out with renewed vigor to replace his fossils. Unfortunately in February 1864 fate was to deal another savage blow. His sister Jane who had been his lifelong confident died unexpectedly and left him devastated. He later wrote to his brother-in-law that he had not lifted a hammer in three months.

On the 29th August 1866 Robert made what was to be his last fossil collecting expedition. Overcome by nausea and giddiness he managed to stagger back to the bakehouse, the local residents thinking he was drunk. In a pathetic last note to Peach, who was now in Edinburgh, he wrote "I fear I can not write to you at all. I have been for four months unable to do anything for swollen limbs. Water on the chest in fact and lest I should die I only notice you. I am very poorly so excuse me. No rest night or day believe me". After he had been seriously ill for two months John Miller called on his old friend. He was horrified at his condition and immediately summonsed a doctor and sent his housekeeper to nurse him. The doctor's advice was to give up work and engage a journeyman to run the business. Robert's condition deteriorated and he became delirious imagining he had bread in the ovens and insisting on being carried down to view them. Eventually his suffering ended on December

24th 1866, exactly ten years after the death of Hugh Miller.

On 27th December there followed a rather bizarre obituary in Wick's *Northern Ensign* under the heading "Death of a remarkable man". Having explained his scientific fame it goes on: "among the people of Thurso and neigbourhood Mr Dick was long looked upon as partially insane. By and by it began to be whispered that men of great influence were visiting the mad Thurso baker.... Among the peoples of Thurso Mr Dick was personally unknown. We believe he was seldom in the street during the day for many years and in these exceptional circumstances he recognized no one. His closing days were dark indeed, suffering from dropsy Mr Dick had little in his comparatively humble abode either of a social or physical character to cheer him and he passed away after much painful agony".

Stung by the implied criticism that they did not appreciate their local genius and let him die a pauper, the people of Thurso hit back with a rebuke in the *John O'Groat Journal*. The long article details Dick's accomplishments including an account by his friend Charles Peach and goes on to state "We regret to find it insinuated that the people of Thurso did not appreciate Mr Dick ... that he died for want of common comforts and necessities of life and that during his life he was treated by his town with contempt. All this is reckless libel full of stupid blunders written in the most wretched taste ... It was utterly untrue that he was uncared for in his last illness Mr John Miller was most assiduous in his attention to his comfort".

The outcome of this publicity was a funeral attended by virtually all the town and the biggest band Thurso ever mustered. To make amends the people of Thurso set up a memorial fund which was used to erect a massive granite obelisk in the cemetery.

The *Alloa Journal and Clackmannanshire Advertiser* carried a long obituary in the Dec 29th 1866 issue including extracts from the *Northen Ensign*. Tullibody was slow to acknowledge its famous son. Although articles appreciative of Dick's work were contributed to *Transactions of the Stirling Natural History Society* (Morris, 1908) there was nothing to commemorate him in his home village. In December 1917 a note appeared in the *Stirling Journal* under the nom-de-plume "onlooker" (apparently a Caithness man) suggesting a commemorative tablet should be placed in front of the house where he was born. David Morris the town clerk of Stirling and the Rev Thomas Miller of Alloa parish inserted a joint letter in the local papers asking for subscriptions which were duly received. A pink granite stone was purchased and inscribed

In this house was born January 1811
Robert Dick
Baker of Thurso; Botanist and Geologist : whose life spent in pursuit of Science amid
many difficulties is an inspiration and example.

It was unveiled on Sept 21st 1918 in the presence of many dignitaries. Rather appropriately the main address was given by Benjamin Peach FRS

whose classic work with the Geological Survey had provided the framework for the geological structure of Scotland. He was the son of Dick's great friend Charles Peach and probably the last man left who had the privilege of visiting Dick in the bake-house at Thurso.

Smiles' biography, the naming of the genus *Dickosteus*, the obelisk and a museum in Thurso and a radio play transmitted in 1949 were all worthy tributes. However perhaps the most appropriate memorial to Robert Dick is an isolated, detached, natural pillar of rock in the Grand Canyon next to the Darwin Plateau and Huxley Terraces, which according to Wharton (1912) *bears the name Dick Pillar, from Robert Dick, the baker-geologist of Thurso, Scotland, who gave such material assistance to Hugh Miller in his studies of the Old Red Sandstone.*

Bibliography

Butler, J.K. (1981) Caithness Grasses. *Caithness Field Club Bulletin Oct 1981*

Dick, R. (1854) Notice of the discovery on the *Hierochloe borealis*, *Annals of Natural History* **XIV**, 314-315.

Geikie, A.(1905) *The Founders of Geology*. London, Macmillan.

Knell, S.J. and Taylor, M.A. (2006) Hugh Miller: fossils, landscape and literary geology. *Proceedings of the Geologists Association* **117**, 85-98

Miles, R.S. and Westoll, T.S.(1963) Two new Coccosteid arthrodira from the middle old red sandstone of Scotland and their stratigraphical distribution. *Transactions of the Royal Society of Edinburgh* LXV no **9**, 179-208

Miller, H. (1858) *Old Red Sandstone*. 7th edn. Edinburgh: Thomas Constable.

Miller, H. (1889) *The Cruise of the Betsy* the collected articles from *The Witness*. Edinburgh: Nimmo Hay and Mitchell.

Morris, D.B. (1908) Some noteworthy local botanists *Transactions Stirling Natural History and Archaeological Society*. **30**, 66-87

Morris, D.B. and Miller, T. (1918) Robert Dick Botanist and Geologist. An account of the proceedings at the unveiling of the memorial at Tullibody. Stirling: Scott, Learmonth and Allan.

Peach, B.N. and Horne, J. (1881) The Glaciation of Caithness. *Proceedings of the Royal Physical Society* **16**, 316-352

Saxon, J. (1967) *The Fossil Fishes of Caithness and Orkney*. Thurso: John Humphries, Caithness Books,.

Shortland, M. (1996) *Hugh Miller and the Controversies of Victorian Science*. Oxford: Oxford University Press.

Smiles, S. (1859) *Self-Help, with Illustrations of Character and Conduct*. London: Ward Lock.

Smiles, S. (1878) *Robert Dick, Baker of Thurso, Geologist and Botanist*. London: John Murray.

Wharton J.G. (1912) *The Grand Canyon of Arizona: How to See It*. Ch. XI. USA: Littlebrown and Co.

Williamson, J.A. (1967) *The Life of Robert Dick*. Thurso: John Humphries, Caithness Books,.

Wintle, J. (1982) *Makers of Nineteenth Century Culture 1800-1914*. London: Routledge and Kegan Paul.

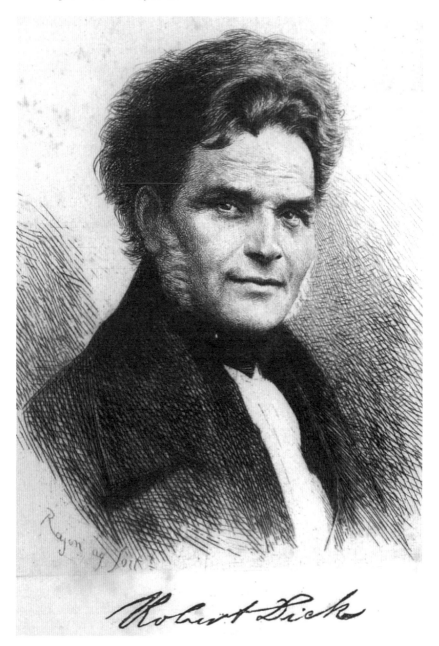

Figure 1 Portrait of Robert Dick from the biography by Samuel Smiles published by John Murray 1878.

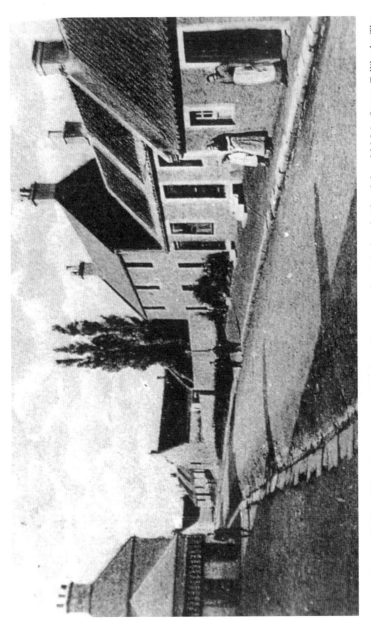

Figure 2 Robert Dick's childhood home is the two-storey house on the right hand side of the old Main Street, Tullibody. The photograph is taken from where the Coronation tree now stands, all these houses have been demolished (reproduced with the kind permission of Clackmannanshire Libaries).

LOCH LOMONDSIDE'S FORGOTTEN WATERWAYS

John Mitchell

It is a curious fact that in the 18th and 19th century annals of engineered waterways designed to assist commercial boat traffic on Loch Lomondside, information is more readily obtained on the grandiose schemes which never progressed beyond the drawing board than the small-scale canals and other water-works that were actually carried out. Although every one of the proposed major schemes failed to attract the financial backing needed to proceed, during their planning stage they were subject to feasibility reports which are still available for study. By contrast, few details have survived on the completed lesser projects and in consequence they are not widely known.

This paper draws attention to four of these poorly documented Loch Lomondside waterways, all of which came into use before the carrying of travellers, raw materials and manufactured goods by water was taken over by road and rail.

The Inchfad Whisky Distillery Canal

Dating back to the second half of the 18th century, the earliest of the four waterways described served a licenced whisky distillery established on Inchfad, an island just off the eastern shore of the loch. Virtually nothing of the distillery's history has been passed down, although it is on record that the first man to take charge of the venture was Duncan Macfarlane, a direct ancestor of the present Macfarlane family at Balmaha. Baptismal entries for Buchanan Parish indicate that he took up residence on the island in 1764/65 after the birth of the third of his eight children. Following his death in 1783, he was succeeded in the post by his eldest son John (1). It could have been either father or son who was responsible for the excavation of a short canal leading from the water's edge to the distillery and incorporating a sheltered harbour set back from the shore. This facilitated boats bringing in grain to the distillery and the taking away of the finished product to secure premises on the mainland.

Before a boundary change made in 1797 which left Inchfad outside of the government defined Highland Region, the distillery enjoyed a much lower rate of taxation than those in the more economically developed southern half of Scotland (2). In common with the other small whisky producers on the highland fringe who lost out by the boundary shift, Inchfad found itself having to compete on equal terms with the well established and larger distilleries in the more populated parts of the country, something that could account for this local enterprise's decline and eventual closure.

With the distillery gone, both the canal and the harbour silted up through lack of use [Plate 1a]. Local recollection backed up by an aerial photograph confirms that the lower half of the canal was cleaned out and the inner harbour

modernised with concrete surrounds in the early 1950s. After the island changed hands some ten years later, the harbour again fell out of regular use and allowed to fill with sediment. Following yet another change in ownership of the island, during the late 1980s work commenced on re-opening the facility to provide safe boat moorings for the present-day Distillery Cottage.

The Inverarnan Steamer Canal

In 1840 the steamboat partnership of David Napier and John McMurrich investigated the possibility of extending their Loch Lomond passenger service between Balloch and Ardlui to Inverarnan, a couple of miles beyond the head of the loch. For tourists and others intending to travel by horse-drawn coach still further into the highlands, the inn at Inverarnan was the staging post for Oban, Ballachulish and Killin. The lower reaches of the River Falloch conveniently covered most of the distance from Ardlui to Inverarnan, but due to the difficulties presented by a particularly sharp bend in the river, it was found that a cut would be needed for steamers to reach the proposed new terminus near the inn. Work on constructing the 500 yard long canal, turning basin and landing stage commenced in 1842, with completion by 1844. For reasons yet to be fully explained, the exclusive use of the Inverarnan Canal almost immediately fell into the hands of rival steamboat owners, before the two concerns settled their differences and amalgamated into the one company in 1845 (3).

LOCH-LOMOND AND LOCH-CATRINE.

NORTH & WEST HIGHLANDS.

THE

STEAMERS,

" Prince Albert," and " Water-Witch,"

WILL SAIL EVERY LAWFUL DAY

FROM BALLOCH,

In connection with Dumbarton Steamers and Railway, at the following hours:—

**From Glasgow—at 7 and 9-15 a.m., and 4 p.m.
From Balloch, foot of loch—at 9 and 11 a.m., and 6 p.m.
From Inverarnan top of loch—at 7-45 a.m., 12-30 and 3 p.m.
Arrives at Balloch—10-30 a.m., 3-15 and 5-40 p.m.
Glasgow—12-30, 5-15, and 7-40 p.m.**

The Loch Lomond Steamboat Company ran its sailings from Balloch to Inverarnan to connect with stage coach services to several highland destinations.

Navigational problems arose through sand and gravel continually accumulating at both the river mouth and the entrance to the canal which - when water levels were low – made it difficult for the paddle steamers to reach Inverarnan. By the late 1860s the company seems to have given up the struggle, retreating back to Ardlui. Any chance of a regular steamer service to Inverarnan being reinstated ended when the long-distance coaches operating in this part of Perthshire were withdrawn in the face of competition from the newly opened Callander & Oban Railway.

Today the steamer turning basin at Inverarnan is partially in-filled, the canal itself obstructed with fallen trees [Plate 1b].

Wards Scow Canal

Wards Tile Works producing field drainage tiles or pipes was well placed, sitting as it did over a thick bed of estuarine clay laid down when the immediate post-glacial Lomond Valley was an arm of the sea. As close as can be ascertained, the business was set up sometime between the publication of the *New Statistical Account* for Kilmaronock in 1840 – when it was stated there were no manufactories in this essentially rural parish – and the *National Census* of 1851 listing master mason James Cross and six other men employed in tile making at Wards. The first edition of the Ordnance Survey map covering Kilmaronock (surveyed in 1860) shows not only the tile works buildings, but a 400 yard long canal providing a link for the shallow-draught scows operating along the navigable lower reaches of the River Endrick accessible from Loch Lomond (4). The digging of the canal from the tile works to the river probably paid for itself, as all of the clay extracted would have been used in the kilns. According to local information, production at the works continued on and off into the early 20th century, although the carriage of the field drainage tiles had by then switched from by water to the roads.

After falling into disuse and becoming overgrown [Plate 2a], Wards Scow Canal was cleaned-out in 1981 to allow small boats to be brought up from the river to be moored by the present house.

The Balmaha Wood Distillation Works Lighter Wharf

It was around 1830 that the firm of Turnbull & Co. of Glasgow established a wood distillation works at Balmaha, their main product pyroligneous acid was used as a mordant in the colouring process of cloth. Both the incoming raw material from the loch-side woodlands and the outgoing barrels of distilled acid destined for the textile factories in the Vale of Leven and elsewhere were usually transported by boat (5). To assist in the unloading of the wood at the work's stack yard, narrow channels faced with timber were cut into the adjoining marshy ground to create berths for the steam lighters which came into service on the loch from the 1860/70s [Plate 2b]. Put out of business by foreign competition and the development of directly applied dyes not requiring a mordant, the wood distillation works closed down in 1922, the stack yard wharf left to fall into disrepair and the water channels to choke-up

with aquatic vegetation.

From time to time other cuts have been made in these same loch-side marshes to be used as sheltered moorings for the Balmaha boatyard.

Acknowledgements

My thanks to all of the local residents who generously shared with me their own and family reminiscences relating to waterways on Loch Lomondside. Also to Norman Tait for preparing the photographic illustrations for publication.

References

(1) Dumbarton Library Local Studies Room Genealogical Collection.

(2) Moss, S.M. and Hume, J.R. 1981. *The Making of Scotch Whisky: A History of the Scotch Whisky Distilling Industry*. Edinburgh: James and James.

(3) Brown, A. 2000. *Loch Lomond Passenger Steamers 1818-1989*. Nuneaton: Allan T. Condie.

(4) Mitchell, J. 2005. *From East Lomondside to the Clyde: a Short History of Local Travel and Transportation by Water*. Drymen and District Local History Society.

(5) Mitchell, J. 2006. The Pyroligneous Acid Works, Balmaha: an almost forgotten rural industry, *Scottish Local History*. 67, 13-15.

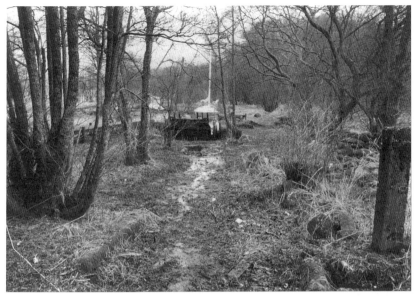

Plate 1a The stretch of canal leading from the long gone Inchfad Whisky Distillery to the re-opened harbour on the island has all but disappeared (Fiona Baker, courtesy of the Friends of Loch Lomond).

Plate 1b Abandoned around 1870 and now hemmed in with trees, the Inverarnan Canal was built to accommodate the early paddle steamers in service on Loch Lomond.

Plate 2a Heavily overgrown, Wards Scow Canal just before it was opened-up in 1981.

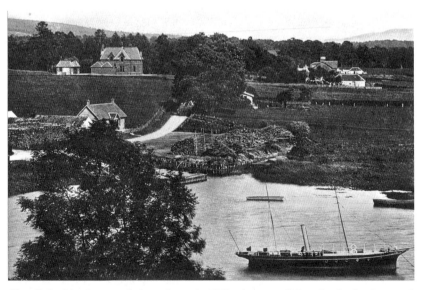

Plate 2b In this photograph from the early 1900s, the steam lighter berths for the wood distillation works at Balmaha can be seen on the far side of the bay (A.J. Macfarlane collection).

THE ROYAL COURT AND THE COMMUNITY OF STIRLING TO 1603

John G. Harrison

Work on the interiors of the palace at Stirling Castle has stimulated interest in the courtly life of the period around 1540 when the main phase of palace construction was under way. I have been fortunate to be involved in the research on which I will draw freely in this paper[1]. Links between town and castle have endured since the twelfth century and were an obvious choice of topic when I was asked to give the inaugural lecture for the Stirling Local History Society in October 2006. In that lecture I identified four main periods in the relationship;

> the royal period to 1603.
> a post-royal interval from 1603 to the 1640s.
> the garrison period from the 1640s to the 1960s.
> the tourist period, overlapping with the garrison from about the later eighteenth century to the present.

In this paper I shall concentrate on the royal period, mainly in the sixteenth century, since that is the best documented period and the main focus of the research for the palace project. The main objective is to examine the relationship with the court from the perspective of the community and its inhabitants[2]. But, examination of the local records also revealed significant new information about the organisation of the court.

The castle is at the summit of a hill, above the town and surrounding countryside, a type of site as important for its socially dominating position as for any military advantage[3]. The castle would have been visible from afar whilst an undeveloped gap between castle and town, corresponding to the modern Esplanade, Valley and Kirkyard, ensured that the visitor approaching from the town saw the eastern façade from a distance, a view described as 'the whole outward beauty of the place' in the early 1580s[4]. Contrary to a widely-stated cliché, there was no question of the populace 'huddling for protection below the castle'; the gap provided 'social distance' and kept the people in their place.

[1] I am grateful to Historic Scotland for permission to draw on work (Harrison, 2005) undertaken for them and also to my colleagues on the Stirling Palace Academic Research Committee (SPARC) and others at the annual reviews of the project for insights, suggestions and lively discussions.

[2] For Stirling Castle itself, see Fawcett 1995; for the Great Hall and court rituals in Stirling see Fawcett ed. 2001; for Scots court life generally see Dunbar 1999.

[3] Much of the discussion in Creighton, 2002, on the landscape settings of early medieval English castles is relevant here. See also Driscoll, 1998; Dennison, *et al.* 1998.

[4] NAS E37/2 Inventory 1581x 1583 mentions 'the foure roundis of the foir entries qlk is the haill utwart beautie of the place'; the façade of that period is now within the early eighteenth century defences and three of the towers have been truncated.

The more prestigious buildings in the town, particularly the kirk, were situated high within the urban area. Probably the upper parts were more socially prestigious from the beginning, though this can only be conclusively shown from later records. So, the town's social profile mirrored its physical profile, with the castle at the top, the urban elite in the middle and the poor towards the bottom of the long hill[5].

The earliest documents refer to the royal lands in the vicinity and a park is first recorded at some time between 1165 and 1174, carved from the earlier royal demesne lands[6]. In the 13th century a New Park was established at St Ninians but the old one was reinstated within a century or so[7]. Amongst the park's many functions was to provide another vantage point from which the castle could be appreciated and an appropriate setting onto which it looked; it is striking that, whilst modern suburbs can be seen from the castle's royal interiors, the old town is almost invisible. In 1506 the Crown granted the part of the park now broadly corresponding to the built-up area around Victoria Square to the town in exchange for the Gowane Hills. The area granted was peripheral to the castle vistas and in any case remained agricultural for centuries. The exchange gave the Crown control of the sight-lines from the castle to the bridge, which increasing fire-power had now brought within range of castle-based artillery[8]. So, the demands of the royal presence influenced the location and form of development of the town whilst some potential agricultural land in the vicinity was set aside for royal use. This Crown land adjacent to the castle was not subject to the magistrates and council of the burgh but was controlled by a royal official who, by the later sixteenth century was known as the constable of the castle; so, the Park, Gowane Hills and the braes around the castle, together with an area around modern Barn Road called Castlehill, were together known as the Constabulary.

From the 12th century, following wider European models, the Scots Crown had encouraged the growth of towns, including Stirling. The reasons included the expectations that towns would, in turn, stimulate the economy, trade focussed in towns was more readily taxed than trade diffused across the entire country and towns also provided convenient foci of royal administration[9]. But towns in the immediate vicinity of royal residences were also useful for providing supplies, accommodation and services for the court. It is thought that in Peebles, for example, establishment of a new burgh followed closely on the establishment of a royal castle[10]. The royal manor of Falkland was granted to Mary of Gueldres (wife of James II) in 1451 and in 1459 some 22 plots of land nearby were feued to people who were obliged to provide accommodation,

[5] Harrison, 1985.
[6] [Regesta II] pp. 206-7.
[7] Miller, 1922; Gilbert, 1979 pp. 82-3; Harrison, 2006.
[8] Renwick, 1884, pp. 69-71; Sadler I, pp. 203-4, Sadler to Privy Council, 20th May 1543, stating that there was no artillery in the castle able to cover the bridge.
[9] Lynch, 1992, pp. 62-4; McNeill and MacQueen, 1996, pp. 196-8.
[10] Dixon et al. 2003.

food, stabling, fodder etc for a total of 250 people and horses when required[11]. Thereafter, Falkland became a favoured royal residence. On the other hand, James III was over-hopeful in making Port of Menteith into a Burgh of Barony in 1467 'to improve the supply situation during hunting expeditions'[12] since clearly the burgh never functioned.

Aberdeen was not often on the royal itinerary but the court was there for Christmas 1497; instructions were issued to bakers, brewers, fleshers, fishers, stablers, candlemakers, cordiners, tailors, skinners and fuel suppliers to be prepared whilst merchants were to lay in suitable supplies of spices, wine, wax and other luxury items[13]. But Stirling was in a very different situation. It was regularly visited by all adult monarchs from the twelfth century to 1603, visits ranging from hours to weeks whilst several child monarchs were brought up in Stirling. In Stirling the royal residence was of the first rank and must almost always have been ready to receive a visit at short notice, whether visits for pleasure and relaxation, visits to deploy political or military might, visits for religious observance and so on.

Supplies and accommodation were problematic for all peripatetic courts. Chatenet describes the frequent, sudden moves of the French court of the sixteenth century, facilitated by well-organised arrangements for purveyance and allotting quarters, whether within the chateaux themselves or in near-by towns or even in barns, tents and other make-shifts. In England, by the time of Henry VIII, the full court had become so vast that the king generally moved within a limited compass along routes fixed well in advance and even so left many of the administrative departments in Westminster. A great deal of work over the past twenty years or so now allows a much more profound understanding of the Scots court of the period in the context of wider European models; we can begin to distinguish what was distinctively Scots from what was the norm of the wider European courtly culture and procedure[14].

James IV had established the Chapel Royal in Stirling between 1501 and 1505 and until the Reformation Stirling became the main focus of the royal religious life where the adult James V almost invariably spent Easter, the main feast of the Christian year. James V, who had around 30 houses and lodgings, spent up to 40 % of his nights in Stirling in the early part of his adult reign but the adult Mary made only a few (mainly brief) visits and the adult James VI used Stirling mainly on summer hunting jaunts[15]. Information about supplies

[11] ER, Vol vi. pp. lxxviii-lxxix; RMS, Vol ii, pp. 706-728.
[12] Gilbert, 1979, p. 42. Such patterns were widespread; for example, in France, the town of Blois grew up following establishment of the chateau and many courtiers had lodgings there, Chatenet, 2002, p. 88.
[13] Blanchard et al., 2002, p. 140. Boardman, 2002, p.204 and p. 449 note 5.
[14] For example for France see Chatenet, 2002; for England, Thurley, 1993; for Scotland see, for example, Dunbar, 1999, Hadley Williams ed. 1996; Edington, 1995; Thomas, 2005.
[15] Thomas, 2005, p. 244; Guy, 2004; Juhala, 2000, p. 132.

and lodgings for the Scots court is sparse but is usefully discussed by Dunbar[16].

The full court of the adult James V extended to around 350 named people and there were certainly others, hangers on, suitors and so on. The great rituals of court life (the baptismal festivals organised by Mary and by James VI are the key Stirling examples) would have drawn in even bigger crowds[17]. A visit might be part of a major progress, accompanied by a vast retinue, followed by a cavalcade of local gentry; but the Scots court, which made many informal moves, was more mobile than its contemporaries in England and France and the limited number of major residences meant that return visits were fairly frequent and did not always involve the full court[18]. Frequent moves meant that probably most of the residences, even quite minor ones, were kept furnished and in a state of near-readiness at all times, reducing the need to move furniture, take down hangings and so on[19]. Stirling might also be occupied by one or more of the satellite households. It was a jointure house for the queens of James II, III, IV and V who each had her own household, smaller than the king's but of similar structure; most used Stirling both before and after their spouses' deaths. And James V, Mary, James VI, Lord James (illegitimate son of James V) and Prince Henry (elder son of James VI) spent all or parts of their infancy and childhoods in Stirling, each with his or her own household, again smaller than an adult monarch's but on a similar model.

Even if there was no royal presence, the castle was not abandoned as there was a permanent staff, including keepers of the park and gardens, probably some stable staff and some of the laundresses as well as a very variable number of guards[20]. Some of these people would have lived in the castle but many probably lived elsewhere, often within the constabulary area, some near the stables at Ballengeich close to the modern fire-station. This was a rural situation but these families, some of whom held their posts over several generations, were closely tied to the burgh community, for example by marriage[21]. From the early sixteenth century, some of the staff of the Stirling-based Chapel Royal had

[16] Dunbar, 1999, pp. 182-191.

[17] Lynch, 2001, pp. 15-22 provides a summary of these events.

[18] Itineraries, becoming fuller and more reliable with time, have been published for James II (McGladdery, 1990, pp. 158-9), for James IV (Macdougall, 1988, pp. 313-5); Thomas, 2005, pp. 245-6 gives fuller details for James V for 1538 whilst an Appendix in Thomas (1997, pp. 386-423) gives recorded detail for the whole adult reign; Hay Fleming (1897, pp. 515-543) has details for Mary, which are discussed by Furgol (1987) and can be supplemented by Guy (2004). Juhala (2000, Appendix 4) gives the itinerary for James VI from Nov. 1597-Oct. 1598 and Anna of Denmark from April 1598-Oct. 1599.

[19] Harrison, 2005 pp. 14-5; NAS SP2/4 p. 304, for letter about the plenishing of the house at Perth.

[20] Walter Cunningham had been appointed gardener in 1525, NAS GD124/10/9, 3 Aug. 1525.

[21] Harrison, 2005, pp. 86-7, pp. 93-4. Thomas (1997, Appendix 1) identifies 15 members of the household of James V as being 'in Stirling'. But, as Thomas is aware, the list is not exhaustive, does not include other royal households (e.g. Margaret Tudor) and those named were not all contemporaneous. There were similar staffs at other regular royal residences (Dunbar, 1999).

houses in Stirling (though their work would sometimes take them elsewhere). The staff to be employed by Lord Erskine as keeper in 1523 were listed as a constable, watchman, garitours and porters whilst in 1561 his son employed the constable, keepers, porters, watchmen, garitours, gardeners and 'other office-men' and when Mar died in 1572 he owed the watchman, porter and gardener of Stirling £31 10s wages for the Whit term[22]. It is likely that this sum would include costs for their assistants. In the later sixteenth century a new stratum of local staff appear, including several artisan-servants (a cook, a baker, a wright or carpenter and others) and some of these got charters to build houses close to the castle, within the constabulary, where the Castlehill suburb developed[23]. Earlier Christian Ray, whose services as Maid of Honour to the dowager queen Margaret Tudor were recognised in 1524 by a land grant, had property in Stirling and Robert Spittal (who is discussed in more detail below) had appeared in court to support her in a dispute[24].

Many of those who accompanied the itinerant court, perhaps particularly the more humble, slept in the castle, close to their places of work. There was some limited accommodation for senior nobles within the castle though this was a huge privilege and (again as happened in France and England) even they might sometimes take lodgings in the town[25]. This must have become increasingly problematic as households and retinues became larger since any senior noble attending court would have a considerable following. During the sixteenth century some courtier families acquired houses in the more favoured towns, particularly Stirling and Edinburgh. These were, of course, subsidiary to their main houses, situated on their rural estates. Stirling's Mar's Wark provides a prime example[26]. These households would have been hugely swollen when the court was in town but must have had some permanent staff. In spite of suggestions that there may have been as many as 20 courtly houses in Stirling, more or less contemporary records suggest a more limited list;

> Lord Fleming's son and heir purchased a tenement in Stirling in 1472, though he sold it to the council in 1473[27].
> The Campbells of Argyll had a house by 1495[28].

[22] Act of Parliament for the safe keeping of the king, 1523; NAS Mar and Kellie Papers GD124/11/1 Copy Gift under the Privy Seal of the office keeper of Stirling Castle, with the endowments etc, 1561; NAS GD124/3/11 Testament and inventory of John, Earl of Mar, Regent of Scotland. RSS V 900, 901, 2977. Garitour, a watchman on a tower or wall.

[23] Morris, 1927; Harrison, 1985; Harrison, 2005.

[24] Cook, 1898, pp. 75-6. Fleming, 1906, p. 30.

[25] For France and England see Chatenet, 2002, pp.63-75 and Thurley, 1993, pp. 67-77 respectively; for Scotland Dunbar, 1999, pp. 197-201.

[26] Dunbar ,1999, p. 201

[27] Renwick, 1884, pp. 39-41 and pp. 184-5.

[28] SCA B66/25/51 10 April 1495 charter of land on the north side of the market gate of Stirling between the land of the Lord Argyll on the west and lands of late John Schaw on the east. This is not the modern Argyll's Lodging but probably adjacent to the south. The Campbells had had houses elsewhere in Stirling even earlier, see HMC, 4th Report (1874) pp. 483-4 for a house as early as 1302 and again in 1430.

An agreement was signed in the 'hospitium' of Alexander, lord Elphinstone in 1529[29].

The Earl of Montrose had a house on Baxter Wynd and adjacent to the Dean of the Chapel Royal's house in 1544[30].

Mar's Wark, built for the Regent Mar, was probably begun about 1570 and work was still ongoing when the Regent died in 1572, when wages were owed to the workmen[31].

All these families had strong local connections. The Elphinstones, Campbells and the Erskines of Mar all had accommodation within the castle, corresponding to official royal duties. These three families, as well as the Grahams of Montrose, had major estates in the locality. So, these houses would not just provide a base close to the court but also, on occasion, for influencing the political and economic life of the town for their own ends or for keeping in touch with their local contacts and power bases; significantly, the business done in Elphinstone's 'hospitium' was a renunciation of the mill of Kippenross at Dunblane and the witnesses included Robert Bruce of Airth, Robert Bissatt of Quarrell, Thomas Colquhoun and Mr John Sinclair, person of Comrie, all more or less local men.

Support for the 'short list' is provided by records of marriages and baptisms in the town in the late sixteenth and early seventeenth century[32]. Between 25 Nov. 1585 and 23 Feb. 1595 a total of 181 marriages are recorded in Stirling; 25 of 181 men and 6 of 181 women, a total of 31 marriages (17 %) have a demonstrable royal or noble link or involve people working within the castle. But 14 of these people were involved with the Mar or Argyll households, five were royal servants and six were people who worked in the castle e.g. as gunners etc; that leaves only six to divide between a scatter of other noble households, all bar one featuring in the list of proprietors above. The baptismal roles (from10 April 1587 to 29 March 1592) are less useful as most parents and witnesses are simply named, without designation; only one parent from 564 baptisms and very few of the 1000 or so witnesses are described as belonging to a noble household and these include a varlet to the king (twice) the earl of Mar (three times) three servants in the Mar household and one each in the households of Graham of Montrose, the Master of Elphinstone's and Lady Argyll. This sparse list does tend to confirm the limited list of noble households involved.

But the clearest support for the 'short list' is provided by people appearing before the kirk session of Stirling between 1598 and 1645, mainly accused of fornication and similar matters[33]. The four royal servants all appeared in 1603

[29] NAS Elphinstone papers GD156/9/ Item 14/2 dated 28 Jan. 1529.

[30] SCA B66/25/113, Jan 29 1543/4 William Earl of Montrose's property, adjacent to north side of the burgh.

[31] Gifford and Walker, 2002, pp. 727-8; Testament of the Regent Mar, GD124/3/11.

[32] Register of Baptisms and Marriages, *Scottish Antiquary*, 1892, 1893, 1894, 1895.

[33] SCA, Stirling Kirk Session Minutes, CH2/1026/1 to CH2/1026/3 cover the relevant dates. After 1645 the garrison begin to make a significant impact.

or earlier. There were 47 members of the Mar/Erskine households with a maximum of four in any year to 1610 but there was then only one year with three, three with two and many with none at all; There were 15 from the Argyll/ Campbell households but they tail off even more steeply with only spasmodic single appearances from as early as 1605. Other households rarely have more than one and account for only 21 of the 88 appearances including a son of the earl of Stirling in 1633 whilst the earl's new house was being built in Stirling. The figures argue strongly for the dominance of the Mar and Argyll households during the late royal period and for their rapid rundown thereafter, being almost eclipsed by 1620, despite these families both continuing to have a presence as landowners in the area.

It is likely that some of the other nobles later described as having accommodation in Stirling, such as the Regents Morton and Lennox, actually rented accommodation in the town as need arose as did visiting envoys and ambassadors[34]. Prior to the Reformation monasteries and friaries provided one option. Edward I had stayed at the Blackfriars of Stirling after his victory at Falkirk in 1298 and Scots monarchs regularly used monastic accommodation at Holyrood, St Andrews and Dunfermline[35]. Lord Graham occupied lodgings at the Blackfriars in Stirling in the 1560s[36]. In 1470, the Abbot of Dunfermline had a lodging on Broad Street, Stirling[37] and Alexander, abbot of Cambuskenneth, had a house in the Back Raw in the mid 1540s; both of these houses could provide accommodation for courtiers and other important visitors[38].

Others took lodgings in private houses. Sir James Hamilton of Finnart lodged in the town whilst involved with work on the palace in the late 1530s[39]. In 1543, once the young Queen Mary was moved to Stirling, Cardinal Beaton was not allowed to lodge in the castle, for security reasons, but had to find lodgings in the town – and her opponents even wanted Marie de Guise, the queen mother, to do so and only be admitted to see her daughter occasionally and under guard[40]. The Bruce of Auchenbowie house survives from about this period and traditions that Darnley lodged there or in William Bell's house are credible if unproven. Several local landowners who were only marginally involved with the court also had houses in the town. Craigengelt of Craigengelt, a laird of modest means, had a very substantial Stirling house and garden. Forrester of Logie Lodging seems far too grand for its very modest,

[34] Chambers (1830, p. 32), mentions the houses of the earls of Morton, Glencairn and Lennox as well as a house allegedly occupied by Darnley and Prince Henry – though this last was actually built many years after Darnley's death.
[35] Dunbar, 1999.
[36] Kirk, 1995, p. lxxvi.
[37] *Stirling Protocol Book*, p. 3, Renwick, 1884, p. 256.
[38] SCA B66/1/24, p. 62; *Stirling Protocol Book*, p. 30, 22 May 1476; SCA, Burgh Register of Deeds, B66/9/1 f. 88 for tack originally dated 1568 with obligation to serve the lodging of the abbot of Cambuskenneth when in Stirling.
[39] TA, Vol vii, p. 482.
[40] Sadler I, p. 245, to Henry VIII, 31 July 1543; L and P, Vol. 18(2) no. 20, 10th Aug. 1543.

Forrester of Logie Lodging seen from St Mary's Wynd. To the right of the tower was a hall of two storeys (Fleming, 1902).

local owner and may well have doubled as accommodation for courtiers[41]. In 1571 half a dozen nobles, including the regent, with many others, were lodged in the town, perhaps all in the same house, when it was attacked and some captured[42]. In March 1578 Lord Glamis was going down the Castle Wynd to his lodgings in the town when he was murdered[43]. Ambassadors and other foreign envoys usually stayed in Edinburgh but, if they came to Stirling, might also be lodged in the town as evidenced by a payment to the 'good-wife of the house where the Herald of Flanders was lodged'[44]. When Throckmorton came to Stirling (in1561) he found the gates of the castle closed against him and had to find lodgings in the town[45].

Quarters were allocated by royal or burgh officials. When the king was in Jedburgh for a justice ayre in 1529 the burgesses of Jedburgh were to supply lodgings as allocated by John Lawson, a royal official; a proclamation was made and Lawson visited premises with two of the magistrates, though on this occasion, they met some fairly stiff resistance from a local chaplain who resented his goods and space being taken[46]. Diplomats were typically allocated lodgings in Edinburgh and were watched over by officials of the Lyon Court, their movements fairly closely constrained[47]. When James VI made his return visit to Scotland in 1617, clean, properly-equipped lodgings were commanded for the royal train in the various burghs and similarly for Charles I visit in 1633 magistrates of all the towns were to make stables, lodgings and supplies available ready for the visit; if there was not enough stabling, stalls and mangers were to be made in barns, whilst 'country men' who followed the cavalcade were to make their own arrangements for accommodation in gentlemen's houses or otherwise, leaving the town for the official party. And in the mid seventeenth century, when Charles II was in Stirling, the Committee of Estates, following ancient precedent, ordered all strangers to be removed from the town, 'to the effect houses and lodgeings may bee had for these that are to attend the King and the affairs of the publict'[48]. So, systems were in place to provide accommodation for courtiers and their horses – though there is

41 Fleming, 1902, pp. 157-164 includes an illustration; for a plan see Harrison, 1994, p. 25. The land was probably divided from a larger tenement belonging to Forrester of Garden about 1535, SCA B66/1/2 f. 19r (1535) disposition by Forrester of Garden to John, his son, of land in Mary Wynd. This house had a 'great hall' and chamber of dais as well as a tower.
42 CSP, II, 1563-1569, p. 680; Forbes (1857) may well be right that this was the rather grand house with a wooden frontage on a prestigious site at the top of Broad Street.
43 Lynch, 2001, p. 18.
44 Brown, 1893, p. 37.
45 Guy, 2004, p. 210.
46 NAS GD40/2/9/33; charge by James V dated 9 June 1529 to the provost and bailies of Jedburgh. Concern about refusal to sell goods to the king went back to medieval burgh laws, SBRS, 1868, p. 119.
47 Harrison, 2005, pp. 40-41 and pp. 90-96.
48 RPC, Vol x, p. 683-4 (Edinburgh and surroundings was to provide for 5000 men and 5000 horses); Nichols, 1828, iii, p. 328; NAS GD90/2/66 1633 note of preparations for receiving the king in Scotland; Renwick, 1887, p. 198.

scope for much more work in archival sources to elucidate the detail.

For supplies and services, the park could supply some fresh venison and there were gardens for herbs, vegetables and fruit. Fish-ponds supplemented salmon from the river, whilst swans and herons were kept at the Park Loch; they were mainly ornamental but might also have ended up on the royal table. Coneyhill and Kenningknows are modern names for areas adjacent to the park; the names suggest that there has been a warren supplying rabbits, a prestigious item served only at the highest tables in the royal household even in the late sixteenth century[49]. By the 1620s there was a doocot, providing pigeons for the table as well as dung for the royal gardens[50]. The protection and management of these wild or semi-wild resources was the business of many of the specialised local staff already mentioned. The park, doocot, gardens, fishponds and so on were fashionable and handsome landscape features, looked down on from the castle. In a world of shortage they put the monarchs at the centre of lands which they controlled and which produced an abundance of varied, exotic and prestigious food[51].

There were also extensive Crown lands in Stirlingshire, known as the Lordship of Stirling. These lands and their incomes were assigned to the royal spouses and widows who had Stirling Castle as their jointure or dower house. About 1541 these lands paid £370 pa in money plus very approximately 17 tonnes each of barley and malt, 9 tonnes of wheat, 4 tonnes of oats, 30 salmon, 90 capons and 600 loads of coal[52]. The wheat, which all came from Bothkennar on the lands beside the tidal Forth, was particularly important as it was little grown locally but was essential for making the leavened wheat bread, favoured in high-status households. Added to that, people gave the king gifts of food, sometimes quite substantial quantities of delicacies, ranging from lampreys to venison, geese to swans, whisky and wine[53]. For the baptismal feast of Prince Henry, James VI seems to have put out a general request for gifts of food and wine, with a seat at the feast as a *quid pro quo*[54]. In preparation for Charles I visit in 1633 the tenants of the royal lands in Stirlingshire were ordered to pay their rents with their best produce, magistrates in all the towns visited were to

[49] 'Coney' and 'cunning' both refer to a rabbit. Positive documentary confirmation of a warren has not, so far, been found. For rabbits as prestigious food see; NAS, Exchequer Records E34/36 Scheme for the King's household, 1582 which indicates that they were supplied only to the highest tables; NAS E 31/16 Household of Anne of Denmark, 1598, 13th Aug. 28th Sept. 13th Oct.

[50] Imrie and Dunbar, 1982, p. 178, p. 253; it is not clear if the doocot was an innovation.

[51] Williamson, 1997, p.92-117. The park's other functions included; army camp, pasture for horses and draft animals, wood and materials supply, tournament ground etc.

[52] ER Vol. xvii, pp. 710-3; there were additional dues, both in cash and kind, which had been assigned to servants for wages and some disputes about exactly what was due; the coal, for example, had not been delivered for some time. See also NAS E40/10 for detailed rental of the crown lands south of Forth in 1541.

[53] Cameron, 1998, p. 265.

[54] *True Accompt*, 1984, Notes.

arrange for deliveries of fish and 'fed beef' whilst game in areas to be visited was to be protected, in case the king chose to hunt[55].

But local purchases were essential. Thurley and Chatenet describe the formal systems for procuring supplies in England and France. In Scotland, there are occasional records of messages sent ahead as the court moved about for preparations to be made for provisions etc, for example, a message sent to the Isles when James V was on his northern naval expedition or the instructions issued for the Christmas visit to Aberdeen, mentioned above[56]. And there were regular suppliers. Robert Githan is recorded as a baker in Stirling, supplying the court in 1531 and Walter Scott, is mentioned as baker in 1522 and 1535. Walter 'Wat' Scott was supplying the 'common bread' for de Guise's household in Stirling in 1543 and in Feb. 1545, Walter Scot, baker and burgess of Stirling, was to bake bread for the queen 'as pertains to his office to do'; in 1546, the queen's bread was supplied by Isobel Broun at Walter Scott's request, perhaps as he was himself dying[57]. So far as supplies were provided by local traders 'on demand', they must have been identical with what was available for others to buy and purchases of beer, vinegar, soap and other mundane items which figure so prominently in the Household Books, were not for the monarch's own use. In an emergency in 1585 it was noted, in a rather shocked tone, that officials had to send into the town 'for the king's owen diett'[58]. More exotic items, particularly wine, were sometimes supplied from central stocks at Edinburgh and distributed to the other residences as needed[59]. Gifts and home produce, as noted above, would have further contributed to the distinctive character of the royal diet.

There may have been a re-organisation of supplies following James V's first marriage. A master flesher to the queen's house was appointed in a ship-board grant on the day before James V and Madeleine landed at Leith in 1537[60]. Between 1538 and 1542 a William Bell who was a groom in the royal larder, received wages and livery[61]. He might be the same man who, in 1541, was paid for a coffer to contain the king's books at Stirling. In 1546-7 a contract was made with William Bell to supply meat in Stirling and around the same time he held the moneys needed for building the town walls. In June 1548 letters were sent to Bell and Walter Cousland to attend the council to receive instructions about providing supplies for 'the Frenchmen' whilst in January 1549 he and the sheriff of Clackmannan were to give in their lists of the taxable lands in the area. In August 1549 Bell was paid £216 for butter supplied for Edinburgh Castle. In 1550 Bell was described as merchant and provisioner to the queen

55 NAS GD90/2/66 1633 note of preparations for receiving the king in Scotland.
56 Murray, 1965, p. 18.
57 Thomas, 1997, Appendix 1; NAS E33/3 July – December 1543; Renwick, 1887, p. 40 and 42.
58 Bannatyne Club, 1835; Calderwood, *Historie of the Kirk of Scotland*, Wodrow Soc. Ed. Vol iv, p. 390.
59 Bannatyne Club, 1835.
60 RMS ii, 2260.
61 TA, Vol vi, p. 429 and 438; TA Vol vii, p. 128, p. 333, p. 476; TA Vol viii,, p. 76, p. 96. p.101.

and was paid for goods supplied whilst in 1558 he was ordered to restore goods taken illicitly from Cambuskenneth. Bell seems to have been a member of the Stirling merchant guild and was briefly a member of town council and he also ran Stirling's tennis court, see below[62].

Others also had contracts to supply the court. For example, in 1548 a Stirling flesher had an agreement to supply meat to the household of an ambassador[63]. In 1568, Andrew Hagy, the provisioner of the king's household, was to supply food and drink only to those on the household list for Stirling. In 1570, James earl of Moray owed £666 to James Marshall in Stirling, 'furnisar' or 'supplier' to the king's house, and owed William Fairbairn in Stirling £243 for coal for the king's house[64]. Alexander Durham had been a servant in the queen's spice house in 1538-9. In January 1543 he was paid for white taffeta he had supplied for the baptism of Mary, Queen of Scots[65]. After the king's death he became an increasingly prominent administrator in de Guise's household and in September 1554 she paid him £500 as part of a greater sum; he was one of many members of her household to get a payment following her death[66]. By the early 1560s, sometimes now described as 'argentier' he was receiving and distributing considerable sums and also regularly supplying the queen's household with provisions and other items and was sometimes described as clerk of the expenses[67]. Then, in 1566, Alexander Durham younger was repaid alms he had given 'by special command of the king and queen'[68]. It is probably the younger man who, around this time was appointed as collector of the Thirds of the Benefices and after Mary's deposition, was associated with the households of the regents Moray and Mar, sometimes still described as the argentier and with a significant control over revenues[69]. In 1570 he was owed very substantial sums for supplying silverware and food both for Moray and the king. After Moray's death, his widow asked that all costs incurred by Alexander Durham in Stirling in supplying ale, wine, bread, meat, fish, spice and other items, should be paid as part of the legitimate expenses of Moray's

[62] Murray, 1965, p. 44.; NAS E34/13 agreement between Andrew Fairny of that Ilk and William Bell [undes] to supply the Queen with meat, July 1547-July 1548; Renwick, 1887, p. 52 and p. 61 for Bell as tax gatherer in Stirling; TA ix, p. 204, p. 275, p. 330; NLS Crawford of Balcarres Adv ms 29.2.5, receipt for payment to William Bell, merchant and provisioner of the Queen, 12 July 1550. TA Vol xi p. 402. For Bell as councillor see Renwick, 1887, p. 61-3 and p. 276-7.

[63] Renwick, 1887, p. 52.

[64] NAS GD124/11/4, for instructions to Earl of Mar as keeper, 5 May 1568; HMC, 6th Report, p. 647. A James Marshall had been a member of de Guise's household at her death, TA Vol. xi, p. 26. Hagy is recorded supplying fabrics to the court in 1569 (TA Vol xii, p. 154) but does not otherwise appear in the treasurer's accounts for the period.

[65] TA Vol vii p. 131. TA viii, p. 165.

[66] TA Vol x p. 240; TA Vol xi p. 26.

[67] TA Vol xi p. 21, p. 23, p. 26, p. 75, p. 76, p. 159; NAS E30/11, my thanks to Michael Pearce for this reference.

[68] TA Vol xi p. 492.

[69] TA Vol XII p. 119, p. 129, p. 251, p. 303; BM Ms Royal 18b VI f. 230-231.

office as regent. Durham's role extended to a degree of financial control and he was also supplier and agent for the households of the earls of Mar and others. Durham (probably the younger) was a burgess, had property in the burgh and he and his wife are buried in the kirk[70].

Like Durham, Bell had a significant financial role, at least in the town and locality, revenue gathering giving them some protection against the risks of long-overdue accounts. It seems that a more French system of procurement had been instituted – along with the French term *argenterie* for the official responsible for supplies – and continued well after any significant French presence at the court[71]. A document from 1582 suggests a return to the old, piecemeal systems of the days of James V. Goods were to be bought at sensible, market prices for cash, if possible. But if there was no cash and goods had to be bought on credit, the prices charged by the purveyors were to be even more closely checked by the Steward, who was also to supervise purchases and to oversee the storage of meat, herring, wine and other goods and their distribution within the household. He was to co-ordinate with the master household, the comptroller and others and to keep proper records[72].

Courtly needs extended beyond food. Robert Spittal was perhaps Stirling's best-known royal supplier, records dating from 1509 to 1541. He was tailor to Margaret Tudor and James IV and supplied clothes to James V. He was rewarded by gifts of lands and his wealth is indicated by his building several bridges in the area. He is never described as a burgess but probably lived at least part of the time in Stirling where he had property and established an almshouse[73]. Jonat Tenant, ancestor of Stirling's John Cowane, was a trader in her own right and supplied cloth for the household of Queen Margaret Tudor – though it took her at least eight years to get payment[74]. Luxury trades must have benefited from even the occasional presence of the court. In 1575 a brodinster or embroider owned part of what would later become Argyll's Lodging whilst in 1601 Janet Cunningham, servant to Lady Argyll's gentlewoman, confessed fornication with Donald Christison, lady Argyll's brodinster. Intermittent records of brodinsters continue to about 1630[75]. John Aickin, goldsmith, valued some items in 1549/50, John Hudson, goldsmith, is recorded in 1589/90 and in 1592; Robert Paterson, goldsmith appears between 1602 and 1613 and John Hudson, goldsmith in 1617, the last record of a

70 Renwick, 1887, p. 48; See e.g. HMC 6th Report (1877), p. 647 and p. 657; RCAHMS, 1963, p. 138. Cook, 1905, pp. 39-40.
71 Purveyance systems helped to smooth out variations in market prices and so stabilise costs and were used by several Scots noble households, Brown, 2004, p. 81 and p. 293, n. 30.
72 Thomas, 1997, p. 31 and Appendix B.
73 Cook, 1905.
74 Renwick, 1887, pp. 54-5. Isobel Williamson, a late 15th century Edinburgh woman, also supplied cloth to the court, see Marshall, 1983, p. 50 and DNB (2005) 'Isobel Williamson'.
75 SCA, Kirk Session Minutes, CH2/1026/1 12th Feb. 1601; ibid, 24 Dec. 1613; Renwick, 1887, p. 148.

goldsmith in Stirling[76] The decline in brodinsters could be due to changing fashions as lace replaced embroidery but loss of goldsmiths is more probably attributable to the loss of courtly patronage.

Locally-mined coal was supplied for the fires in the castle. Some came from the royal lands as part of the rent, the best-recorded mine being at Skeoch, near Bannockburn, but there were other sources. Marie de Guise had coal shipped in from Alloa on her arrival in summer 1543 whilst David Sibbald was described as collier to the queen dowager in 1546; again, there seems to be an adoption of a contract system as he had a regular contract to supply her with coal in Stirling for the year 1546-7[77].

The town also supplied services of various kinds. During the reign of James V, tennis courts were available for all the main residences including Stirling[78]. The Stirling court (called a cachepull- or cachepell-yard) was operated by William Bell (whose role in providing supplies was noted above) from about 1532 and was in a courtyard later called Bell's Yard, off modern Baker Street, rather than in the castle. It was presumably open to the public though some of the expenses for construction, maintenance and equipment were met by the Treasurer whilst in 1540, the Pursemaster paid William Bell for balls which the king 'tynt' ie lost 'in his cachepeill'[79]. In France, by the late16th century, tennis was so popular that there were said to be more tennis courts than churches[80]. The Stirling tennis court continued to function well into the seventeenth century, so it was not entirely reliant on royal and noble support[81].

Another service provided within the town was education. Jacques Collumbell was one of the minstrels, recorded from 1538 to 1542. His two sons' boarding and clothes at school in Stirling was paid between Lammas 1540 and

[76] Renwick, 1887, p. 58; Stirling Registers, 17 June 1592 for John Hudson, goldsmith; ibid baptism, Feb 8 1589/90 John Hudson, goldsmith, is witness to baptism. SCA, CH2/1026/1 29 July 1602, Robert Paterson, goldsmith, fornication; RPC Vol X p. 10 for Robert Paterson, goldsmith, burgess; SCA, B66/16/2 burgh court 23 June 1613, Robert Paterson, goldsmith; CC21/5/2 4 June 1617, testament of John Gibb, cutler, burgess, owed to John Hudson, goldsmith in Stirling, £18 as balance of a greater sum.

[77] Harrison, 2005, pp. 73-4; Renwick, 1887, p. 44, p. 46. He is probably the David Sibbald, carter, who had carried her goods, bedding etc prior to the king's death, TA Vol vi – Vol viii *passim*.

[78] Dunbar, 1999, pp. 205-8.

[79] SCA, B66/1/4 f. 175 and f. 179v; TA Vol vii, p. 168; Thomas, 1997, Appendix 1, William Bell ; Harrison, 2005, pp. 88-9.

[80] Chatenet, 2002, p. 126.

[81] Bell probably died in 1573, still in possession of his tennis court; SCA B66/1/6 p. 17 1573 for William Bell's own catchpuill; for his testament ibid p.18 and p. 32; SCA B66/1/6 p. 6 1573 William Bell delivers the keys of the lodging, yard and ketchpill of Stirling to Malcolm Drummond of Borland in terms of their contract. He also admits receipt of 100 merks of the 800 merks due; See SB6/3/1a for the contract referred to; NRAS 3094/185 for William Bell in Stirling involved with teinds of Nairn, 1561-2.

Lammas 1542; presumably their father travelled with the court[82]. When the Regent Mar died in 1572 he owed £33 6s 8d (50 merks) to Mr Thomas Buchanan for his fee for teaching at the school. Buchanan, nephew of the more famous scholar George, was a man of some standing, as recognised by his being consulted on national educational issues and this payment of 1572 might indicate that he was already, as he certainly was later, a salaried official of the royal household himself, in parallel with his role at the school[83]. The chance of having courtly and noble (if not royal) pupils would certainly enhance the standing of the post of head teacher of the school and so, presumably, help to secure better teaching for local boys.

The basic transport needs of the court were met by horses from the royal stables and by regular liveried carters paid by the load, such as David Sibbald, just mentioned. Senior courtiers would have their own horses. But Stirling was often called on to supply transport for special needs such as to carry coal from the shore to the castle when Marie de Guise first moved into the castle in 1543 or to bring up fireworks secretly, at night, for the baptism of Prince James in 1566[84]; stabling and fodder have already been mentioned and adequate supplies were essential for the peripatetic court. Building projects would also have been a source of employment – though major projects were rare and, unfortunately, for sixteenth century Stirling they are poorly recorded. Specialists marshalled from elsewhere for major projects would require accommodation whilst there would be less skilled work for local people and demand for supplies of stone, sand, lime and timber, all needing to be transported to the site by local labour[85].

There are no sources which can allow us to quantify the costs and benefits of the royal presence for the town and its economy. Most records refer to benefits – to money paid for goods and services and so on. They can hint at the downside. It might have been an accident when James V killed the park keeper's wife's cow with a gun. It was predictable that the courtly japes of the Abbot of Unreason would lead to damage to property – though at least the damage to Gilbert Brady's house was paid for[86]. There are no records of formal 'entries' to Stirling but a procession through the town to celebrate the victory of the King of France against the emperor, organised at short notice and in which Marie de Guise took part shortly after taking up residence with her

[82] Thomas, 1997, Appendix A; TA Vol vii, p. 271, p. 328, p. 413, p. 438, p. 482; TA Vol viii p. 55, p. 93.

[83] NAS GD124/3/11 testament of John, Earl of Mar; Hutchison, 1904, pp. 28-33.

[84] NAS E33/3 extraordinary expenses, p. 24 for coal shipped from Alloa and carried to castle. TA Vol xii, pp. 403-9 for ten carts to carry the fireworks at night 'for fear of knowledge'.

[85] Paton, 1957 has the relevant accounts.

[86] TA, Vol i p. clx and p. 270 (1496) for Gilbert Brady's house in Stirling damaged by the Abbot of Unreason; CRA, B66/1/24 p. 140 mid 16th century sasine for Castle Brady, which stood at the south west corner of 'Broad Street' and continues in record at least through the 17th century.

daughter, could clearly have been very disruptive[87]. The most famous attempts to capture the castle (those of the period of the Wars of Independence, for example) did not relate to its being a royal residence. But, from time to time, the royal presence was a factor; the Douglases are said to have burned the town in revenge for the king's murder of their kinsman in the castle in 1452 and there were recurrent (if less damaging) raids, many directed at capturing and manipulating child monarchs, particularly James VI.

The Crown could commandeer accommodation or horses or goods and so on – this was not a free market which local people could choose to ignore if they wished. There was the promise of payment but it took Jonat Tenant eight years to get payment whilst on one occasion Marie de Guise had to pawn her own hat to cover her expenses. Powerful, capricious customers are not an unmitigated blessing[88]. In 1547 new regulations were instituted for claims against the court and nobility for supplies of merchandise, bread, ale, fodder and other supplies, to be passed via the Provost rather than complaints being made directly; there were serious penalties for infraction and clearly this was a contentious area[89].

One factor to emerge strongly from the evidence is that the burghal and courtly communities were not two distinct entities. The schoolmaster and the gardeners, the purveyancers and the maid of honour, the baker and the laundress, the tennis court keeper, the tailor and the noble householders all had feet in both camps. In 1615 Agnes Bowye was described as mistress laundress to His Majesty and widow of Francis Galbraith, servant in His Majesty's pantry when she gave £20 sterling (a very considerable sum) to Stirling kirk session 'for the love she bears to this city' to establish pensions for two poor, elderly women[90]; here was a family which had done well out of royal service and was closely tied to the local community. The boundaries were blurred – and were blurred even more by the sexual relationships apparent from the kirk session evidence. And it is also striking that the records, so often fragmentary, indicate links between these people; Durham's managerial role spanned several households, Spittal the tailor represents Ray, the Maid of Honour, the schoolmaster teaches the nobles' sons, whilst the noble and courtier householders, with their local estates and linkages, used the town's lawyers, as well as its goldsmiths and embroiderers. Stirling's merchants would, in any case, have travelled to European sea ports. But the courtly presence exposed far more of the inhabitants to Scots and European intellectual and aesthetic influences, particularly given the close ties between the crown and the local clergy. Even if, at times, the crown acted to repress diversity and discussion, the royal presence contributed to a livelier intellectual

[87] Dickinson, 1942, p. 21.
[88] Renwick, 1887, p. 49; the earl of Argyll also pawned goods in security of a debt in 1549, ibid p. 57. Dennison for Aberdeen p. 140 also highlights the difficulty of getting payment.
[89] Renwick, 1887, p. 46.
[90] SCA Stirling Kirk Session Minutes, Kirk Session CH2/1026/2, 19 Jan 1615 and 13 June 1616.

milieu than would otherwise have been the case[91].

Economically, the castle and court and the noble households were supported by rents and taxes garnered from across Scotland but spent locally. Considerable sums were involved. In 1522, during the minority of James V and when he was in Stirling for an extended period, the salaries of the keeper, constable, footmen, captain and others totalled around £1250 Scots per annum plus expenses[92]; this takes no account of the senior servants, courtiers and officials, cooks, nurses and so on. It is true, as Boardman has pointed out, that an occasional royal visit in course of a royal progress called for suitable 'propines' or presents. But these were not necessary during the routine presence of the court whilst, at the baptism of Prince Henry a modest return was made when 'largesse' was scattered from the castle walls[93]. Stirling, like any other royal burgh, had to contribute to the royal coffers through taxation; but unlike many others, Stirling had a chance to get something back and there must have been a net inflow in many years, at least. But several factors would serve to protect local businesses from over-dependence on courtly patronage. The demand was intermittent, with short- and long-term fluctuations. The peak, surely, was from 1529 to 1536 when James V spent from 27 to 44 per cent of his nights in Stirling; from 1537 to his death in late 1542 the range was from 1 to 28 % but the average only 13 %. Thereafter, Stirling was home for Marie de Guise, for royal minors and the setting for two major extravaganzas, the baptismal festivals for the Princes James and Henry. Throughout, the political capital was Edinburgh, where parliament and the courts met, ambassadors were based, the Exchequer and Privy Council usually sat and so on; not only monarchs but regents including Arran, de Guise, Moray, Morton and even Mar, based themselves in Edinburgh where their households consumed much of the royal revenue. There was not so much left for the household of a child monarch in Stirling[94]. We have seen that nobles who had Stirling houses had them largely for local reasons. But the greater number of nobles, prelates and others who had Edinburgh houses had them for national reasons. It was the

[91] For example, Cambuskenneth Abbey, both the town's friaries, various chapels in the vicinity and the parish kirk all benefited from royal patronage whilst several local clergy and others were burned for heresy in 1539 and James VI disputed with Patrick Simpson, the minister of the town who he had himself nominated; these pre- and post-reformation links form a huge topic deserving separate treatment.

[92] NAS GD124/10/6, copy of ordinance for keeping of the king, 3 Aug. 1522; NAS124/10/8, extract act of parliament anent keeping of the king's person in Stirling Castle, 2 Sept. 1523. The footmen also had liveries supplied, leaving more of their wages free to spend; the exchange rate for £s Scots to £ Sterling was around 3:1 at this period.

[93] Boardman, 2002, p. 204 and p. 449 note 7. The gifts Stirling gave to Charles I on his 1633 visit, were expensive but not ruinously so. For 'largesse' see Meikle (ed.) Vol ii p. 185.

[94] From July 1543 until her departure for France, the infant Mary queen of Scots lived mainly in Stirling. It was her mother's dower house and de Guise had the revenues of the Lordship of Stirling though that was probably dwarfed by the revenues she received from France. De Guise spent a good deal of time in Stirling prior to her appointment as Regent but her main base was Edinburgh thereafter.

best place for networking – and its merchants, lawyers, landlords and others, had the certainty of a steady demand for their goods, services and accommodation.

There was scarcely time for Stirling to become dependent on the court's presence in the brief window of the late 1520s and early 1530s, a period long forgotten by the time the court finally departed in 1603. Thereafter, some luxury trades faded from the scene, the great noble households shrank then vanished, the halls of the lodging houses fell silent or were converted to other uses. But there is no sign of a sudden collapse of the economy. Stirling survived to face a new series of challenges in the seventeenth century.

Bibliography

Bannatyne Club, 1835, *Excerpti E Libris Domicilii Domini Jacobi Quinti, Regis Scotorum, MDXXV-MDXXXIII (1525-1533).*

Barker, K. and Darvill, T (ed.) 1997. *Making English Landscapes*, Bournemouth.

Blanchard, I., Gemmill E., Mayhew N. and Whyte I.D. The Economy: Town and Country. In Dennison et al., 2002 pp 129-158.

Boardman, S, 2002. The Burgh and the Realm; Medieval Politics, c. 1100-1500. In Dennison et al. pp. 203-223.

Brown, K.M., 2004. *Noble Society in Scotland; Wealth, Family and Culture from Reformation to Revolution*, Edinburgh.

Brown, P H, 1893. *Scotland before 1700 from Contemporary Documents*, Edinburgh.

[CSP] *Calendar of State Papers Relating to Scotland and Mary, Queen of Scots, Vol II, 1563-1569*, Edinburgh, 1900.

Cameron J., 1998. *James V: The Personal Rule 1528-1542*, East Linton.

Chambers, R., 1830. *A Picture of Stirling; A Series of Light Views*, Stirling.

Chatenet, M., 2002. *La Cour de France au XVI ^e Siècle; Vie Sociale et Architecture*, Paris.

[Sadler] *The State Papers and Letters of Sir Ralph Sadler*, Vol I, Edinburgh, 1809.

Cook, W.B., 1898. 'Robert Spittal and his Hospital'. In *Transactions of the Stirling Natural History and Archaeological Society*, pp. 72-82.

Creighton, O.H., 2002. *Castles and Landscapes: Power, Community and Fortification in Medieval England*, London.

Dennison, E.P. 1998. Power to the People; the myth of the medieval burgh community. In Foster et al (ed.) pp. 100-131.

Dennison E.P., Ditchburn, D. and Lynch, M. (ed.), 2002. *Aberdeen before 1800: A New History*, East Linton.

Dickinson G. (ed.) 1942. *Two Missions of Jacques de la Brosse; an account of the affairs of Scotland in the year 1543 and the Journal of the Siege of Leith, 1560*, Edinburgh..

[DNB] Dictionary of National Biography, Oxford, 2005.

Dixon, P.J., Mackenzie, J.R., Perry D.R. and Sharman, P. 2003. The origins of the settlements at Kelso and Peebles, Scottish Borders: archaeological excavations in Kelso and Floors Castle and Cuddyside/Bridgegate, Peebles by the Border Burghs Archaeology Project and the Scottish Urban Archaeological Trust, 1983-1994, *Scottish Archaeological Internet Reports*, 2 (http://www.sair.org.uk/sair2/index.html).

Driscoll, S., 1998. Formalising the mechanisms of state power: early Scottish lordship from the ninth to the thirteenth centuries. In Foster et al. (ed.) pp. 32-58.

Dunbar J.G., 1999. *Scottish Royal Palaces; The Architecture of the Royal Residences during the Late Medieval and Early Renaissance Periods*, East Linton.

Edington, C., 1995. *Court and Culture in Renaissance Scotland: Sir David Lindsay of the Mount*, East Linton.

[ER] Exchequer Rolls of Scotland, various dates, Edinburgh.

[Fasti] *Fasti Ecclesiae Scoticanae; the Succession of Ministers in the Church of Scotland Since the Reformation*, Vol iv, Edinburgh, 1923.

Fawcett R. 1995. *Stirling Castle*, Edinburgh.

Fawcett R (ed.) 2001. *Stirling Castle; The Restoration of the Great Hall*, Council for British Archaeology, Research Report 130.

Hay Fleming, D., 1897. *Mary Queen of Scots from Her Birth to Her Flight into England*, London.

Fleming, J. S., 1902. *Ancient Castles and Mansions of Stirling Nobility*. Stirling..

Fleming, J.S. 1906. *The Old Castle Vennal of Stirling*, Stirling.

Forbes J. (ed.) 1857. *The Tourist's Companion Through Stirling*, Stirling.

Foster, S., Macinnes, A., and MacInnes, R. (ed.) 1998. *Scottish Power Centres from the Early Middle Ages to the Twentieth Century*, Glasgow.

Furgol, E.M.,1987. The Scottish Itinerary of Mary Queen of Scots, 1542-8 and 1561-8, *Proceedings of the Society of Antiquaries of Scotland*, Vol 117, pp. 219-231.

Gifford J. and Walker F A, 2002. *The Buildings of Scotland: Stirling and Central Scotland*, London.

Gilbert, J.M., 1979. *Hunting and Hunting Reserves in Medieval Scotland*, Edinburgh.

Guy, J., 2004. *'My Heart is My Own'; The Life of Mary Queen of Scots*, London.

Harrison, J.G., 1985.The Hearth Tax and the Population of Stirling in 1691, *Forth Naturalist and Historian*, Vol.10, pp.88-107.

Harrison, J.G., 1994. The Toun's New House; An Early Georgian Development in Stirling, *Architectural Heritage*, Vol. v, pp 21-28.

Harrison, J.G. 2005. *People, Place and Process; Unpublished Report for Historic Scotland.*

Harrison, J.G. 2006. Coxet Hill and the New Park of Stirling, *Forth Naturalist and Historian*, Vol. 29, pp. 29-33.

[HMC] Historic Manuscripts Commission, *Fourth Report*, 1874, *Sixth Report*, 1877.

Hutchison, A F., 1904. *History of the High School of Stirling*, Stirling.

Imrie J. and Dunbar, J.G., 1982, *Accounts of the Master of Works: 1616-1649*, Edinburgh.

Juhala, A.M. 2000. *The Court of James VI*, Ph.D. Thesis, University of Edinburgh.

James Kirk (ed.) 1995. *Books of the Assumption of the Thirds of the Benefices*, Oxford.

Laing, D (ed.) 1846. *The Complete Works of John Knox*, Wodrow Society.

[L and P] Letters and Papers, Foreign and Domestic of the Reign of Henry VIII, Vol. 18(2), 1902, London.

Lynch, M., The Great Hall in the Reigns of Mary, Queen of Scots and James VI. In Fawcett, 2001, pp. 15-22.

Lynch, M. 1992. *Scotland: A New History*, London.

Macdougall, N., 1988. *James IV*, Edinburgh.

McGladdery, C, 1990. *James II*, Edinburgh.

McNeill P.G.B. and MacQueen, H.L., 1996. *Atlas of Scottish History to 1707*, Edinburgh.

Marshall, R.K., 1983. *Virgins and Viragos; A History of Women in Scotland from 1080 to 1980*, London.

Meikle, H.W. (ed.), 1936. *The Works of William Fowler*, Scottish Text Society.

Miller, E. 1922. The Site of the New Park in Relation to the Battle of Bannockburn, *Transactions of the Stirling Natural History and Archaeological Society*, Vol. 44 pp. 92-137.

Morris, D.B., 1919. *The Stirling Merchant Gild and Life of John Cowane*, Stirling.

Morris, D.B., 1927. The Incorporation of Weavers of Stirling. *Transactions of the Stirling Natural History and Archaeological Society*, Vol. 49 pp. 6-61.

Murray, A.L. 1965, Accounts of the King's Pursemaster, 1539-1540 *Scottish History Society, Miscellany x*, pp. 13-51.

Nichols, J., 1828. *The Progresses of King James the First,* London.

Paton, H.M.,1957. *Accounts of the Masters of Works for Building and Repairing Royal Palaces and Castles, 1529-1615,* Edinburgh.

[Register of Baptisms and Marriages] *Scottish Antiquary* Vol vi (1892) pp 159-168; Vol vii (1893) pp. 37-42 and pp 70-78 and pp. 166-168; Vol viii (1894) pp. 32-39 and pp. 82-86 and pp. 113-117 and pp. 173-175; Vol ix (1895) pp.35-38.

[Regesta II] Barrow, G.W.S. (ed.) 1971, *Regesta Regum Scottorum II, Acts of William I King of Scots 1165-1214,* Edinburgh.

[RMS] *Register of the Great Seal of Scotland,* various dates, Edinburgh.

[RPC] *Register of the Privy Council of Scotland,* Vol x, 1891, Edinburgh.

[RSS] Register of the Privy Seal of Scotland, Vol v (1), 1957, Edinburgh.

Renwick, R. (ed.) 1884. *Charters and other Documents Relating to the Royal Burgh of Stirling, AD 1124-1705,* Glasgow.

Renwick, R. (ed.) 1887. *Extracts from the Records of the Royal Burgh of Stirling 1519-1666,* Glasgow.

[RCAHMS]Royal Commission on the Ancient and Historical Monuments of Scotland, 1963, *Stirlingshire; an Inventory of Ancient Monuments,* Edinburgh.

[SBRS] *Ancient Laws and Customs of the Burghs of Scotland, AD 1124-1424,* Scottish Burgh Records Society, 1868.

[*Stirling Protocol Book*] *Abstract of a Protocol Book of the Royal Burgh of Stirling, AD1469-1484,* 1896, Scottish Antiquary, Edinburgh.

 [TA] Accounts of the Lord High Treasurer of Scotland, various dates, Edinburgh.

Thomas A, 1997. Renaissance Culture at the Court of James V, 1528-1542, University of Edinburgh, Ph.D. Thesis.

Thomas, A., 2005, *Princelie Majestie: The Court of James V of Scotland, 1528-1542.* Birlinn, Edinburgh.

Thurley, S. 1993. *The Royal Palaces of Tudor England,* Yale.

[*True Accompt*] *The Stirling Saga; Baptism of Prince Henry,* 1594, Stirling, 1984.

Williams, J.H. (ed.) *Stewart Style, 1513-1542; Essays on the Court of James V,* East Linton.

Williamson, T., 1997. Fish, fur and feather; man and nature in the post-medieval landscape. In Barker and Darvill pp. 92-117.

Archival Sources

BRITISH MUSEUM
BM Ms Royal 18b VI f. 230-231, Queen of Scots household.

NATIONAL ARCHIVES OF SCOTLAND (NAS).
CC21/5 Stirling Commissary Court, register of testaments
E31 – Exchequer Records – Household Books.
E33 - Exchequer Records: Despences De La Maison Royale
E34 –Exchequer Records – Household papers and Accounts.
E37 – Exchequer Records – Works Papers.
E40/10 – Rental of the King's Lands south of the Forth, 1542.
GD40 – Lothian Muniments
GD124 – Mar and Kellie papers.
GD159- Elphinstone Papers.

NATIONAL LIBRARY OF SCOTLAND (NLS)
Adv Ms 29.2.5 Crawford of Balcarres manuscripts.

STIRLING COUNCIL ARCHIVES
B66/1 Protocol Books of Burgh of Stirling
B66/9 – Burgh Register of Deeds
B66/16 court books of the burgh of Stirling.
B66/25 charters to Burghal subjects.
CH2/1026 – Stirling Holy Rude Kirk, Session Minutes.

This paper is published with the aid of a grant from Historic Scotland

THE STIRLING HEADS AND THE STIRLING SMITH

Elspeth King

The re-presentation of the royal palace within Stirling Castle has been many years in the making and it is time to consider the contribution of the Stirling Smith Art Gallery and Museum to the end result.

Stirling does not have a particularly good record of caring for its antiquities and historical artefacts. The carved oak charter chest, 1636, from Cowane's Hospital was carried off by the Jacobites in 1746, served as a meal chest for over a century, and was only recovered at auction in 1882. The key of Stirling, taken by Bonnie Prince Charlie at the same time, was only returned in 1961, courtesy of the collector Captain Charles A. Hepburn of Red Hackle Whisky, Glasgow, who purchased it at auction. The frame carved from the Wallace oak of Elderslie in which the letters of the European liberators Garibaldi, Mazini, Kossuth, Blind and Blanc were exhibited in the Wallace Monument, was purchased in a junk sale by a private citizen who intended to make a bathroom mirror of it. The purchaser died and the letters and frame were recovered in 1998. The architect's drawing for the National Wallace Monument was seriously 'mislaid' and recovered in 1999. All of these artefacts are in the Stirling Smith.

Referring to the disappearance of Stirling's antiquities before his time when Cowane's Chest was recovered in 1882, a correspondent wrote to the Dean of Guild as follows:

> 'There is nothing surprising... after what we know of the Stirling Heads and other relics which have been recovered. Our forefathers place a little value upon these things, and were as likely to utilise an old oak chest for a corn bin as a butter shop to use old manuscripts for wrapping around butter, which has been found out on more occasions than one.'[1]

Unfortunately, attitudes have not changed with the times, and rescue operations for Stirling's material culture are still mounted by the Stirling Smith when resources permit.

Antiquities outwith the museum have also suffered. The Heading Stone on the Gowan Hill was for long used by a butcher at the Old Bridge as a block for chopping off the horns of sheep, prior to its rescue in 1888.[2] In the *Forth Naturalist and Historian*, Vol. 29, J. Malcolm Allan described how the town of Bridge of Allan lost two museums and their collections.

The loss of artwork and artefacts from Stirling Castle over the last 400 years has not been assessed in any detail. Items of considerable value from the Castle "from which thrown out among other woodwork during some repairs" still appear in auction house catalogues today[3] and disappear without trace. The

more recent military history of Stirling Castle has been obliterated in favour of Renaissance-style re-display. There is now no trace of the pikes and other instruments taken from the radical weavers of 1820. The Diary of Helen Graham 1823-1826, daughter of Lieutenant-General Samuel Graham (1756-1831) of Stirling Castle, recounts how the children of the Castle re-enacted the Battle of Bannockburn, playing with the pikes of the weavers. The objects were still in the castle when the Diary was published in 1956, as was the collection of antiquities shown to visitors in the Douglas Room, from the 1860s onwards.[4] All have since disappeared.

The loss of artefacts from the nineteenth and twentieth centuries pales into insignificance when the destruction of the original Renaissance fittings is considered. The popular present day press fables[5] about the dismantling of the ceiling of the King's Presence Chamber for safety reasons in 1777, and the gathering together of the Stirling Heads two hundred years later, is one which is very economical with the truth.

The closest contemporary comment which can be obtained are the Stirling Lines of Robert Burns, scratched on a pane in Wingate's Inn (now the Golden Lion Hotel). Burns visited Stirling on 27 August 1787 when he had dinner with Lieutenant Forrester of the Castle garrison, Dr David Doig of the Grammar School and Christopher Bell, a singing teacher. This was fully ten years after the destruction of the ceiling with the Stirling Heads, but the condition of the Castle left a profound impression on the poet:

> *Here Stewarts once in glory reign'd,*
> *And laws for Scotland's weal ordain'd;*
> *But now unroof'd their palace stands,*
> *Their sceptre fallen to other hands;*
> *Fallen indeed, and to the earth,*
> *Whence grovelling reptiles take their birth;*
> *The injur'd Stewart line are gone.*
> *A race outlandish fill their throne;*
> *An idiot race, to honor lost –*
> *Who know them best despise them most.*

This critique almost cost Burns his employment as an exciseman.

A report on the destruction, filed with the Society of Antiquaries in 1828, fully fifty years after the event, was not less passionate:

> 'The whole ceiling was destroyed and dispersed in different directions. A gentleman who witnessed this barbarity states that, on the day the ceiling was pulled to pieces by the workmen who were employed to repair the roof of the Palace, beautifully carved heads, larger than life, supposed to be of the Scotish (sic.) Sovereigns, their Queens, and men of renown in the kingdom – among them the effigy of Sir William Wallace – were rolled down the streets from the Castle. Several bakers seized on some of them, and heated their ovens with

them. Others found their way into the jail, where the prisoners amused themselves with bedaubing them with red paint, ochre, and other colours; whilst a few only out of many scores fell into the hands of those who appreciated their value.'[6]

Ten years previously in 1817, Jane Graham (1767-1846), wife of Lieutenant-General Samuel Graham and sister of the novelist Susan Ferrier published a splendid folio volume *Lacunar Strevilenense*, with her own drawings and written descriptions of thirty-eight of the then surviving Stirling Heads. The report of 1828 concerned a panel in Jane Graham's possession, measuring five feet six inches high, by two feet in width, which was purchased from a woman in Torbrex, who had obtained it from the sheriff-substitute of Stirling, who in turn had obtained it from Stirling Castle. The panel featured a carved portrait, thought to be that of James V, with a thistle, fleur-de-lis and crown below. It is quite unlike the wainscot panelling now in the Stirling Smith collection, and has not been deposited in any public collection.

The author of the 1828 report, Major General Sir James Alexander KCB (1803-1885) was a Stirling man and a regular contributor to the Society of Antiquaries. A Stirling antiquary of the next generation, David Buchan Morris (1867-1943), Town Clerk, wrote an account of how some of the Stirling Heads came to be in the Tolbooth. Ebenezer Brown, Governor of Stirling Prison in 1777 met a young girl with a bundle of firewood which contained interesting shapes. He hastened to the Castle, and rescued thirteen of the Heads from being chopped into firewood. These were housed in the jail, then passed to the burgh council in the same building.[7]

Jane Graham's book of 1817 ensured that the existence of the Stirling Heads were at least known among antiquarians. The Society of Antiquaries managed to secure three for their museum collection in Edinburgh. In 1843, John Waddell, a Gunner and Driver of the Royal Artillery in Stirling Castle, advertised for sale sets of miniature (eight and a half inches in diameter) Stirling Heads, suitable for the 'Hall of the Antiquary or the Withdrawing room of the Modern Gentleman'[8] but these were so rare that no set has found its way into a public collection.

For most of the nineteenth century, there was no public display or general knowledge of the Stirling Heads. John Lessels (1808-1883) architect of the new Smith Institute, working with Alexander Croall (1804-1885) its first curator, and the Smith Trustees put this to right in the fabric of the building. The collection of twelve heads remaining in the council chamber in the Tolbooth was gifted to the Smith Institute. To demonstrate their use as ceiling ornamentation, the heads were cast, and the casts built into a panelled ceiling measuring 50 by 28 feet in the Reading Room of the Institute. Additional ornamentation included shields with the Stirling Wolf and the Old Bridge from the arms of the Royal Burgh and the monogram of Thomas Stuart Smith. The contract for all the plasterwork, and the production of this special ceiling was in the hands of John Craigie of Stirling, who had executed the plaster work of most of the Victorian

villas in Stirling and the country houses in the district. The Smith was his last job before retirement.[9]

The decorating contractors were the esteemed Edinburgh partnership of Bonnar and Carfrae. The groundwork of the ceiling panels were turquoise, the whole being enclosed in bands of soft red, and the Heads and other woodwork were stained to look like oak. The Reading Room walls were painted in 'drab Etruscan' to harmonise with the ceiling.

When the new Smith Institute opened on 11 August 1874, the general public had the opportunity of inspecting the Stirling Heads for the first time, and seeing their use in a ceiling setting. The Heads, created for a royal palace and dispersed in private hands, were at last in the public domain, and being treated with respect. They were displayed in the Small Museum (now the Lecture Theatre) opposite the Reading room. This initial donation attracted several others. Purchases were also made, and in 1924, an intensive fundraising campaign took place to secure an additional twelve Heads from Langton House in Berwickshire. Prominent people in the area were asked to make pledges to a guarantee fund to secure the purchase, an operation successfully concluded in June 1925, when an event was organised to celebrate their acquisition for the Smith Institute.[10] This brought the total to 28 of the 38 recorded by Jane Graham in 1817. The printed letters of appeal, the written responses and the subscription calculations are part of the Stirling Smith's archive.

The fifteen fine carved oak panels, purchased by Provost George Christie at Nancy Lucas's sale in 1876 and presented to the Smith Institute, came from wainscot panelling in Stirling Castle. Michael Bath in *Forth Naturalist and Historian*, Vol. 29, dismissed them as a pair of wardrobe doors on the mistaken assumptions that the Lucas family sought to deceive and that the Provost was gullible.

Provost Christie (1826-1904) is commemorated by the Christie Memorial Clock in Allan Park, Stirling. He was a smart businessman, who guided Stirling through the local government reforms of 1870. More important still, he persuaded Thomas Stuart Smith to bequeath his fortune to establish a museum and art gallery in Stirling; Smith's original preference was to support the Artist's Benevolent Fund. Within a month of writing his Last Will and Testament, Smith died, and Stirling had the prospect of a gallery, thanks to Provost Christie.

The story of the dismantling of the panelling to accommodate it in the Lucas household was well known in the community, and as the sale took place after the death of Nancy Lucas (1810-1876), the last member of the family, there was no financial interest on her part.

The fifteen panels are small in size (264 x 355 mm) and must have been part of a very large arrangement to require them to be removed from their setting. The Lucas family home, Marieville, was a large Georgian structure of three storeys and many rooms, built by physician and surgeon Dr Thomas Lucas

(1754-1822) in 1810. He built it in the area which became known as Upper Bridge Street. After his daughter Nancy's death, the house and grounds were sold to the Roman Catholic Church. The house was demolished and the present St Mary's R.C. Church was built on the land.

Dr Lucas's diary is an important local history source for Stirling[11] and his work book, with its record of patients and prescriptions is in the national archive.[12] He was a precise individual, meticulous in his notes on contemporary events, and personally very acquisitive. He managed to privatise a public well by building his wall around it in 1809.

His records of the pageant processions of the Shoemakers and the great Bannockburn demonstration of 1814 are invaluable, as is his record of the garden and orchard on his land. When his fruit crop was badly damaged in 1821 he knew that the culprits were the sparrows which nested in the thatched houses belonging to Dr Buchan on Upper Castlehill.

His son James Lucas who collected the panelling from the Castle did so after his father's death, otherwise we would have a detailed diary record. James Lucas was a Stirling solicitor who was chiefly known for his interest in antiquities, and who contributed information to the local press under the name *Sterlinense*. In 1835 he fought and won an important case against the builder of Valley Lodge house, who wanted to encroach on the public land on Castlehill known as 'The Valley', now the Valley Cemetery.[13] With his legalistic and forensic attention to detail, it is unlikely that he would have been mistaken in the matter of panelling from Stirling Castle. The iconic painting of Stirling by Johannes Vosterman (1643-1699) was also in his collection and was sold in the same sale. There is also no indication of any interest in wishing to communicate information about the panelling or the painting. The Lucas family were very private people, brought to public attention through their posthumous house sale and the manuscript material acquired by W.B. Cook of the *Stirling Sentinel* in the early years of the twentieth century.

An additional carved figure from Stirling Castle in the Smith's collection takes the form of a robed figure, 500 mm high, kneeling with a crown at his feet. A heraldic historian, the late Dr Patrick Barden noted that the crown was Scottish, and prior to the time of James V when the imperial arches were added. He identified the figure as representing the Earl of Fife, who served at the inauguration of most kings of Scotland, and postulated that any carved scheme depicting a Scottish coronation would have included members of the royal family, the bishops of St Andrews and Glasgow, and the Abbot of Cambuskenneth.[14] Such information deserves further investigation, contextualisation and acknowledgement.

There is bountiful evidence that wainscot panelling, both plain and carved, was the stylistic preference in Scottish aristocratic houses of the sixteenth century. The carved examples from Stirling Castle in the Smith collection are less elaborate than other panels of the same date from town houses in Edinburgh and Dundee, in the collection of the Museum of Scotland. However,

the Stirling panels bear a remarkable resemblance to the panelling thought to be from the royal palace at Dunfermline, now in Pitfirrane House[15], only 27 miles distant from Stirling. Although the present arrangement was constructed in the nineteenth century, the thirty eight carved panels in the window embrasures are contemporary with, and similar to, the fifteen in the Smith collection. James VI drank his farewell to Dunfermline and to Scotland from the Pitfirrane Goblet before riding south in 1603; the Halkets of Pitfirrane were the nearest beneficiaries in the break-up of Dunfermline palace and monastic complex. The last of the Halkets of Pitfirrane died in 1951.

If the panelling in Stirling was arranged similar to that of the 1828 report on the now-missing panel, there would have been quantities of plain panelling below each head. It was undoubtedly the size and quantity of this to which Agnes Lucas had objected.

For almost a hundred years, the Stirling Heads were part of the Smith Institute collection, and Stirling's public heritage. During that time – until 1969 – they were advertised in the annual guide books to the burgh, as one of the main attractions of the Smith Institute. They were loaned to important exhibitions, such as the Glasgow International Exhibition of 1901[16] and the Scottish Art Exhibition organised by Stanley Cursiter at the Royal Academy, London in 1938. Conservation was also undertaken. The Heads purchased in 1925 were repaired by Robert Cowie of Edinburgh, using oak from the Duke of Gordon's town house in Castle Wynd 'which was almost identical in use and texture'. All traces of paint and varnish were removed. Between April and October 1927, Cowie also removed the paint and varnish from the Heads given to the Smith in 1874, and at no cost.[17] This was the generation which believed that Classical sculpture was unpainted, and that only the prisoners in the Tolbooth would have been so uncouth as to apply paint to the carved wood.

Given the depredation and destruction which goes with military occupation, the survival of the 31 Heads and 15 panels in the Smith collection is a minor miracle. The collateral damage to the Smith itself, through use as a barracks in two World Wars, was substantial. The Stirling Ceiling of 1874 was severely damaged in 1945, and had to be dismantled completely in the early 1970s.

With the poor condition of the building after the War, pressure was put on the Trustees to return the Heads to Stirling Castle. Much of this was exerted by R.B.K. Stevenson of the Museum of Antiquities (now the Museum of Scotland) and it was believed that the ceiling in the King's Presence Chamber was to be reconstructed. Interestingly, there was never any question of the three Stirling Heads in the Museum of Antiquities being returned, and these are still on show in the Museum of Scotland today. 1997 saw another change in Historic Scotland's plans as regards the Heads. At a lecture in the Smith, Richard Fawcett said that as they were 'too valuable' as works of art, they would be displayed in gallery conditions and replicated for the purposes of the ceiling in the King's Presence Chamber. In 2003 the contract for reproducing the Stirling Heads was advertised.[18]

In 1997 in the Smith, the plaster Stirling Heads from John Craigie's ceiling were re-cast by sculptor Tim Chalk in fibreglass,[19] and painted to demonstrate the aesthetic change which colour brings. Only through the use of colour can the finer details of the carving be seen at a distance. These have been part of the Smith's interpretive displays for ten years, and it is good to know that Historic Scotland's conservators have recently recognised that the Heads were indeed painted.

If the same effort could be expended on locating and securing material which has gone missing from Stirling Castle, and looking at Scottish woodwork rather than French tapestries, the end result might be an interpretative scheme with some credibility. Without the Smith's care and curation of 1874-1970, Historic Scotland would have had a great deal less with which to work, and the large team presently involved in developing the Castle displays have due cause for gratitude to the past efforts of the few Smith curators.

References

1. *Transactions of the Stirling Field Club*, 1881-1883, Vol. IV, pp.110-116, Vol. V, pp.75-81.

2. *Transactions of the Stirling Field Club*, 1886-1887, Vol. X, pp.57-66, p.79.

3. See for example *Christie's Scottish Sale Catalogue*, 28 October, 2004, Lot 1, Franco-Scottish School portrait of a gentleman, 16th century, oil on panel. Sale price: £16,000. Mentioned in *Proceedings of the Society of Antiquaries of Scotland*, 12 March, 1883, p.290.

4. *Parties and Pleasures*, ed. Marion Lochhead, Edinburgh, 1956. See also Isabella Murray Wright, *Stirling Letters*, 1894, Stirling, [1998], pp.25-26.

5. *Sunday Herald*, 4 January, 2004. "The surviving 38 heads... have never before been studied [and] ... were not gathered together until the late 1960s, by which time two had been destroyed in a house fire".

6. Alexander, J.E. 1831. Notice regarding an Ancient Oak Pannel from Stirling Castle, on which is carved the Head of a King of Scotland. *Archaeologica Scotica: Transactions of the Society of Antiquaries of Scotland*, Vol. 3, p.308.

7. Morris, D.B. The Stirling Heads. In *Stirling Castle, its place in Scottish History*, Eric Stair-Kerr (Stirling, 1928), pp.223-225.

8. *Stirling Observer*, 30 October, 1843, p.1, column E. I am indebted to Elma Lindsay for this reference.

9. *Industries of Stirling and District*, Stirling, 1909 (re-published by Stirling Council Library Service, 1998), p.173.

10. *The Scotsman*, 8 June, 1925. *Stirling Sentinel*, 9 June, 1925. *Stirling Journal* and Advertiser, 11 June, 1925.

11. Stirling Council Archives, PD16/4/2, Diary of Dr Thomas Lucas 1808-1821.

12. National Archive of Scotland, CS96/1485. Daybook of Dr Thomas Lucas 1802-1807, with record of patients and prescriptions.

13. *The Stirling Antiquary*, Vol. 4 (Stirling, reprinted from the *Stirling Sentinel*, 1908), pp.283-284.

14. *The Times, The Herald, The Daily Express, The Courier and Advertiser, The Press and Journal*, 4 October, 2001.
 Stirling Observer, 5 October, 2001.

15 I am grateful to the geneologist Sheila Pitcairn, the Carnegie Dunfermline Trust and the Dunfermline Golf Club for allowing access to, and permission to photograph, Pitfirrane House and its panelling.

16 International Exhibition Glasgow 1901. Official Catalogue of the Scottish History and Archaeology Section, p.211.

17 Stirling Smith Archive.

18 *The Scotsman*, 25 February, 2003.

19 The series can be inspected at <www.scran.ac.uk>, together with the wainscot panelling and other artefacts in the Stirling Smith collections.

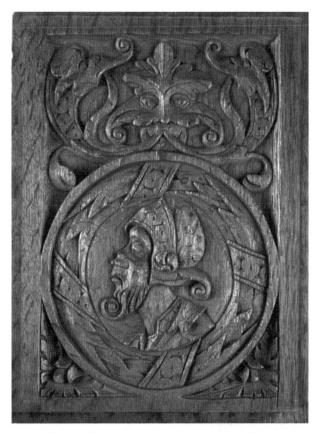

Figure 1 Head from the Stirling Castle panelling.

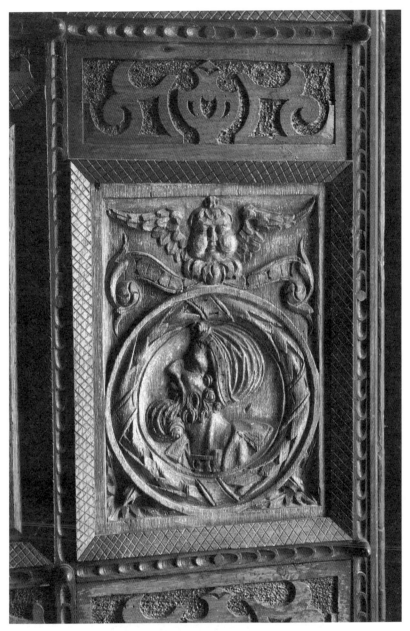

Figure 2 Head from the Pitfirrane House panelling.

MUSEUM HALL, BRIDGE OF ALLAN

John Murphy

In the Forth Naturalist and Historian volume 29, Malcolm Allan contributed a paper on the Macfarlane Museum of Natural History, Coneyhill. One of his first lectures on the subject was at the Annual General Meeting of the Welsh Trust, 1986. This was followed by a paper from John Murphy on the cultural history of Museum Hall, the text of which is given here.

The stated intention of John Macfarlane, founder of the Macfarlane Museum of Natural History, was to combine with the Museum a large hall which could be used in providing amusement and instruction to the inhabitants. In 1886, to secure the necessary funds, the Trustees obtained the co-operation of several public-spirited gentlemen. The countenance and help of several of the ladies naturally followed. Their deliberations resulted in the famous three-day bazaar of April 1886, which was 'of a sale of such work as taste and skill created of their gentle arts won from their friends'. It was held in the new public halls in Stirling – the Albert Halls. The bazaar was given an Eastern aspect, and the stalls were arranged to resemble the Alhambra in Granada, being named Barcelona, Andalusia and Madrid. The opening on successive days was by J.C. Bolton, MP for Stirlingshire, Colonel Stirling of Kippendavie, and Lawrence Poor, Chief Magistrate. First day entrance was two and six, no small sum in 1886. £500 was also contributed by the YMCA, for the use of the lesser hall, £450 of that to be returnable and £50 to be kept for – and these are the words – 'tear and wear'. Work on the Museum Hall proceeded apace under the architect, Mr William Simpson. Style was said to be early French Gothic. The stone work at the front is from Polmaise. The roof is of Scotch slate, from Luss. The walls have been decorated with beautiful replicas of the Elgin Marbles, which used to hang in the old museum (see Allan, 2006).

The opening was in September 1887, with a grand *conversazione*, to which the leading inhabitants were invited by the Trustees. At the chairman's opening address, he said, "in the course of my life, I have seen men elevated to distinguished rank through no other quality than their vitality, which has enabled them to outlive their seniors and their compeers alike. My position as the so-called chairman of the Macfarlane Trust is due to a similar unfortunate accident, and to no great deserving on my part. That is, I have survived all the original Trustees, and being the first Trustee appointed, I now – as the oldest – take the Chair at our meetings. Hence I now have the distinction of making a short opening address." He then goes on to say, rather strangely, "I suppose the building was first intended for a residence, for several families, and that its dedication as a museum is now an afterthought. The internal arrangements have made ample accommodation for the collection itself, and ample central space has been provided for lectures and entertainment of an educational, instructive and of course elevating character." The audience sang "God Save

the Queen", led by Miss B. Ruff. Provost Yellowlees then spoke. Amongst other profundities he said, "I do not think a *conversazione* is a place for formal speaking." The audience responded "hear hear". That did not stop Provost Yellowlees. "With your approval, I shall now offer you a few gleanings from the field of which our chairman has already gleaned." He goes on for another half-hour. But he says, "we have an impression that Bridge of Allan wants something to shake it out of its present dormant position. Nature has done much for it, but in late years art has done remarkably little for this beautiful, fashionable spa. I express the hope that this museum will make us as popular a resort as Baden Baden." He ended, "I apologise for intruding so long on your patience." Long shouts of "hear hear". Mrs W. Pullar sang, with much feeling, *Love Has Only Eyes*, and the encore was *Home Sweet Home*. Below this account in the *Stirling Journal* was an advertisement for the blood purifier *Old Dr Andrew Simpson's American Sarsaparilla*. Five year old whisky was eighteen shillings a gallon, and natural sherry – non-intoxicating – one and four a bottle. There were also adverts for the supply of calling cards, depilatories, and worms in children.

Well and truly launched, the hall was the major social centre for the district for nearly a hundred years. The 1914-18 War saw its occupation by the rough and rude soldiery, as did the 1939-45 War. There are many good stories of serious and comic incidents of these times, including one about a bustard, a large bird like a turkey. At one stage during the war, there was a signal sent to a dinner where there was a young lieutenant of the HLI, to say that his men were either rioting or mutinying in the Museum Hall, and he had to go there hotfoot. And when he got there, he found to his amazement and horror that the sergeant major was trying to reduce the men into a state of order by whirling a large, stuffed bustard over his head. The men were advancing on him, hurling all other kinds of birds as projectiles, and using some of the other exhibits as well. After each occupation, major rehabilitation was required. In 1928, the Public Interest Association held a two-day bazaar. In February 1939, the hall was purchased for a thousand pounds by the Trustees, a group of townspeople led by Mrs Irwin of Westerton. John McKay's notebooks observe that the YMCA looked for their £450 in vain. In 1950 the Burgh Council bought the halls for public use. In 1961 there was a major reconditioning. In 1975 it passed with all the other Burgh assets to Stirling District. By 1977, it began to be considered redundant.

In 1935 the hall was short of funds, and the electricity board – as electricity boards will do – cut off the supply for a debt of £44. One Miss Beattie Christie and others proposed to organise a *café chantant* to raise funds. It never came off, and the only result was that Beattie Christie was left with the bill that the electricity board sent to her. No good deed goes unrewarded.

So much for the history. Among the great social occasions, the Bridge of Allan Amateur Operatic Society used the hall for forty years. The society seems to have been founded in 1907. 1908, '09, '10 were the great years. The principal parts were taken by local people, who became famous in their various roles.

The most sensational being the Chancellor in *Iolanthe* as played by the Reverend Hamish Mackenzie of Chalmers Church. Can you visualise subsequent ministers hopping about in wig and gown? I'm sure this must have been a lot for Edwardians to take in. *The Pirates of Penzance* in March 1914 was the last performance for nearly ten years. 1923 and '24 saw revivals of the Society under the secretary Mr David Fyfe, and the conductor Mr R.C. Almaston. In 1926 they presented *The Gondoliers* with Mr George Davidson as the Duke of Plazatoro. The exception to the War years was that in 1917, Chalmers Church presented an operetta – *The Birth of the Union Jack* – in which Britannia was played by Jeannie Edgar and St Andrew by Carrie Watt. I've never been able to establish much about the Society's productions in the thirties, and shortly after the War it was amalgamated with Stirling to become the Stirling and Bridge of Allan Amateur Operatic Society.

Music

In the nineteenth century, there was a flourishing Choral Union whose conductor was John Erskine, stationer, bookseller and house agent. The earliest concert was in 1882, and the centenary was in 1982. There's a photo of 1897 which showed John Erskine, conductor. The old music hall was demolished in 1902 to make way for the newsagents, McDonalds, then Gideon's, and now a supermarket. In 1926 the Australian Lady's Pipe Band visited, and it's said that an excellent concert was provided on a Saturday night in Museum Hall. Unfortunately, there was a poor attendance. A pipe rendering of *Loch Lomond* was greatly encored, as was *Scotland in Australia* sung by wee Molly Innes. Adverts in that issue of the *Stirling Journal* include Exide batteries for clockwork at McNab's, Woolsey pure wool underwear from McCulloch and Young's, and farola puddings and Artines for relief.

The Orpheus choir visited in 1922-23, '32 and '49. It's interesting to note that in October 1952, the funeral of Sir Hugh Roberton was conducted by his lifelong friend, the Reverend Archie Jamieson, who resided at the Allan Water Hotel. In December 1930 the Scottish Orchestra performed under its conductor Nikolai Malkov. In 1933 the Alloa Burgh Band gave a performance in the Memorial Park. In 1939 a March *Journal* reports that Bridge of Allan's newest musical combination, the Strathallan Chamber Orchestra, gave its second concert under Mr William Kitchin. In 1945 the Polish Military Band was to perform in the Pullar Park on a March Sunday. Owing to unfavourable weather the concert was given in the Museum Hall; the audience manifested warm appreciation in no uncertain manner. In 1949, the Cork and Seal (now U.G. Closures) Choir, with their practice in the October of that year, entertained the Deputy Mayor of Invercargill with *Auld Scots Sangs*.

But all these were mere side-shows to the golden age of music in Bridge of Allan, which probably dawned in the mid-'20s, and ran for some near fifty years. In 1924 the Bridge of Allan Public Interest Association, under the presidency of W.L. Pullar, aided and abetted by Dr Welsh and others, launched a series of concerts which attracted European celebrities not to be heard outside

of London, Glasgow or Edinburgh. For a small town, the prestigious performances were quite incredible, and the programmes read like a musical legend. 1925 saw Corto Tibor and Pablo Casals at a mere £300. In 1926, Elizabeth Schuman and Myra Hess, and as if that were not enough, that was followed by Maurice Ravel, the French composer, and Arthur Rubenstein. In '45-'46, the Bridge of Allan Music Club was set up, a successor of the earlier Public Interest Association concerts. One of the leaders in this should be mentioned. This was Mrs Jesse Kerr, who did outstanding work in establishing quite high standards in music. We should refer also to the supporting work that was done by Dr Neil Reid, County Medical Officer, in later times. On the 16th of October 1952 the *Stirling Journal* headline read "Kathleen Ferrier Again Captivates" – she'd been here in 1950 – "Full House Thrilled by Superb Singer". Gerald Moore was a frequent visitor. A January 1953 headline reads: "Brilliant Lecture by Gerald Moore: The Accompanist Speaks." Reflecting that he didn't speak at other times. No prima donna, or great violinist, was there to steal his thunder. In '58, a Viennese pianist. In '62, a Romanian pianist. In '65, the Smetana Quartet. In '64, the Strathallan Singers. Checking these dates in the *Stirling Journal*, other significant dates leapt to the eye. Kathleen Ferrier shared the limelight in 1952 with a new minister who was inducted into Chalmers Church, none other than the Reverend Willie McDonald. 1953, as well as these mid-European pianists, saw Chalmers Church Dramatic Club rehearsing *Arsenic and Old Lace*. The heyday of the great Bridge of Allan concerts were glittering occasions, patronised by a well-fed, well-read, well-dressed society from far and near. Evening dress and fine furs were the order of the day. The smell of camphor mothballs was all-pervasive. There were plenty of buses right to the hall doors, for those who were not deposited by car or carriage. Seating was not reserved, but God help anyone who sat in the wrong seat. In 1978 as part of the Stirling Festival, the Roseneath Ensemble performed five Tennyson songs by William Kitchin. In 1972 the Music Club moved from the Museum Hall to the MacRobert, where Peter Katyn gave a concert. Other great names of this post-Museum Hall period are John Ogden and Janet Baker. It is said that Elizabeth Schwarzkopf wept here – according to Neil Reid, she was generally temperamental. 1985 saw the end of the Music Club, and the last concert cost £1500. I think we may have seen the end of an era.

Dancing

Up to December 1933 the Merchants' Annual Ball was one of the great social occasions. The catering was by Allison's, the festoons and draperies by Graham and Morton, and the music by Fitzpatrick's. Change came in December 1953 when the Merchants' Association Annual Ball moved up to the Allan Water Hotel. The *Stirling Journal* reports it: "A gay company patronised the Allan Water Hotel last Friday". In 1925 the Badminton Club held a fancy-dress ball, and in wartime years dances were held for various charities. In February '46 a dance was held in Museum Hall in aid of the Red Cross Sanatorium Scotland. In 1951 and again in '54 Jimmy Shand provided the music. I have it on good authority that on one occasion, when takings were a bit thin, Jimmy Shand

forewent part of his fee for the charity concerned. In 1951, faced with the expensive upkeep of the hall, the Burgh tried a commercial venture, and the *Stirling Journal* reports at first: "It will be welcome news to enthusiasts in the District that the Museum Hall has been taken over on a six-month contract for Saturday night dances." Quite the reverse, Saturday night dances were not welcome news for the adjacent residents, who reacted with protests and tales of disturbances. The bucolic bacchanalia of the Young Farmers were notorious, and disturbed the pre-Sabbath cerebrations and slumbers of the adjacent manse, containing a future Moderator and family. The words of the Psalmist, "joy cometh in the early morning", were of little consolation here.

Drama

In 1925 the Scottish National Players visited. In 1930, they visited again with *The Grenadier Rizzio's Boots* – an historical impertinence – and *Diplomacy and Draughtsmen*, a Clydeside comedy. In 1933 and '36 there was Daphne Waddel's Children's Theatre, with The Magic Acts. In '38, Bridge of Allan Dramatic Club was established by a few locals who had played with the Dunblane Club. In 1946, there was a Dramatic Club Festival. Stirling Amateurs presented *Count Albany* and *Gibbie Proposes*. 1950 saw the start of the Dundee connection. Dundee Rep made spring and autumn visits in '51, '52 and '56, with such plays as *The Shop at Sly Corner* and *The Holly and the Ivy*. In May '56, Mrs Mary Thom of Westerton was the winner of the Scottish Community Drama Association one-act playwrighting competition.

Old People's Welfare

No account would be complete without mention of the Old People's Welfare Christmas dinners. The Old People's Welfare Committee probably started as the Provost's Fund in the late forties under Provost Turnbull. By the early fifties the dinner had grown so big that it had to be held in the Museum Hall. These dinners were financed by grants and locally raised money. For instance, the *Stirling Journal* of 14th October '52 records: "The Provost's Fund benefited by £50 from an old time dance held in the Museum Hall, and from a whist drive held in the Masonic Hall. Judging by the prize list, most of the gents were ladies. The Christmas dinners were indeed great occasions. No expense was spared. Local personages were in attendance. Some lent china, some lent charm, and some gave help with food – and, I suspect, at times with the drink as well, which flowed liberally.

Public Occasions

The hall was of course the main focus for public occasions up until 1970; for nearly a hundred years. Elections, prize-givings, coronations, the Festival of Britain, Chalmers Centenary. The only documented occasion that has been found of a political one was in December 1933. The *Stirling Journal* reads: 'Mr Tom Johnston, MP, addressed a sparsely-attended meeting on trade and unemployment.' Interpreting, the sparseness was probably due not just to the

subject, but the appearance of a yet-unrecognised Labour star in a traditionally Tory town. By 1941 the *Stirling Journal* reported the town's approval for the local MP. It says: "No more suitable and popular a Secretary of State for Scotland could have been found by Mr Churchill". The MP was, of course, Tom Johnston. In September 1918, there was another event. Major Fox of the Scots Guards had a better audience when he told the tale of his captivity and escape from Germany, and the title was 'A Nation Beyond the Pale'.

Ballet and Badminton

The St James' Ballet Company visited in 1949, the Ballet Rambert in '51 and '59. In 1956, the Ballet Minerva were here. The fifties seem to have been the decade of ballet.

Badminton was played in the Museum Hall, certainly from before 1935. The pre-War setup is described as a very happy club, with great age range from seventeen to seventy plus. It was not regarded as being so high-falutin as the tennis club. Even so, entrance could be highly selective. It is recalled that in the early thirties, two young ladies were proposed. Half the members supported, half opposed. Some resigned, the rest went to Dunblane. My wife and I have memories of joining in 1961; obviously, by that time they'd altered the criteria. At that time there was a jolly, mixed crowd, but they took their badminton very seriously. The first necessity before playing was to find the canvas mat, and roll it out as a protection over the dancefloor. And even before you did that, I think you had first to find the caretaker, which wasn't always easy.

That is my presentation, for which I am indebted to Ella McLean the mother of Bridge of Allan's history; to Dr Neil Reid a supreme raconteur of the same; to Bill Kitchin the authority on music; to Mary Robertson Smith, quondam Provost and guardian of the town's traditions; to Stirling District Libraries; to fellow members of the Welsh Trust and particularly to Malcolm Allan who launched me in the right direction, even if I did not always follow it. But I must finish with the words of Viscount Wavell who said of his poetry anthology, "I have gathered other men's flowers, and nothing but the thread that binds them is my own".

Epilogue

By 1970 the Hall's Dancing Years were over. The new MacRobert together with the old Albert Halls were more than adequate for concerts, operettas and drama. And finally the new Community Centres made ample provision for badminton and indoor games.

Yet a brave local group, involving some famous names, soldiered on for a few years with the slogan "Save the Museum Hall". This was flogging a dead horse, or really trying to resurrect an age that was gone. The Museum Hall had had its day, or rather its era – and what colourful and glorious era it was.

Various and ingenious uses were suggested, such as National Museum for Forestry – none proving practical. These were years of dilapidation and decay.

Finally the building has been taken over by a developer to be turned into flats. The Welsh Trust (for Preservation of Bridge of Allan's Heritage) recommended that some of the interior's treasured features, such as the stained glass windows and parts of the replica Elgin Marble frieze, should go to the Smith Institute.

Historic Scotland, oblivious as often to local knowledge and wishes, have insisted the windows stay in situ.

It defeats John McFarlane's wishes and intent to educate Bridge of Allan people and tastes. It means cloistering them away from the people they were meant to benefit in a tenement of private flats, where only the tenants and visiting Historic Scotland officers can see them. They will also be lost to the wider Scottish public.

This is burial of our history, not preservation and promotion.

* * *

The 1986 AGM of the Welsh Trust was a stirring meeting. The Bridge of Allan Local History Society was established on that night, and ran for nearly twenty years, such was the interest which was aroused by the lectures of Malcolm Allan and John Murphy on that occasion. A tape recording of the 1986 AGM has been deposited in the collections of the Stirling Smith Art Gallery and Museum. This article was constructed from a transcription of John Murphy's lecture by Thomas Christie, the Smith's Administrator, and has been edited for publication in the Forth Naturalist and Historian with the approval of the author.

Reference

Allan, J.M., (2006). The Macfarlane Museum of Natural History. *Forth Naturalist and Historian vol* **29**, 17-25.

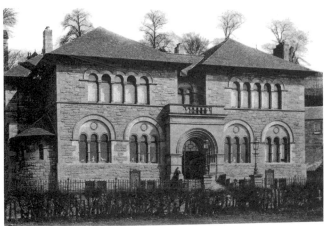

Figure 1 Museum Hall, Bridge of Allan. *Malcolm Allan Collection.*

Author Addresses

John Gallacher, UPM Tilhill, Stirling Road, Dunblane FK15 0EW

John Harrison, 14a Abercrombie Place, Stirling FK8 2QP

Elspeth King, Smith Art Gallery and Museum, Dumbarton Road, Stirling FK8 2RQ

Margaret Mercer, 7 Main Street, Tullibody FK10 2PM

John Murphy, 3 Stanley Drive, Bridge of Allan FK9 4QR

Sue and Roy Sexton, 22 Alexander Drive, Bridge of Allan FK9 4QB

Malcolm Shaw, 5 Pendreich Road, Bridge of Allan FK9 4LY

John Mitchell, 22 Muirpark Way, Drymen G63 0DX

Heather Young, 8 Coxburn Brae, Bridge of Allan FK9 4PS

BOOK REVIEW

Cowane's Hospital Garden (The Guildhall) Stirling. Private publication.

 Almost a decade ago Stirling NADFAS (National Association of Decorative and Fine Arts Societies) initiated a project to publish an account of the history of Cowane's Hospital Garden. Four members, Marjory Lumsden, Audrey Hancock, Carol Green and Mary Eastop, were appointed and began work researching documents and illustrations. It was finally completed in April of this year (2007) and a book produced which was formally launched in a ceremony held at the Guildhall.

 John Cowane (1570-1633) was a merchant from a wealthy Stirling family who owned ships supplying goods to King James at Stirling Castle; honey, prunes, saffron, spices and wool, between Stirling and Campver in Holland. He ran a shop in Broad Street, was a money lender and a farmer. In 1611 he was elected as a Stirling Councillor and Baillie. In 1624 he became Dean of Guild, and from 1625 to 1632 was a Member of Parliament, and was the most influential man in Scotland. He died aged 63 leaving a fortune. Forty thousand merks were given to provide an almshouse, or "hospital" for "twelve decayed Gild Briether".

 The land beside the Church of the Holy Rude was cleared and Cowane's Hospital was built on the south side of the church. Between 1637 and 1649, with interruptions caused by the Civil War, famine and plague the "yaird" (garden) was levelled to make a walking green. Trees were planted and the "out walk" was laid with the "hewin' stones" which still remain. The old town wall was on one side and the Church on the opposite side, with the cemetery to the West. The walking green was probably made by scything the grass and weeds already on the plot. In the style of that time the green was divided by strip beds the width of a man's arm cut into the grass as in the yards of medieval gardens. Vegetables and weeds (for salads), and medicinal herbs were grown to provide a system of self sufficiency for the household, and exercise for the inhabitants. There may have been bee-hives and chickens in a small orchard of apple, pear and bullaces. A midden would have been made in the furthest corner of the yard for the disposal of all household and human waste as well as garden waste. Water was provided by a well (no longer in existence) in the paved yard in front of the building.

 A gardener was appointed by the Masters in 1667. William Stevenson remained at Cowane's for forty years his job also entailed ringing the bell at six o'clock morning and evening. He planted a mixed hedge to make a vandal proof barrier, possibly where the Old Town Jail wall is now. In 1702 the gardener ordered from Holland a rather fanciful list of plants:- apricot and peach trees, double yellow roses, jasmine and "July flowers" (gilly flowers) or pinks, all at a cost of 22.08 pounds Scots which included freight and customs charges.

 In 1673 a sundial, by John Buchanan, was set up in the garden, later to be dismantled when a bronze dial was made by Andrew Dickie (clock maker of Stirling). In 1702 stone balustrades were set up on the "high walk". In 1710 William Houston (gardener) advised the Masters to "write to Thomas Harlaw, gardener to the Earl of Mar" for advice on a plan to re-lay the garden as a bowling green. In 1712 Thomas Harlaw devised a plan which included re-siting the sundial, making new borders and the new parterre and bowling green, possibly modelled on a very similar plan at the Earl of Mar's Alloa garden (sadly no longer in existence). Over the next twenty years seats beside the bowling green were provided, as were bias bowls, six oak trees and many flowers for the parterre beds and the borders. This is the plan as it still exists in Stirling. The bowling green is the second oldest in Scotland. The protection of the garden from intruders and vandals was and still is a problem. Gates, fences, walls and hedges have all been tried, without success.

In the course of time gardeners followed gardeners making small changes in the bedding plants. etc., and the popular game of bowls continued to give pleasure. Highland dancing and band concerts were also held on the green. The gardens developed with the availability of new plants, it was now a pleasure garden rather than a subsistence garden as in the past.

Cowane's Hospital was no longer an almshouse, the elderly men preferred not to live in the house because the rules were very restricting, curtailing their independence. A summer-house was built in 1770 at the east end of the yard, and a "necessary house" and "middings" (toilets) were built, neither exist now. Cowane's Hospital was and still is used by the Guildry of Stirling and in 1724 became known as The Guildhall.

A new prison was built in 1806 (now the 'Old Jail') and a high wall was built to divide it from the Guildhall garden.

The garden attracted many distinguished visitors, and in 1842 a visit by Queen Victoria and Prince Albert was attended by seventy Guild Brethern in the Guildhall.

By 1846 the garden maintenance was taken over by the Town Council, to work with the gardeners. An ornamental fountain was set up beside the bowling green in 1862, but by 1866 it was removed (lack of water pressure perhaps). In 1880 a complaint from the Prison Commissioners for Scotland stated that the "Guildhall Bowl-house has been erected against the prison wall and the Patrons shall be obliged to remove it and also any plants against the wall".

In 1883 the bowling green at this time was kept by Mr Wands who collected "all the pennies collected to play on the green". In 1886 a letter to the Patrons asked if they would sell part of the bowling green to add to the prison grounds. The Patrons declined.

In 1894 Dr Paterson of Bridge of Allan offered a fig tree to be planted at the Guildhall where a similar tree had grown for some years. A fig tree still exists against the wall of the Guildhall (now heavily protected by a cage against vandals). A flagpole was erected in 1894 to attract tourists to the garden where a new shrubbery had been planted.

Two world wars then intervened, and records were lost. However the gardens were kept in spite of difficulties, but by 1946 the Guildhall Bowling Club sent a letter to the Patrons to consider having alterations made to the bowling green to make it a square in accordance with the regulations of the Scottish Bowling Association. The Ministry of Works considered the proposal and deferred action – it was felt that the proposed extension would encroach on the garden, cause removal (again) of the sundial and "adversely affect the historic features of the garden." They recommended that "the Cowane's Hospital and grounds shall be scheduled in the terms of the Ancient Monuments acts".

In 1960 the borders were cleared out and bush and climbing roses were planted, also 1200 tulips were planted, with myosotis, all at a cost of £97. Two years later an electric mower was purchased and the Club were permitted to bowl on Sundays from 2.30 to 5.30 pm. By 1970 it was agreed that labour intensive plantings should be replaced by 750 roses, and a "curfew gate" be installed for the protection of the gardens and green. By 1986 after prolonged pressure the bowling green was extended into the parterre to achieve the regulation size. This required the sundial to be moved again, and new paths laid, causing the loss of a large part of the garden and the loss of the original balanced plan of 1710. A decade later (1996) the bowling green fell into disuse. By this time the Town Council and Cowane's Trust were given the task of upkeep.

Now the garden and bowling green and surroundings have fallen into an unkempt shadow of its former self. The bowling green is approaching its 300th Anniversary, surely a cause for celebration and refurbishment?

The garden forms part of the curtilage and setting of an A listed and Scheduled Building, an historic component of the historic landscape of Stirling, and part of the tourist route to the Castle, the Church of the Holy Rude, Mar's Wark and Argyll's

Lodging. The regeneration of Cowane's Hospital Garden should be a priority, part of the regeneration of the historic core of Stirling. The garden forms an essential element in the history of the Castle Rock; if it is allowed to degenerate it will be a substantial loss to Stirling and Scotland.

The book can be consulted for further reference at The Library Stirling, The Stirling Smith Art Gallery and Museum, The Library of Scotland, the Library of the Botanical Gardens Edinburgh, The British Library, the Stirling University Library, The Guildry Stirling, and others.

Mary Eastop

THE NORTHERN BROWN ARGUS IN THE OCHIL HILLS, CLACKMANNANSHIRE

John Gallacher

Introduction

The major threats to Northern Brown Argus butterfly (*Plebius artaxerxes*) are the extremes of overgrazing or neglect of its grassland habitat; combined with fragmentation of habitat leading to small colony size and increased chance of local extinction.

In 2004, following the publication of the Clackmannanshire Local Biodiversity Action Plan (LBAP) 2003-2008, Clackmannanshire Biodiversity Partnership funded a survey of the Ochil Hill's population of this nationally scarce species.

The Clackmannanshire LBAP contains an Action Plan for the Northern Brown Argus. This largely reflects the UK Action Plan and has the following objectives:

1. Maintain the range of the butterfly in Clackmannanshire.

2. Locate all colonies by 2005.

3. Protect key sites.

4. Encourage beneficial management on all other sites.

The primary aim of this survey was to locate and map all areas of the larval foodplant common rock-rose (*Helianthemum nummalarium*) within the Ochil Hills and to look for extant Northern Brown Argus colonies. Other objectives were to observe current habitat condition, to suggest any necessary management works to maintain and enhance populations and to use the butterfly to help raise the wider profile of biodiversity issues within Clackmannanshire through the Alva Glen Heritage Trust.

The Northern Brown Argus in the UK

The Northern Brown Argus is a nationally scarce UK BAP priority species and defined as being of conservation concern. It occurs in well drained, unimproved grasslands where common rock-rose grows in a lightly grazed or ungrazed sward. Most sites are sheltered (often with scrub) and have thin, base-rich soils with patches of bare ground, for example coastal valleys, steep slopes, sand dunes, and quarries. In Scotland it may also occur on predominantly neutral and even acidic soils where common rockrose is able to grow if there is some calcareous influence through weathering or flushing.

While the species has shown serious decline in England and Wales, the Scottish population is thought to be widespread though little is known about colony size or population trends. The area of known occupancy is thought to

be less than 2,000 hectares in the UK (Ravenscroft and Warren, 1996). Viable populations are known to persist on small patch sizes of suitable habitat of no more than 0.2 to 0.25 ha. However such sizes are vulnerable to local extinction especially as it is thought that adults rarely stray from areas of suitable habitat. Indeed, research indicates that 96 % of recorded movements were below 100 metres. These observations suggest that many small sites are highly isolated, prone to local extinction and unlikely to be re-colonised.

The Northern Brown Argus in the Ochil Hills.

The appropriate Northern Brown Argus habitat, base-rich to neutral grassland, is a rare and localised habitat within Clackmannanshire (LBAP) being largely confined to the steep south facing scarp slopes above Menstrie and Alva. Such unimproved grassland habitats are included within the Glens and Unimproved Grassland-Heathland Mosaic Action Plans of the LBAP.

The grassland habitat above Menstrie-Alva is typical of other Northern Brown Argus sites within the UK being base-rich, free draining and vegetated by the NVC CG10 *Festuca ovina-Agrostis capillaris-Thymus polytrichus* grassland (Roberston and Gallacher, 1991). Most of the larval foodplant occurs on the mid to upper slopes of the scarp that also includes adult nectar sources such as thyme (*Thymus polytrichus*) and bird's-foot trefoil (*Lotus corniculatus*).

Alva Glen (NS884 983) is a well known historic site for Northern Brown Argus and all the recent records in Clackmannanshire relate to this site. However, the Craigleith and Myretoun Hills SSSI, notified on the 30 March 1990, includes the Northern Brown Argus as part of the qualifying interest and states that "*it is the only known breeding colony in Central Region*". The SSSI however lies due west of Alva Glen and no recent records relate to the SSSI.

All the recent (1998) records for Northern Brown Argus in Clackmannanshire, provided by Butterfly Conservation, are confined to Alva Glen. This may be a true reflection of actual species distribution though it is more likely to reflect the ease of access compared to the steep unpathed slopes either side of the Glen.

In 1992/3 the Glen was fenced to exclude sheep under a Forestry Commission Woodland Grant Scheme project. The aim of this project was to assist the regeneration of semi-natural woodland and scrub which had been held in check by many years of sheep grazing. The Unimproved Grassland-Heathland Mosaic Action Plan notes that such projects, while beneficial for woodland restoration, may have a detrimental effect on neutral/calcareous grassland habitats and their associated species. Shading of common rockrose is likely to adversely impact on the extant Northern Brown Argus colonies within Alva Glen.

Survey methods

The survey methodology, as agreed with Butterfly Conservation (Kirkland pers comm.), included the following elements:

- Areas of common rockrose to be mapped during 2004 using a Geographical Positioning System (GPS).
- Plant species associated with common rockrose to be recorded.
- Height of common rockrose to be measured.
- Presence/absence of Northern Brown Argus butterflies to be recorded using a Geographical Positioning System (GPS).
- Presence/absence of Northern Brown Argus eggs on common rockrose to be recorded using a Geographical Positioning System (GPS).
- General comments on the habitat condition and other associated butterfly species to be recorded.

The field survey schedule was as follows:

Table 1: Field Survey Schedule 2004

Date	Location
4 July 2004	Alva Glen
6 July 2004	Slopes below Wee Torrie, west of Alva Glen
9 July 2004	Slopes below Craig Leith towards Balquharn Glen
30 July 2004	The Kipps south east of Dumyat summit
5 August	Balquharn Glen

The 2004 survey was confined to the known locations of Northern Brown Argus within Alva Glen and areas to the west of the Glen that were known to hold good populations of common rockrose. The survey of both these areas provided a good contrast between the ungrazed Glen and the sheep grazed open hill.

The Kipps area (due east of Dumyat summit) was added to the survey on account of historical records for common rock-rose (Blake, 1976).

Results

The results are summarised in Table 2.

The largest continuous areas of common rockrose occurs below Wee Torrie and Craigleith within the Craigleith and Myretoun Hills SSSI. Lower down the slope, including the Glen, the plant occurs as small isolated clumps on the steeper, free-draining slopes.

The thin, base-influenced soils which favour common rockrose also favour other mesotrophic grassland species such as thyme (*Thymus praecox*), marjoram (*Origanum vulgare*), purging flax (*Linum catharticum*) and pepper saxifrage (*Pimpinella saxifraga*). A feature of the common rockrose stands in the Glen is the strong association with scrub species such as gorse (*Ulex europaeus*), blackthorn (*Prunus spinosa*), dog rose (*Rosa canina*), broom (*Cytisus scoparius*) and hazel (*Corylus avellana*).

The sward height of common rockrose within the Glen can be as much as 20 cm and on the open slopes is typically 5 to 10 cm. However, there is evidence that the open slopes are becoming less intensively grazed since the grassland survey of Robertson and Gallacher (1991) as indicated by the presence of false oat-grass (*Arrhenatherum elatius*) – a species largely intolerant of heavy grazing pressures.

Northern Brown Argus was generally found in small groups of 3 to 4 adults. They were more likely to be found within the Glen rather than the more exposed open hill to the west even though the extent of common rockrose was greater in the latter areas. The shelter provided by the Glen and the scrub/woodland may be important in this regard. However, new records for Northern Brown Argus were confirmed to the west of Alva Glen within the Craigleith and Myretoun Hills SSSI. No evidence of Northern Brown Argus was found in Balquharn Glen. Further to the west, no common rockrose was found on The Kipps despite past records for this species in this locality.

Associated species of butterfly included small blue (*Polyommatus icarus*), small heath (*Coenonympha pamphilus*) and ringlet (*Aphantopus hyperantus*) the latter being particularly abundant in the ungrazed acid grasslands of the upper glen.

Discussion

Over-grazing and neglect of grassland habitats are two key factors that may affect the suitability of sites for Northern Brown Argus. Over-grazing leads to short turf and loss of habitat structure. Neglect, or under-grazing, leads to scrub encroachment onto species-rich grassland with the loss of larval foodplants and nectar sources. Both of these events are potentially at play in the known locations of Northern Brown Argus in the Ochil Hills: under-grazing in the Glen on account of stock exclusion with higher grazing levels on the adjacent sheep grazed open hill.

This survey has provided locational data for Northern Brown Argus both within the ungrazed Alva Glen and the grazed open hill to the west indicating that the species is currently coping with a range of grazing intensities. However, a tentative conclusion is that the colonies above the Glen are smaller despite the extensive areas of the larval foodplant below Wee Torrie and Craigleith. Obviously other factors contribute to the "ideal" Northern Brown Argus habitat and of particular importance is habitat structure. Here the Glen scores more highly than the open hill with the former providing better vegetative and topographic shelter.

The lack of vegetative shelter on the open hill is, in part, related to the continued stock grazing and burning management (burning being used to control gorse) to which this site has been historically subject. Indications since the 1990 grassland survey of Craigleith and Myretoun Hill SSSI are that grazing intensity (by sheep and rabbits) has reduced since then as indicated by the presence of false oat-grass (*Arrhenatherum elatius*). Further, the size of common

rockrose plants for egg laying is at its optimum in this area being in the medium range of 6-10 cm.

While the Glen is likely to be the type locality for Northern Brown Argus in Clackmannanshire, this report raises the concern that the Forestry Commission funded grazing exclosure around the site is encouraging the encroachment of scrub onto the areas of common rockrose. Gorse, blackthorn (*Prunus spinosa*), dog rose (*Rosa canina*) broom and hazel have all been noted as species spreading onto the remaining small areas of Common Rockrose (see Table 2). Left unchecked, this situation is likely to threaten the viability of Northern Brown Argus at this location.

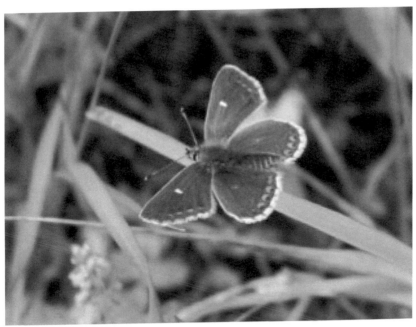

Northern Brown Argus.

Table 2: The Ochil Hills Northern Brown Argus Project 2004 (text in bold indicated adults or eggs recorded)

NGR	Species associated with Helianthemum	Height of Helianthemum	NBA present/absent	Eggs present/absent	Comments
NS 88481 98155	*Origanum vulgare, Ulex europaeus, Teucrium scorodonia, Rosa canina, Lotus corniculatus, Deschampsia flexuosa, Ononis repens, Lapsana communis, Geranium robertianum, Asplenium trichomanes, Thymus polytrichus, Pimpinella saxifraga.*	20cm	A	A	All sites in Alva Glen are largely ungrazed following erection of a stock fence some 15 years ago to encourage natural regeneration. This has resulted in the spread of scrub (e.g *Prunus spinosa, Rosa canina*) which is encroaching onto the *Helianthemum* sites. Other species noted from the Glen includes Small Heath (occasional), Common Blue (rare), Chimney Sweeper (rare) and Ringlet (abundant).
NS 88452 98125	*Deschampsia flexuosa, Thymus polytrichus, Pleurozium schreberi, self-seeded Fraxinus excelsior.*		A	A	
NS 88439 98230	*Teucrium scorodonia, D. flexuosa, A. elatius, Sedum anglicum, T. polytrichus, P.schreberi,* young rowan.	18-20cm	A	P	Several eggs noted.
NS 88450 98152	*Dactylis glomerata, T. scorodonia, T. praecox, Alchemilla agg. P. schreberi.*	12.5cm	A	P	4 NBA noted. *Cytisus scoprius, Corylus avellana* and *Prunus spinosa* invading area of base-rich grassland.
NS 88449 98157				P	This area is essentially and outlier to the above also with *P. spinosa* spreading into *Helianthemum* area. This area is considered to be the highest clump of *Helianthemum* in the glen.
NS 88428 98127	*A. elatius, Galium saxatile, T. polytrichus*		A	A	
NS 88425 98111	As above.			A	Also small outlier at NS88424 98094.
NS 88448 98079	*A. elatius, D. glomerata, T.scorodonia, S. anglicum, D. flexuosa, T. polytrichus, P. schreberi, G. saxatile, G. verum*	15-20cm	P	P	*Ulex europaeus* invading sward. Four NBA noted. Also outlier at NS88461 98076.
NS 88515 98122	*T. scorodonia, D. flexuosa, P.schreberi, S. anglicum, P. saxifraga, Solidago virgaurea, G. saxatile, G. verum, Lotus corniculatus, Ononis repens, S. anglicum*	15-20cm	P	A	This patch extends to NS58507 98151. 6 NBA noted. *R. canina* and *C. avellana* encroaching site.
NS 87973 97750	*S. anglicum, G. verum, O. repens, T.polytrichus*	5-7.5cm	P	P	4 NBA noted. *Helianthemum* area surrounded by *Pteridium aquilinum* and *Ul. europaeus* kept open by rabbit grazing.
NBS 87950 97740		5-7.5cm	A	P	This site is outlier of above.
NS 87953 97803	*Anthoxanthum odoratum, T. polytrichus, Festuca ovina, T. scorodonia. D. flexuosa, Pteridium aquilinum*	5-7.5cm	A	P	2 NBA eggs noted. Other species include Ringlet (abundant) and Small Heath (occasional).

Table 2 cont.

Grid ref	Vegetation	Height			Comments
NS87948 97820	Helianthemum spread through grassland/bracken with A.odoratum, T. polytrichus, G. saxatile, D flexuosa.	5-7.5cm	A	A	This is a large diffuse area of exposed *Helianthemum* on the steep slopes below Wee Torrie.
NS 87835 97845	As above.	5-7.5cm	A	A	Small outlier to above.
NS 87815 97870	Linum catharticum, Saxifraga pimpinella.		P	A	2 NBA noted. Sheltered area alongside Carnaughton Burn.
NS 87769 97832			A	A	Small diffuse colony of *Helianthemum*.
NS 87707 97844			P	A	1 NBA noted within small diffuse colony of *Helianthemum*.
NS 87629 97825 to NS 87559 97813			A	A	Large extent of diffuse *Helianthemum*.
NS87541 97861			P	P	1 NBA noted plus 1 egg.
NS87444 97861		10-12.5cm	P	A	2 NBA noted.
NS87570 97810	Undergrazed Arrhenatherum elatius grassland.		P	A	1 NBA noted.
NS87007 97607	Potentilla sterilis, G. verum, D. flexuosa, A. elatius, Agrostis spp., Festuca ovina, T. polytrichus, S. anglicum, Veronica chamaedrys, A. odoratum.	10cm	A	A	All crags below Craigleith hold *Helianthemum*.
NS87131 97854	T. polytrichus, G. saxatile, A. odoratum, Aira praecox, S. anglicum, A. tenuis, P. aquilinum.	10cm	A	A	6 spot burnt moth.
NS87139 97887	As above.				
NS87169 97936	A. odoratum grassland.		A	A	Diffuse population of *Helianthemum* with A. odoratum grassland. Small Heath.
NS 86987 97953			A	A	Small are of *Helianthemum*.
NS86752 97864	D flexuosa, A. odoratum.		?	A	Small green caterpillar noted feeding on *Helianthemum*. NBA?
NS86717 97910			A	A	Area of *Helianthemum* sheltered within stands of *U. europaeus*. Worth second visit.
NS842 974	The Kipps - south east of Dumyat summit.		A	A	Old record for *Helianthemum* noted by Blake in Forth Naturalist and Historian Vol. 1 1976. No *Helianthemum* recorded - too acid?
NS86717 97910	Balquharn Glen		A	A	Second visit. No NBA noted in visit of 5 Augist 2004. Too late?

Further work

Further survey work is required to help estimate colony size and identify any further colonies outside the main area of Alva Glen. Some of this work should be concentrated within Balquharn Glen where the foodplant is present and topographic and vegetative shelter is similar to that found in Alva Glen.

Some educational and practical management works, including scrub control has been undertaken by the Alva Glen Heritage Trust and has involved work within the Glen to remove scrub that has encroached onto the areas of common rock-rose.

References

Craigleith and Myretoun Hills SSSI map and citation.

E. A. Blake (1976). Ecological aspects of some of the more local flowering plants of the western Ochils. *Forth Naturalist and Historian*, Vol 1.

Clackmannanshire Local Biodiversity Action Plan 2003-2008.

N. Ravenscroft and M. S. Warren (1996) UK BAP for Northern Brown Argus

J. Robertson and J. Gallacher (1991) A grassland survey of Central Region, Nature Conservancy Council Internal Report.

WEATHER 2006 PARKHEAD CLIMATOLOGICAL STATION

Malcolm G. Shaw

That was the record year that was. The BBC weather-men emphasised before half time that it could break records, it did not disappoint. They had no hesitation in declaring it the warmest year for Scotland since their record began, and they have 60 year normals compared with our Parkhead records only stretching back 30 years.

There is a problem though. When the BBC says average temperature, they are averaging temperature recordings made on a continuous (hourly) basis at multiple sites, but the Parkhead normals are in the form of average maxima and average minima. In addition, in 2006 the Parkhead station which can now make hourly temperature measurements, did this for only 10 months, and no reliable rain data were collected. For the missing months (February and December), and all the rain data we are indebted to Mr. Niel Bielby, of Dunblane for substitute measurements.

The nearest one can get to an average temperature from these records, is to average the minima and maxima assuming they vary in a linear manner. I've tried it, and as you might guess, the relationship is not linear.

January and February taken together were relatively mild and dry. Day time maxima were average, but cloudy nights were almost a whole degree warmer and had a smaller number than average of air-frosts. January is usually our wettest month, and February our 6th, but only 56 % fell last year. That's interesting against what would overall be a +25 % wetter than average year. Our subjective recollections however can be different – the days with some rain ie ">0.2 mm rain" were very close to average at one day in 2.

March was significantly colder and wetter (169 % ave. rain) than average. Predictions of the "warmest year yet" looked bold. Never the less, a remarkable number of daffodils were in bloom for St David's day – a trick we once believed only the Welsh could pull off.

The beginning of the month was actually cold and dry and very sunny, in a northerly veering easterly airflow. Temperatures elsewhere were more extreme: $-16°C$ in Altnaharra on the 2nd, $-10°C$ at Stranraer on the 4th and $-7.2°C$ in Dunblane also on the 2nd, making it the coldest night of the year locally.

On the 11th, Atlantic fronts moved in against this cold air and most areas had a good covering of snow before it turned to rain. Glasgow measured 22 cm and locally 27 cm was recorded.

A foot note to March might be to suggest we have a micro-climate, for Scotland as a whole did not have an especially wet March (106 % ave. rain)

April continued with low temperatures by day and near average rain fall. But look again at the number of days with some rain blowing in the air (>0.2 mm days). More than half were cloudy and wet.

In **May** the day/night temperatures at least came close to normal but the dreach weather continued with 60% more rain, and 50% more wet days than average. With all the cloud it is not unsurprising that air frost in both April and May were less than 50% normal.

The summer. Locally, June and September were not the warmest months of the year, that title goes to July and August as one would expect, but they stand out as being nearly 2 degrees warmer than their averages and that has an obvious bearing on our memory of a long warmer summer. September did unfortunately – except for plants – herald the beginning of our rainy season.

July and August were in most ways unexceptional at Parkhead as the data shows. Interestingly, July was the month that the BBC picked as the month that was 3 degrees warmer than average, but see the earlier remarks a data recording.

Out of our area some really high temperatures were recorded. For example Aberdeen recorded 30°C on 17th July, Wisley, Surrey 36.5°C (a new UK record) on 19th July, Aboyne 28°C on 14th Aug, the Moray coast 24°C in mid-September, but would you believe that Altnahara recorded an air frost on the 26th June, and Tulloch bridge on the 14th July!

In October and November the mild but very wet trend continued. The nightly minima remained consistently high, and we recorded our first and only November frost since the 10th April on 3rd November. Even after that temperatures rose again with the rain to end the month with nightly lows of only of 5-10 deg.

December continued a run of 4 really very wet months, (rain fall 190 % average). Those last 4 months produced 55 % vs 40 % normal of the rain in what was already a year with 125 % average rainfall.

Unfortunately this did little for the December day time temperatures which fell well below average for the first time since March. Another footnote of caution though is indicated because apparently we had, Scotland wide, a mild December (a full 1 degree C warmer than average).

So how should we remember 2006 in the Stirling area? Well, perhaps no individual day or month broke any record at Parkhead, but we had a winter/spring of grey days with few nightly frosts, benefiting early flowerings and perhaps survival of more pests, a summer which started earlier and went on longer with more warm evenings. Finally we had an autumn which was exceptionally mild, even if only our heating bills really benefited.

Table 1 Temperature readings Parkhead Climatological Station
February to December 2005

	mean - maxima		mean - minima		Number of Air Frosts	
January	6.7	(6.5)*	1.4	(0.5)	9	(13)
February	6.8	(6.9)	1.6	(0.8)	3**	(11)
March	7.0	(9.1)	1.3	(1.9)	9	(7)
April	11.6	(11.8)	3.1	(3.4)	2	(4)
May	15.3	(15.3)	6.0	(5.8)	0	(1)
June	19.4	(17.7)	10.0	(8.4)	0	(<1)
July	19.7**	(19.8)	10.9**	(10.6)	0	(0)
August	19.6	(19.4)	10.8	(10.2)	0	(0)
September	18.7	(16.3)	9.5	(8.3)	0	(<1)
October	14.6	(12.9)	8.0	(5.4)	0	(2)
November	9.9	(9.2)	4.5	(2.6)	1	(8)
December	5.7**	(7.2)	1.2**	(1.1)	10	(11)
Year January-December 2006	13.6	(13.2)	6.2	(5.3)	34	(44)

Table 2 Rainfall and Wind Feb.-Dec. 2005 Parkhead Climatological Station

	Total rain (mm)		Greatest fall (mm)		Number of days >0.2 mm		Number of days >1.0 mm		Number of days >5 mm		mean Wind strength (m/s)	Gust max. at time, date (m/s)
January	58.4	(110.7)	11.9	(40.0)	16	(19)	9	(16)	4	(8)	0.4 .	12.5N 11.00, 11/01
February	45.3	(73.2)	10.0	(31.8)	15	(16)	8	(12)	3	(5)	0.4 .	8.0SW 13.00, 07/02
March	138	(81.4)	26.0	(44.0)	19	(17)	16	(14)	8	(5)	0.8 .	10.7 E 21.00, 24/03
April	39.6	(47.5)	6.0	(35.3)	17	(13)	11	(10)	2	(3)	0.7 .	12.1 W SW 13.00, 22/04
May	92.3	(56.9)	10.9	(28.3)	20	(14)	17	(11)	7	(4)	0.9 .	12.1 WSW 13.00,.22/05
June	61.4	(57.1)	20.3	(35.8)	10	(13)	9	(10)	4	(4)	0.9 .	10.7 WSW 09.00, 21/06
July	44.0**	(62.9)	12.3	(65.5)	11	(13)	6	(10)	4	(5)	0.4 .	9.4 WSW 17.00, 12/07
August	56.8	(68.1)	14.9	(30.0)	15	(14)	9	(11)	4	(5)	0.6 .	8.9 WSW 21.00, 18/08
September	145.8	(87.7)	36.5**	(44.2)	22	(15)	19	(12)	8	(6)	0.5 .	8.9 WSW 11.00, 18/09
October	126.5	(97.9)	21.7	(66.2)	22	(17)	17	(14)	10	(6)	0.3 .	13 WSW** 10.00, 31/10
November	198**	(98.9)	21.1	(68.3)	22	(17)	19	(14)	16	(7)	0.5 .	12.5 SW 19.00, 23/11
December	193	(101.0)	26.8	(43.8)	19	(18)	19	(15)	10	(7)		n/a
Year Jan.-Dec. 2006 1199		(943.3)	36.5**	(68.3)	186	(186)	159	(149)	80	(65)	0.6 .	13.0 WSW**

* Climatological normals 30yrs 1971-2000 are shown in ()s
**high/low of the year

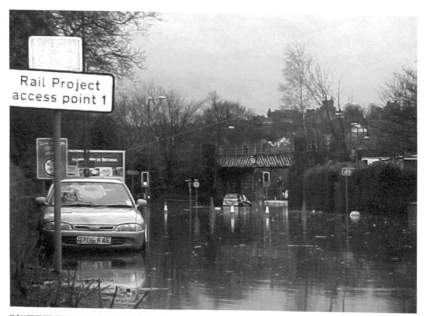

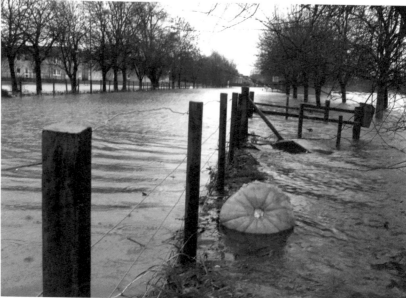

On 14 December 2006 direct links between Stirling and both Bridge of Allan and Causewayhead were blocked by floodwater. The photographs are of the railway bridge on the Causewayhead road and of Cornton road by the playing fields and allotments (below). Courtesy of Allan Water News.

NEW RECORD FOR THE COMMA BUTTERFLY IN CENTRAL SCOTLAND

Heather Young and Sue and Roy Sexton

The recent northwards expansion of the comma's range was confirmed by two independent sightings of a single specimen near the "Gathering Stone" on Sheriffmuir on the 21st and 24th August 2006 (NN 814022). This memorial, which marks the site of the famous battle between the Jacobite supporters and government troops loyal to George I (Inglis, 2005), appears to be the front line of a new invasion from the south. Photographs sent by the authors to Richard Sutcliffe (SW Scotland Recorder for Butterfly Conservation) revealed imperfections in the wings which confirmed both sightings were of the same individual.

The comma (*Polygonia c-album*) is a member of the *Nymphalidae* family and the sub-group known as vanessids. These include the more common peacock (*Inachis io*), small tortoiseshell (*Aglais urticae*), red admiral (*Vanessa atalanta*) and painted lady (*Vanessa cardui*). It is approximately the same size as these but is easily identified by the scalloped outlines of its dark spotted, orange-brown wings (Figure 1). A characteristic white comma shaped mark on the underside of its hind wing gives the butterfly its name. The comma's rapid flight and twisting glides can cause it to be mistaken for a fritillary (Lewington, 2003).

A northerly expansion of the comma into Central Scotland was widely anticipated. The 1972-82 distribution maps in the *Millennium Atlas of Butterflies in Britain and Ireland* showed that at that time it was restricted to the south of a line from the Mersey to the Wash. By 1995-9 it had moved north into 700 new 10 km squares reaching the Scottish border (Asher et al., 2001).

Historically the range of this butterfly has also undergone enormous change. During the early nineteenth century it covered much of England and Wales with scattered records in Scotland. For example in 1868 it had been described as scarce in Berwickshire with other earlier records in Fife and Edinburgh. However a century later George Thompson (1976), in his article on "*Scotland's Disappearing Butterflies*", concluded that the comma had been extinct north of the border for a long time.

Following a population crash in the early 20th century the comma became restricted to the Welsh border and a few sites in SE England. It has been suggested that this early race of the butterfly relied on the hop (*Humulus lupulus*) as its food plant and the decline coincided with the reduction in its cultivation. The nettle (*Urtica dioica*) is regarded as the main food plant now, though in Northern England most larval records are on wych elm (*Ulmus glabra*). Climate change and the associated milder winters have also been implicated in the northerly spread. The solitary comma larvae are more vulnerable to cold than gregarious caterpillars like the small tortoiseshell which

can raise their communal temperature in "tents" or silk webs spun round the top of nettle plants (Asher et al., 2001).

In recent years sporadic sightings north of the border in Dumfries and Galloway, Ayrshire and Lanarkshire have become more consistent, suggesting colonisation rather than migration (Spooner, 2002; Futter et al., 2006). The comma over-winters as an adult on tree trunks, branches and in leaf litter, becoming active again in March and April. The caterpillar is very distinctive, similar to other vanessids, but with a white stripe along its back making it resemble a bird-dropping. Until 2006 there was only a single record of a Scottish comma in early spring (Futter et al., 2006) but in 2007 an adult was reported locally on March 7th in Mugdock Country Park near Strathblane. Butterfly Conservation Scotland has also recorded a comma caterpillar on elm in the borders.

The local comma was recorded in the heath surrounding the "Gathering Stone" a quarter of a mile north of the MacRae monument on the Sheriffmuir road. This is an excellent site for butterflies. In May the green hairstreak can be seen on blaeberry (*Vaccinium myrtillus*) its food plant and basking on rowan, willow and birch trees. The orange tip which is now common throughout the area is found with the green veined white along the path on lady's smock (*Cardamine pratensis*). In early summer the small copper, small heath and small white have also been recorded as well as good numbers of the small pearl bordered fritillary in marshy open ground in the surrounding woods. The ringlet and meadow brown were both present in the same area in late July. In autumn the verge along the path by the eastern wall is frequented by hundreds of vanessids which included the comma. A count along the path on 20th August 2006 recorded 157 peacocks, 37 red admirals, 14 painted ladies, 34 small tortoiseshells, eight green veined whites, one common blue and three hummingbird hawk moths. They are probably attracted by large stands of devil's bit scabious (*Succisa pratensis*) and knapweed (*Centaurea nigra*) which provide sources of nectar, together with the shelter provided by the surrounding dry stone walls and trees. Recent clear-felling of the conifer plantation to the north of the heath means the site will be more exposed and it remains to be seen whether this will have a detrimental effect on the rich variety of life to be found there.

References:

Asher, J., Warren, M., Fox, R., Harding, P., Jeffcoate, G. and Jeffcoate, S. (2001) *The Millennium Atlas of Butterflies in Britain and Ireland*. Oxford: Oxford University Press.

Futter, K., Sutcliffe, R., Welham, D., Welham, A., Rostron, A.J., MacKay, J., Gregory, N., McLeary, J., Tait, T.N., Black, J., and Kirkland, P. (2006) *Butterflies of South West Scotland*. Glendaruel: Argyll Publishing.

Inglis, B. (2005). *The Battle of Sheriffmuir – Based on Eye-Witness Accounts*. Stirling Council Libraries.

Lewington, R. (2003). *Pocket Guide to the Butterflies of Great Britain and Ireland*. Hook, Hampshire: British Wildlife Publishing.

Spooner, D. (2002) The Present Status of Scotland's Rarest Butterflies. Forth Naturalist and Historian **25**, 41- 52.

Thompson, G. (1976) Our Disappearing Butterflies. Forth Naturalist and Historian **2**, 89-103.

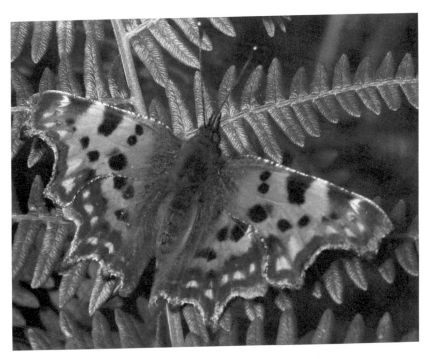

Figure 1 The comma butterfly showing its scalloped wings.

FORTH AREA BIRD REPORT 2006

A.E. Thiel and C.J. Pendlebury

The present report is the 32nd bird report for the Forth Valley (or Upper Forth) bird recording area. The report was written by Chris Pendlebury (waterfowl, excluding waders, raptors and gamebirds) and Andre Thiel (waders, passerines and escapees) with Cliff Henty contributing the half-monthly summaries to the wader accounts. Cliff remains the Bird Recorder and all data should be sent to him in the first instance.

The main part of the report consists of detailed species accounts presented in a systematic list arranged in the traditional Voous order. This is preceded by a summary of the main bird news from the past year, additional sections on the Breeding Bird Survey (BBS) and the Wetland Bird Survey (WeBS), the latter two written by Cliff Henty, and a Ringing Report, compiled by Andre Thiel.

ROUND-UP OF THE YEAR

Skinflats and Kinneil hosted a number of scarce species in January. A pair of Scaup were at Skinflats from 6th to 25th January, a female Common Scoter at Kinneil on 9th and 15th January and an Iceland Gull there on 14th. A male Scaup at Lake of Menteith on 16th January and a pair of Long-tailed Ducks there on 21st January were in a rather unusual location. As in 2005 the very mild winter encouraged a number of scarce waders to stay on. One to two Greenshanks and one to two immature Ruff were seen repeatedly at Skinflats in January and thereafter until at least March. Green Sandpipers were reported from Larbert House Loch on 14th and Kinneil on 27th January. Comparatively small numbers (1-3) of Jack Snipe were recorded from Skinflats and Kinneil in January. The fifth record of Mediterranean Gull in our recording area came from Kinneil on 14th January; this may have been the same bird as seen there in November 2005. Among the more usual winter visitors were a Snow Bunting at Stob Binnein on 3rd, 27 Waxwings at Cambus on 15th and a total of 11 in Stirling on 27th January. With a maximum count of 90 birds on 22nd January, the Raven roost in Doune hosted fewer birds than in 2005.

February was rather quiet, the highlight being a winter roost count of 50 Red Kite at Braes of Doune on 7th with a flock of 12 Turnstone at the mouth of the R. Carron on 12th another good record. Water Rails at Cambus Pools on 12th and Callendar Park Loch, Falkirk on 25th and redhead Smew at Gart GPs on 15th and Vale of Coustry on 25th brightened up the lengthening winter days, as did 25 Snow Buntings at Allt a Chaol Ghlinne, Tyndrum on 6th March.

The first signs of spring passage at Skinflats were a Greenshank and White Wagtail on 31st March. These were followed in April by 5 Avocets on 20th, a Little Ringed Plover on 24th, the first of a small influx of Garganeys on 27th, 3 White Wagtails on 28th as well as 9 Whimbrel at The Rhind, Alloa on 30th. The upstream shift of Black-tailed Godwits in spring when numbers decline in the

Kinneil/Skinflats area was again evident with a maximum of 31 recorded at Cambus Village Pools on 26th. Excellent finds elsewhere were a 1st winter Mediterranean Gull at Kinneil on 4th, Long-eared Owls at Cambus on 10th and Skinflats on 22nd and a Marsh Harrier at Darnrigg Moss, Slamannan on 29th.

May highlights included a summer-plumaged Spotted Redshank at Skinflats on 2nd-3rd, a Dark-bellied Brent Goose there on 4th-8th, Garganeys in Callander on 10th, at Gartmorn on 17th and at Cambus Village Pools on 21st-22nd, a Long-eared Owl at Wester Moss on 11th, 8 Whimbrel at Fallin on 13th, a Ring Ouzel at Sron Eadar a' Chinn, Callander on 19th and an Arctic Tern at Skinflats on 21st. The best bird of the month without any doubt, however, was a Black-crowned Night Heron in Bridge of Allan on 21st, only the second record for the area.

The highlight of June was a Hoopoe at Thornhill Muir Farm on 7th. This is only the third record for the recording area, the last one having occurred in 1984. As in 2005, Little Gulls were recorded at Skinflats. This time one to two 1st summer birds were there between 29th June and 1st July, followed by an adult on 13th July. Six days later the site hosted an adult Mediterranean Gull, the 7th for the recording area. Autumn migration started with a Greenshank at Kinneil on 26th.

August was rather quiet, the only birds of interest being a single passage Greenshank at Kinneil on 12th and two at Cambus on 20th. Things didn't really pick up until the start of September. A Ruff at Skinflats between 1st-15th was followed by an excellent count of 14 on 17th. This was accompanied by 4 Curlew Sandpipers on 5th, increasing to 14 on 7th, a Sanderling on 6th-7th, a Little Stint on 21st and 2 on 23rd. Kinneil supported an excellent 10 Greenshanks on 15th. Elsewhere a radio-tagged juvenile Marsh Harrier that fledged in the Tay estuary area arrived at Tullibody Inch on 7th Sep and stayed in the same general area until at least 21st. A Scaup was at Devonmouth, Cambus on 9th with a drake at Lake of Menteith on 19th. A Razorbill at Loch Katrine on 15th would have come as a bit of a surprise. A Green Sandpiper on the River Carron on 19th was less unusual. Less expected were two Great Grey Shrikes at Skinflats on 23rd. An adult Ring-billed Gull at Kinneil was intermittently seen from 26th September to 23rd December. This is the second record for the recording area and may be the same bird that was present there in 2005.

October started with a good count of 30 Guillemots at the Kincardine Bridge on 1st with a Razorbill at Skinflats on 6th and two at S. Alloa on 22nd. Two Little Gulls at Carriden on 2nd were a good find, while two Arctic Skua passing Skinflats on 8th was the only record of rather a poor show this year. The run of Nuthatches continued this year with a bird in Aberfoyle on 13th. Another Great Grey Shrike was seen at N Third Reservoir on 21st, 28th and 29th, while a well watched immature Spoonbill frequented the Kinneil/Skinflats area and was also seen at Kincardine Bridge and Cambus Village Pools between 17th October and 20th December.

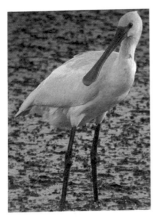

Immature Spoonbill at Kinneil/Skinflats

Photo by Keith Hoey

Barrow's Goldeneye. Some of the diagnostic features are shown nicely in this photo: slightly larger size than the drake Goldeneye behind it; more elongated less triangular head with a peak to the front, white crescent reaching above the eye; black spur on the flank; more extensive black upperparts encircling white 'windows'.

Photo by Nick Franklin

November started with two Little Auks at Kinneil on 5th and yet more Mediterranean Gulls in the form of a second winter bird at Skinflats on 4th, an adult and a second winter bird there on 12th and an adult at Kinneil on 17th. Two days later two Iceland Gulls graced Airth shore. Arguably the best bird of the year was a drake Barrow's Goldeneye commuting between the Teith in Callander and Loch Venachar between 19th November and the end of the year. This is only the third British record of the species, if accepted (while there is no question about the bird's identification, as with all wildfowl the likelihood of it being of wild origin will need to be determined by the BBRC). This bird comes hot on the heels of one on the Ythan estuary (Aberdeenshire) in 2005. It is thought that either the Callander bird or a second bird that appeared in Ireland at the same time may have been the same as the Aberdeenshire bird. If any confirmation was needed that winter had arrived, it came in the form of a Waxwing in Callander on 25th and 26th.

Not surprisingly December was dominated by wildfowl. The 17th of the month was a good day to be out and about: a drake Green-winged Teal was seen at Grangemouth, a Mediterranean Gull was seen at Kinneil as was a 1st winter Iceland Gull with a 2nd winter bird there on 26th-27th. The year ended as it started with overwintering waders including a Green Sandpiper on the River Carron on 17th, a Ruff at Skinflats on 30th and up to 3 Greenshanks in the Skinflats/Kinneil area between 1st and 30th.

RECORD SUBMISSION

Annual Bird Reports depend largely on contributions from the local birdwatching community. Due to the increasing (and welcome) datasets generated by birdwatchers as well as the now commonplace electronic dissemination of data from sources such as the bird news services and the BTO's Birdtrack online survey, it has been possible to produce a more detailed account of the avifauna over the past few years. As a corollary the bird report grew from year to year to the point where the editors of the Forth Naturalist and Historian felt that the bird report was over-represented. As a result it has been necessary to significantly cut down the report. This has been done in a number of ways.

Species sections have been reduced to the most relevant data. As in the past but increasingly so now, this means that some data that may be of relevance in one year may not be so in another year. This should not discourage contributors from submitting data that they feel are of relevance to their local area, as it will only become obvious whether a particular record should be included or not once the entire dataset is available. Several observers send in a list largely or entirely for their home locality. Much of this information is not appropriate for inclusion in these annual reports but it is valuable to have on record (e.g. for conservation action). These are kept in a special file. At the moment there are fifteen such lists referring to the whole district from Falkirk to Killin. Several contributors send in data, often of common species, from repeated transect visits to the same locality, e.g. Roughcastle, Falkirk; Hollow Burn, Fallin; Airthrey; King's Park, Stirling; Cobleland, Aberfoyle. This has become more common since the advent of the BTO's Birdtrack on-line project. Such data reflect birds per walked route rather than flock sizes. These data are especially useful, if collected repeatedly and using the same effort between years, as it allows valid comparison between seasons and years to be made.

The reader will notice another obvious way in which the bird report has changed. While all contributors whose data are included in the report are listed in the contributors section, in a deviation from the past the initials of only those who were lucky enough to witness scarce or rare species or unusual events are shown against the specific records or summarised after a series of these. While this may not seem to represent a great saving of space, its cumulative effect does add up, especially where lists of initials spill over into a separate line.

To facilitate the preparation of the report, contributors are strongly encouraged to submit their data as soon as possible after the end of the year. Electronic files are much the preferred format, as it greatly speeds up cross-checking and summarising of data. A standard spreadsheet is available from Cliff Henty. Special thanks are due to those contributors who are now submitting their data in this format.

Following on from the last couple of years, an increasing number of records are submitted with 6-figure grid references. While it is not appropriate to list these in the report itself, it enormously speeds up cross-checks and is a valuable

resource for conservation action. Also more contributors add the name of the nearest village which, too, is very much appreciated.

The sparse information available about common breeding species is improved by data from the Breeding Birds Survey (BBS). For less common species data can sometimes be summarised in terms of the numbers of pairs or apparently occupied territories for particular locations. The organisers for both the estuary and the inland waters parts of the national wildfowl counts (WeBS) have also made available the results from these for this report. Where appropriate, these are included in the species accounts.

For many species the records sent in are very unrepresentative of their general distribution. This applies particularly to very common species or to those that are secretive or breed in inaccessible locations. The status of species is detailed in a Check List, published in the Forth Naturalist and Historian, Vol 15. Additional information along with guidelines for the submission of records can be obtained from N. Bielby, 56 Ochiltree, Dunblane, FK15 0DF (tel.: 01786 823830, e-mail: n.bielby@sky.com). In addition there is a coded summary of general distribution after the species name. This often apparently contradicts the detailed records that are published for the year. The codes are thus:

B - Breeding status: widespread (present in more than five 10 km squares)
b " " : local , scarce (present in fewer than five 10 km squares)
W - Winter status: widespread or often in groups of more than ten
w - " " : local, scarce (local and usually fewer than ten in a group)
P : Passage (used when species is usually absent in winter; P or p used for widespread or local as in winter status)
S or s : Summer visitor (used for species present in summer but which do not normally breed; S or s used for widespread or local as in winter status).

Thus BW would be appropriate for Robin, B for Swallow, p for Ruff and SW for Cormorant. No status letter is used if a species occurs less than every other year.

An asterisk (*) in front of the species name means that all records received have been quoted. The SOC has pressed for a more systematic vetting of records of species that are unusual locally. Our area has an informal panel of five members: C. Henty (Recorder), A. Smith, D. Orr-Ewing, A. Blair and D. Thorogood. They have produced a list of species that are scarce locally and where the records need to be supported by either a full description or sufficient evidence to remove any reasonable doubt. The list is available from Cliff Henty. Any species which is a vagrant to the area and some of those which are asterisked in this report will fall in this category. The judging of Scottish or national rarities continues as before and descriptions need to be submitted to the relevant committees. The first 20 occurrences of a species in our recording area are noted. Observers should be aware that aberrant individuals of common species of birds appear quite regularly and these sometimes resemble

rarities. There is also the problem of escaped birds and of hybridisation, a particular problem in captive wildfowl which may escape and appear in natural situations.

The British Ornithologists' Union (BOU) has appealed for introduced/escaped species to be recorded locally. As the published information on these species is not necessarily complete, self-sustaining populations of such species may exist which are not known about or adequately recorded. The BOU therefore encourages observers to record and monitor all naturalised species (particularly but not exclusively breeding records and interactions with native species) and escaped species seen in the wild to assist it to make future recommendations for category C status, if a self-sustaining naturalised population is established.

The following abbreviations have been used in the report: Ad(s). - adult(s), AoT - apparently occupied territory, b/lkm - birds per linear kilometre, Br. - bridge, BoA - Bridge of Allan, c/n - clutch of n eggs, conf. - confluence, BBS - Breeding Bird Survey, CP - Country Park, E - east, Est. - estuary, Fm. - farm, F - Female, G. - Glen, GP - gravel pit, Imm. - immature, incl. - including, Juv - juvenile, L. - Loch, N - north, NR - Nature Reserve, nr. - near, M - Male, Max. - maximum, ON - on nest; pr. - pair; Res - Reservoir, R. - river, Rd. - road, S - south, SP - summer plumage, W - west, WeBS - Wetland Bird Survey, Y - young, > - flying/flew.

The area covered by the report comprises the council areas of Falkirk and Clackmannan together with Stirling, excluding Loch Lomondside and other parts of the Clyde drainage basin. Please note that we do not include the Endrick water, i.e. Fintry and Balfron.

CONTRIBUTORS

This report has been compiled from records submitted by the contributors listed below. Where initials are given, the contributors are listed in the species entries.

D. Anderson (DA), M. Anderson (MA), M. Andrews, P. Ashworth (PMA), S. Ashworth, A. Ayre, E. Barclay, B. Barker, Bean Goose Action Group (BGAG), D. Beaumont (DB), L. Bowser, M. Bell (MVB), N. Bielby (NB), Bird News Services, A. Blair (AB), A. and L. Brown, R.A. Broad (RAB), R. Bullman, J. Calladine (JRC), D. Cameron (DJC), G. Cannon, I. Carmichael, A. Carrington-Cotton (ACC), P. Carter, D. Chamberlain, Central Scotland Black Grouse and Capercaillie Group (CSBGCG), Central Scotland Raptor Study Group (CSRSG), R. Chapman, D. and A. Christie (DAC), Frank Clark (FCC), N. Clark , K. Conlin, S. Cooper, F. Clark, S. Coulter, R. Cowen, T. Craig, R Dalziel (RDZ), Ben Darvill (BD), R. and H. Dawson (RHD), A. Derks, R. Downie, D. Egerton (DE), K. Egerton, Alan Everingham (AE), T. Findlay (TF), S. Forbes, Forthbirding Web site, G. Fraser (GF), K. Freeman, J. Fulton (JF), J. Gallacher, M. Given, T. Goater, R. Gooch (RLG), A. Gowans (AG), J. Grainger, S. Green (SRG), R. Griffiths, A. Hannah, I. Henderson, D Holland, J. Holland (JPH), C. Hemple,

C. Henty (CJH), J. Holland, Liz Humphries (EMH), L. Ingram (LI), Andy Jensen (AJ), D. Jones (DJ), D. Kerr, E. Keenan, I. Keenan, J. Kaye, R. Knight, M. Kobs, A. Lauder, D. Lang, P. Lee, G. and E. Leisk (GEL), P. Lubbers (PAL), I. Madden, C. Mallett (CJM), D. Matthews, R. Mcbeath, M. McCartney, M. McDonnell, M. McGinty (MMcG), B. McGowan, K. Macgregor, A. McIver (AMC), R. McKenzie, M. Maclean (MML), P. McSorley (PMS), A. Masterman, P. May (PM), J. Mercer, S. Milligan, C. Moore, B. Murphy (BM), F. Murray (FAM), M. Mylne, J. Nimmo, L. Nisbett, M. O'Brien, C. Oldham, D. Orr-Ewing (DOE), B. Osborn, G. Owens (GO), J. and E. Payne, C.J. Pendlebury (CJP), D. Pickett, K. Pilkington, S. Rae (SR), D. Redwood, C. Renwick (CR), S. Renwick (SRE), G. Richards (GR), R. Ridley (RR), E. Rimmer, M. Roberts, G. Robertson, D. Robertson, A.C. Rogers (ACR), N. Rossiter (NR), David Rugg (DR), A. Samson, the late P. Sandeman (PWS), M. Scott, S. and R. Sexton, R. Shand (RS), J. Shanks, A. Simpkins (AS), G. Skipper, K. Smith (KS), A. Smith, E. Smy, C. Spray, H. Simpson, M. Stephen, P. Sutton, Stirling District Ranger Service, Rob Swift (RSW), D. Taylor, A. Thiel (AET), M. Thoroe (MT), D. Thorogood (DT), J. Towill (JT), M. Trubridge, N. Trout, A.E. Watterson, A.E. Whittington, A. Wallace (AW), C. Waddell, M. Ward (MWD), C. Wernham, M. White, N.D. White, K. Wilkinson, J. Willett (JW), M. Williamson, P. Wills, K. Wilson, R. Wilson (RW), L. Winskill, A. Woods, M. Wotherspoon (MWO).

Thanks are also due to Keith Hoey and Nick Franklin for the kind permission to use their photos of the Spoonbill and Barrow's Goldeneye, respectively, and to D. Orr-Ewing for RSPB data on Red Kites and Ospreys.

BREEDING BIRD SURVEY (BBS)

The Breeding Bird Survey is a UK survey organised by the BTO (British Trust for Ornithology) to provide yearly population trends for a range of common and widespread bird species in the UK. The local organiser is Neil Bielby who makes a detailed report for contributors which is also the basis for this brief summary. Each survey plot is a 1-km square of the National Grid visited twice during a breeding season with the observer walking the same two 1 km transects on both visits. The squares were originally selected at random and the aim is to survey the same squares each year.

Thirty eight out of the 45 squares allocated to our area were surveyed in 2006, six more than the previous best. The area covered by the BTO's 'Central Region' corresponds roughly to that of the Upper Forth Bird Reporting Area within the old Central Region, plus an area of Perth and Kinross stretching as far as Glen Devon to the east and Glen Artney to the north.

For general analysis the squares can be allocated to four broad habitat groups: Mountain and Moorland, Conifer Woodland (plus moorland edge), Farmland and Urban/Suburban. Inevitably the squares not covered have tended to be the more remote ones and in addition the initial randomisation did not give perfect weight to habitat importance Thus, compared with land use statistics from the old Central Region, Mountain and Moorland is under-represented by 18 % whilst Farmland is over-represented by 19 %. In addition,

these relative proportions have varied over the years as has the number of BBS squares. This can give rise to large changes as a result of changes in habitat representation rather than bird numbers. This should be borne in mind when interpreting the data. Data from 1994-1996 are excluded from the long-term mean due to the small sample size of squares surveyed. The mean therefore refers to the period 1997 to 2006 (inclusive). Absolute numbers for several species are small, which should be borne in mind when interpreting the data.

One hundred and two species were recorded in 2006, a new high and five more than in 2005. Dunlin and Ring Ouzel were recorded for the first time, making a total of 119 species that have been recorded during the 12 years the survey has taken place. BBS data are mentioned in the individual species sections of this report. On a national scale BBS a most reliable method for detecting changes in the abundance of species, except for seabirds, scarce and rare species, etc. Birds which are scarce though widely distributed locally, e.g. woodpeckers, Spotted Flycatcher or Bullfinch, are only recorded in small numbers on BBS transects and annual variations therefore need to be interpreted with great care. Amongst the passerines the most frequent were Starling, Chaffinch and Meadow Pipit. Stonechat, Whitethroat, Goldfinch, Tree Sparrow, Yellowhammer and Reed Bunting were all in good numbers whilst Whinchat recovered strongly from a low level last year.

WETLAND BIRD SURVEY (WeBS)

WeBS is a monthly waterfowl census organised under the auspices of the BTO. The core months are September to March inclusive. For this survey 'waterfowl' includes divers, grebes, cormorants, herons, swans, geese (excluding Pink-footed and Greylag for which WWT (Wildfowl and Wetlands Trust) organises separate counts), ducks, sawbills, rails and coots. Wader, gull and Kingfisher numbers are also collected; locally, we also record raptors, Dipper, and Grey Wagtail.

For the 2006 Bird Report the more important individual records are mentioned in the individual species sections but a detailed summary of the whole survey is not possible since the WeBS system is centred on the autumn, winter and early spring period, not a calendar year, and also the FNH deadlines have become more stringent so that a complete breakdown of the coverage and results for 2006 is not available. Suffice it to say that about one hundred lochs and reservoirs are covered regularly together with the Forth estuary and large sections of the Union and the Forth and Clyde Canals, and of the rivers Teith, Forth, Allan Water, Devon, and Carron. It is anticipated that a fuller account of WeBS 2006/2007 will be published in the report for next year. Details of individual species can be found in the systematic list below.

RINGING REPORT

This is the third full ringing report. The following section lists all ringed birds seen in the recording area during the year. Contributors are encouraged to report colour-ringed wildfowl to the relevant organisers and/or the BTO and

not to assume that somebody else has already done so, as all movements are of interest to the ringers and add to our understanding of bird ecology and migration patterns. Thanks are due to Allan and Lyndesay Brown, Christie Hemple and Bob Swann for making available data on movements of birds seen in the recording area.

A total of 29 recoveries (excluding multiple sightings of the same bird) were made in 2006. Most are, not surprisingly, of Mute Swans (15) and Greylag Geese (7). Others related to Pink-footed Geese (4), Shelduck (2) and an interesting record of a Marsh Harrier.

Allan and Lyndesay Brown, who are ringing Mute Swans in Fife and the Lothians, are particularly keen to learn if any of the birds ringed by them (green or white Darvic rings) breed outside their study area.

Recoveries are listed in Voous order, as for the systematic list, under the headings shown below. Where an asterisk appears behind a ring number, further details of sightings are given in the 2004 and 2005 ringing reports.

Ring number	Date ringed	Location ringed	Date seen	Location in recording area (codes as in main list)	Recorder

followed by the location(s) where the bird was seen in between

•PINK-FOOTED GOOSE

Grey neck PKV	20 Nov 2005	Loch of Lintrathen (Angus)	22 Dec 2006	Carse of Lecropt (S)	NB

No sightings in between.

Grey neck PVI	20 Nov 2005	Loch of Lintrathen (Angus)	22 Dec 2006	Carse of Lecropt (S)	NB

No sightings in between.

Grey neck TAL	22 Oct 2006	Loch of Lintrathen (Angus)	4 Nov 2006	Tulligarth (C)	AET

No sightings in between.

Grey neck TSZ	22 Oct 2006	Loch of Lintrathen (Angus)	4 Nov 2006	Tulligarth (C)	AET

Carsebreck (Perth and Kinross) 27 Oct 2006.

•GREYLAG GOOSE

Grey neck BZV*	28 Jul 1997	Masvatn, S-Ping ICELAND	20 Jan 2006 25 Feb 2006 11 Mar 2006	West Gogar East Gogar East Gogar (S)	AET

Having spent most winter visits between 1998 and 2003 in Fife, this bird was first recorded in Clackmannanshire in Feb 2004. It has since been recorded repeatedly in Clackmannanshire with the occasional foray back into Fife. It was present in various localities in Clackmannanshire in Jan and Feb 2005 and in the Gogar area, nr. Menstrie, between Jan and Mar 2006. After its return migration, it was seen at Tarrel, nr. L. Eye, Easter Ross on 31 Oct 2006.

| Grey neck DPS* | 13 Oct 1998 | Loch Eye (Easter Ross) | 11 Mar 2006 | East Gogar (S) | AET |

Between 1998 and 2001, this bird was seen in various localities in northern Scotland and Tayside. In Nov 2004 it appeared in Orkney before stopping over at Cambus in Jan 2005. It returned to the same area in 2006.

| Grey neck HCA* | 24 Feb 2000 | Loch Eye (Easter Ross) | 20 Jan 2006 25 Feb 2006 7 Mar 2006 24 Mar 2006 | West Gogar East Gogar East Gogar East Gogar (S) | AET |

Following sightings nr. Montrose (Angus) and in Iceland in 2001, this bird was seen at Drymen, Stirlingshire, in Jan 2003. It has since been a regular visitor to Clackmannanshire, notably Sheardale nr. Dollar (Mar 2003, Feb 2004) and the area between Alva and Tillicoultry (Oct 2004 to Jan 2005), before relocating to the Cambus-Gogar area in Jan and Mar 2005. It returned to the Gogar area between Jan and Mar 2006.

| Grey neck HDA | 24 Oct 2000 | Loch Eye (Easter Ross) | 25 Feb 2006 4 Mar 2006 11 Mar 2006 | East Gogar East Gogar East Gogar (S) | AET |

This bird spent the early part of winter 2000/01 in the area around L. Eye in Easter Ross. From mid-Dec 2000 to Apr 2001 it was in the area around Elgin in nearby Moray. It returned to this area in Jan 2002 before relocating to Skene, west of Aberdeen, in Mar and Apr 2002. After another sighting in the Elgin area (Moray) in Nov 2002, it was seen at Annfield Farm, Giffordtown, Rossie Bog and East Kilwhiss (all Fife) in Nov 2003 and between Jan and Apr 2004. On 23 Feb 2005 it reappeared at Newton nr. Elgin and made its way to Gogar (ca. 160 km) two days later where it presumably stayed into Mar.

| Red neck BBU | 30 Oct 2004 | Loch Eye (Easter Ross) | 1 Jan 2006 | E of Coalsnaughton (C) | AET |

The day after being rung, this bird was at Clachnamuach, nr. L. Eye. It appeared in Jan 2005 near L. Leven (ca. 160 km). It was seen at Cluny Marsh, nr. Newtonmore (Badenoch) in early Dec 2005 before relocating to Clackmannanshire by the new year.

| Red neck BKL | 13 Nov 2004 | Loch Eye (Easter Ross) | 25 Feb 2006 4 Mar 2006 11 Mar 2006 | East Gogar (S) | AET |

In Nov 2005 at Kinbeachie, then Udale Bay (both Cromarty Firth) Dec 2005. After its stay in Clackmannanshire in Feb and Mar 2006, the bird was seen at Akurbrekka, Hrutafjordur, **Iceland** on 28 Oct 2006.

| Red neck BNN | 14 Nov 2004 | Loch Eye (Easter Ross) | 16 Mar 2006 | West Gogar (S) | AET |

At Carsebreck, Braco (Tayside) on 26 Jan 2006, then Gogar in Mar before being seen at Melrakkasletta, Nordur-Thingeyjar, **Iceland** on 23 Apr 2006. By 20 Nov 2006 the bird was at Pulrossie, Dornoch Firth.

•SHELDUCK

| Blue over white plastic on right leg. Black 1 on left leg | 29 Jul 2005 | Eden estuary (Fife) | 28 May 2006 | Skinflats (F) | AET |
| Blue over red plastic on right leg. Black 1 on left leg | 29 Jul 2005 | Eden estuary (Fife) | 28 May 2006 | Skinflats (F) | AET |

•MUTE SWAN

Metal Z89438	17 Aug 1997	Union Canal, Winchburgh (West Lothian)	18 Jul 2006	Cambus Village Pools (C)

5 Jul 1998 Alexandra Park, Glasgow. 25 Sep and 11 Oct L. Gelly (Fife). 8 Nov-28 Dec 1998 Craigluscar NR, nr. Dunfermline (Fife). 24 Oct, 7 Nov and 5 Dec Torry Bay. Bred with Z92188 at Cambus Village Pools and had 3 cygnets.

Metal Z92188	16 Apr 1998	Hogganfield Loch (Clyde)	18 Jul 2006	Cambus Village Pools (C)

Alexandra Park, Glasgow 15 Nov 1998. Bred with Z89438 at Cambus Village Pools and had 3 cygnets.

Green BUA	16 Aug 1997	Bara Loch, nr. Gifford (East Lothian)	17 Jan 2006 14 Feb 2006 7 Mar 2006	The Boll, Alva (C)	NB

Moved around Edinburgh ponds until 1999, then seen at Torry Bay 18 Jan 2001 and Linlithgow Loch 15 Sep 2002. At Skinflats 26 Jan 2003, then The Boll 16 Jan-7 Mar 2005.

Green HLY	3 Aug 2003	Blackford Pond, Edinburgh	17 Jan 2005 14 Feb 2005	The Boll, Alva (C)	NB

Remained at Blackford Pond until Mar 2004, then moulted at Musselburgh. Present at Crammond 4 Sep, Torry Bay Nov, Alva Dec and back to Cramond Dec 2004. After a stay at Boll Farm 14 Feb-16 Mar 2005, returned to Cramond on 16 Mar 2005.

Green HPI	30 Aug 2003	North Esk Res., Carlops (Borders)	16 Jan 2006 7 Mar 2006	The Boll, Alva (C)	ALB AET

Abandoned by parents and taken into care. Ringed and released at Linlithgow Loch 20 Dec 2003, where it remained until 1 Aug 2004. Gartmorn Dam 22 Aug 2004, Torry Bay (Fife) 23 Nov 2004, The Boll 27 and 29 Dec 2004. St. Margaret's Loch, Edinburgh 5 May 2005, Musselburgh 13 and 17 Jun 2005. Rutherford, E. Maxton (Borders) 14 Oct 2005.

Green IFT	21 Aug 2004	Stenton Pond, Glenrothes (Fife)	14 Feb 2006 7 Mar 2006	The Boll, Alva (C)	NB

Last seen at Stenton Pond on 7 Feb 2005.

Green IPT	21 Aug 2004	Stenton Pond, Glenrothes (Fife)	17 Jan 2006	The Boll, Alva (C)	NB

Original ring IFN replaced by IPT at Stenton Pond on 1 Jan 2005. Last reported from there 7 Feb 2005. At The Boll 15-16 Mar 2005.

Green IPZ	23 Jan 2005	Clatto Res. Dundee (Dundee)	16 Jan 2006 14 Feb 2006 7 Mar 2006	The Boll, Alva (C)	

Broughty Ferry 1 Apr 2005. Airthrey Loch, BoA 9 Nov, 2 and 12 Dec 2005.

Green ITU	14 Sep 2003	New Mill, Lanark (South Lanarkshire)	7 Mar 2006	The Boll, Alva (C)	NB

Taken into care with leg injury at Bonnybridge 13 May 2004. Released at Linlithgow Loch 13 Jun 2004 when colour ring added. Stayed there until present sighting.

Green IXN	14 Aug 2005	Union Canal, Broxburn (West Lothian)	1 Dec 2006	Black Loch, Limerigg (F)	NB

No sightings in between.

Orange 3ASL	13 Oct 2001	Balloch, Loch Lomond (Clyde)	1 Apr 2006 5 Feb 2006	Airthrey (S)	

Gartmorn October 2002. Airthrey Jan, Feb and Mar 2003 and Mar 2004

Orange 3CDF	20 Aug 2004	Maggiscroft Fishery, Cumbernauld (Falkirk)	19 Feb 2006	Lake of Menteith (S)	NB

Gartmorn Dam 16 Oct, 28 Nov and 25 Dec 2004.

Orange 3CKU	12 Feb 2005	R. Leven (Dunbartonshire)	19 Feb 2006	Lake of Menteith (S)	NB

Airthrey Loch, BoA 12 Dec 2005.

Orange 3CLF	18 Sep 2004	Forth-Clyde Canal, Auchenstarry	15 Mar 2006	Vale of Coustry (S)	NB

Broadwood Loch, Cumbernauld 20 Aug 2005.

White 284	24 Aug 2002	Yetholm Loch (Borders)	14 Feb 2006	The Boll, Alva (C)	NB

Also at The Boll 17 Feb 2005.

•MARSH HARRIER

FP06677 (radio-tagged juvenile female)	summer 2006	Tay estuary area	7 Sep 10 and 12 Sep (C)	R. Forth, Alloa Tullibody Inch

Remained around nesting area until 27 Aug. Magus Muir (Fife) 28 Aug. Carsebreck Loch (Perthshire) 30 Aug and 6 Sep. Peppermill Dam 8 Sep. Roosted on Tullibody Inch on 12 Sep and stayed in same general area until at least 21 Sep. Auldmuir Res., nr. Dalry (Ayrshire) 23 Sep. N of Kingarth, Isle of Bute (Argyll) 24 Sep. Logan Mains, Mull of Galloway 26 Sep. Copeland Island, Northern Island 29 Sep. South of Belfast 2 Oct. Roosted at Crymlyn Burrows, east of Swansea overnight on 3/4 Oct, a journey of 333 km. N of Slapton Ley, South Devon coast 5 Oct. NW of Parehame, Devon and at Weymouth, Devon 7 Oct. Believed to have been near Poole Harbour 8 and 9 Oct where confirmed sighting 10 Oct. No further signals after that date and believed to have been illegally killed (http://www.roydennis.org/Marsh%20 Harrier%2021251.htm).

SYSTEMATIC LIST

Codes - S, F and C indicate records from Stirling, Falkirk and Clackmannanshire "Districts".

*RED-THROATED DIVER *Gavia stellata* (b, w)
F Five Kinneil 19 Mar. 1 Skinflats 17 Sep. 1 S Alloa 22 Oct. 1 Kinneil 5 Nov. 1 Dunmore 29 Dec.
S One L. Drunkie 30 Apr. 1 L. Katrine 9 May. 1 pr. Trossachs 13 Jul had no Y. 1 Kildean, Stirling 21 Oct.

*BLACK-THROATED DIVER *Gavia arctica* (b, w)
S Trossachs: pr. reared 2 fledglings at undisclosed site (DJC).

LITTLE GREBE *Tachybaptus ruficollis* (B, w)
C Site max.: 6 R. Devon, Alva-Menstrie 25 Jan; 4 Gartmorn Dam 2 Nov; 2 Cambus Pools 2 Apr.
S Breeding: 2 Prs. L. Ard Forest 2 May; 1 Pr. Strathyre 8 May; 1 Pr. with 3 Y

Sheardale Park 15 Jun. Site max.: 18 L. Dochart 4 Mar; 15 Carron Valley Res 17 Sep; 5 L. Walton, Carron Valley 7 Jan; 5 Polmaise Lagoons 21 Sep; 2 Callander 26 Nov.

GREAT CRESTED GREBE *Podiceps cristatus* (b,W)

Webs max.: 55 Forth Est. in Jan.

F Site max.: 45 Kinneil 15 Jan.

C Site max.: 7 Gartmorn Dam 23 Mar.

S Sixteen Lake of Menteith 9 Mar; 1 Pr. there 22 May; 21 on 1 Oct. 1 Pr. and 1 juv. Gartmore GP 20 Jul. 1 Pr. Gart GP, Cambusmore but nest flooded 1 Aug. 2 Vale of Coustry 25 Mar. 6 Carron Valley Res 17 Sep. 2 L. Venachar 28 Dec. 1 L. Earn 16 Oct. 1 Callander 31 Dec.

*RED-NECKED GREBE *Podiceps grisegena*

F One Kinneil 16 Sep and 19 Oct (JRC). These are the 12th and 13th records, respectively, for the recording area.

*SLAVONIAN GREBE *Podiceps auritus*

S One Carron Valley Res 19 Nov (DAC). This is the 20th record for the area since modern recording began in 1974.

*GANNET *Morus bassanus* (p)

F One juv. > Skinflats 30 Sep (AE); 7 juv. there 6 Oct (GO); 3 juvs. > W 12 Nov (BD). 1 juv. Kinneil 29 Oct (RHD).

S One juv. Polmaise 26 Dec (RHD).

CORMORANT *Phalacrocorax carbo* (S, W)

Forth Est. (WebS): 85 in Jan, 64 in Feb and Mar, 141 in Sep, 47 in Oct, 70 in Nov, 54 in Dec.

F Ninety-nine S Alloa roost 25 Nov. 66 Higgins Neuk 11 Jan. 37 Skinflats 14 Jan. 27 Kinneil 19 Mar.

C Fifty-six Alloa Inches 23 Dec.

S Ten L. Walton, Carron Valley 19 Nov; 8 Carron Valley Res 17 Sep.

*BLACK-CROWNED NIGHT HERON *Nycticorax nycticorax*

S BoA 21 May (GO). Record accepted by the SBRC. This is the 2nd record for the area. The first record was a bird shot on the Black Devon, Alloa on 23rd May 1879. Since then there have been a couple of records, all of which are thought to have originated from a free-flying colony at Edinburgh Zoo.

GREY HERON *Ardea cinerea* (B,W)

Forth Est. (WebS): 75 in Jan, 15 in Feb and Mar, 82 in Sep, 61 in Oct, 49 in Nov, 41 in Dec. BBS[1]: recorded at 0.13 b/1km, similar to annual mean (1997-2006).

F Breeding: 20 nests estimated with at least 50 discarded eggshells Dunmore Wood heronry 16 Apr (AB). Site max.: 37 Skinflats 8 Oct; 11 Higgins Neuk 11 Jan; 10 S Alloa 14 Jan.

C Site max.: 26 Kennetpans 14 Jan; 9 Cambus 20 Aug.

S Site max.: 24 Lake of Menteith 21 Jan; 14 North Third Res 18 Feb; 8 L. Lubnaig 26 Feb; 6 Carron Valley Res 7 Oct.

*SPOONBILL *Platalea leucorodia*

F One Imm. Kinneil 17 Oct to 15 Dec; also at Skinflats 5 to 9 Nov and 19 Dec; also at Kincardine Bridge 17 and 19 Dec (RHD, GO, MVB *et al.*).

C Above also at Cambus Village Pools 20 Dec (RR).

This is the 4th record for the area since modern recording began in 1974.

[1] Data from 1994-1996 are excluded from the long-term mean due to the small sample size of squares surveyed. The mean therefore refers to the period 1997 to 2006 (inclusive). Absolute numbers for several species are small, which should be borne in mind when interpreting the data.

MUTE SWAN *Cygnus olor* (B,W)
F Six Skinflats 2 Apr. 5 Carronshore 4 Jun.
C Breeding: 1 ON Cambus Village Pool late Apr and May, 3 Y in Jul; 1 Pr. Cambus Pools 23 May.
 Site max.: 57 Gartmorn Dam 18 Oct; 27 The Boll, Alva 14 Feb.
S Breeding: 3 Prs. Airthrey Loch Jun hatched 3, 4 and 7 chicks and fledged 2 cygnets. Site max.: 26 R. Forth, Stirling 21 Jan; 25 Lake of Menteith 21 Jan.
WHOOPER SWAN *Cygnus cygnus* (W)
F Winter/spring: 25 Bonnybridge 1 Mar. Autumn/winter: 6 Skinflats 8 Oct, 14 there 2 Nov; 15 Kinneil 21 Oct; 20 Torwood 17 Nov; 18 Larbert 30 Nov.
C Autumn/winter: 4 Cambus 2 Nov; 5 (3 juvs.) Tullibody Inch 18 Nov; 3 over The Rhind, Alloa 17 Dec.
S Winter/spring: 10 (2 juvs.) Carron Valley Res 7 Jan to 18 Mar; 8 (2 juvs.) L. Lubnaig 5 Jan; 12 Killin, L. Tay 6 Jan; 25 (7 juvs.) Thornhill Carse 17 Jan; 4 L. Arklet 7 Feb; 1 Pr. Craigforth 1 Apr to 7 May.
 Autumn/winter: 16 (2 juvs.) over Lecropt Carse 25 Oct; 3 over Stirling 4 Nov; 26 Thornhill Carse 22 Nov.
*BEAN GOOSE *Anser fabalis* (W)
F Slamannan plateau: 268 on 6 Jan; 290 at roost 4 Feb (max. count, 25 more than 2005); last record of 4 on 1 Mar; 7 on 10 Oct were the first autumn birds with 150 there 13 Oct. 255 there on 29 Oct had 31 juvs. (12 %) (BGAG).
PINK-FOOTED GOOSE *Anser brachyrhynchus* (W)
 Last spring record: 1 Flanders Moss 22 May. First autumn return: 34 at Skinflats 25 Sep (DOE, GO).
 Forth Est. (WeBS): 641 in Jan, 1320 in Feb, 4440 in Mar, 427 in Oct.
F Winter/spring: 1230 Skinflats 12 Feb; 4400 there 16 Mar; 150 on 2 Apr. Autumn/winter: 650 at Skinflats 16 Oct.
C Winter/spring: 2640 Kennetpans 12 Feb, 1850 there 26 Mar; 899 Gogar Mains 5 Apr. Autumn/winter: 300 Tullibody Inch 30 Sep; 920 Haugh of Blackgrange 19 Nov; 2000 Tulligarth 4 Nov.
S Winter/spring: 1565 Thornhill Carse 15 Feb; 1000 Lecropt Carse 20 Feb; 608 West Gogar 17 Mar; 1040 Little Kerse 10 Apr. Late birds: 16 Dunblane 4 May; 2 Lake of Menteith 11 May; 1 Flanders Moss 22 May. Autumn/winter: 2000 > W Flanders Moss 22 Oct; 1380 Thornhill Carse 25 Oct; 3020 Lecropt Carse 17 Dec.
*WHITE-FRONTED GOOSE *Anser albifrons* (w)
F Two birds of the Greenland race at Skinflats 16 and 18 Oct (GO).
GREYLAG GOOSE *Anser anser* (b, W)
 Forth Est. (WeBS): 13 in Jan, 100 in Mar, 93 in Sep 62 in Oct.
F Summer (probably feral): 58 Skinflats 18 Sep. Autumn/winter: 340 S Alloa 8 Oct.
C Winter/spring: 136 R. Devon, Alva 29 Jan; 315 Belhearty, Coalsnaughton 1 Jan; 2000 Cambus Pools 20 Mar. Summer (probably feral): 6 Tullibody Inch 26 Jul; 15 Cambus Pools 27 Aug. Autumn/winter: 521 Cambus-Alloa Inch 30 Sep; 178 Gartmorn Dam 18 Nov.
S Winter/spring: 200 Killin, L. Tay 23 Jan; 1270 E. Gogar 17 Feb; 200 Thornhill Carse 18 Feb; 420 Kinbuck 11 Mar. Autumn/winter: 425 Thornhill Carse 17 Dec.
CANADA GOOSE *Branta canadensis* (b W)
F Site max.: 13 Skinflats 5 Jun; 71 Dunmore 8 Oct; 55 S Alloa 8 Oct; 196 St Helen's Loch, Bonnybridge 1 Dec.
C Site max.: 15 Cambus 12 Aug; 21 Blackdevonmouth Marshes 21 Nov.
S One brood G Finglas Res 2 May. Lake of Menteith: 38 Ads. with 2 broods 11 May; 84 Ads. there 30 May but no Y; 2 goslings 5 July. Site max.: 50 Killin, L. Tay

9 Jan; 80 L. Ard 9 Jan and 23 Dec; 200 Thornhill Carse 13 Oct; 44 L. Voil 4 Dec; 117 Lake of Menteith 20 Dec; 170 L. Venachar 28 Dec.

*BARNACLE GOOSE *Branta leucopsis* (w)
F Five S Alloa 8 Oct.1 Skinflats 16 May; 37 there 25 Sep; 6 on 16 Oct (GO, MVB, AB).
C R. Forth: 2 Cambus-Tullibody Inch 30 Sep; 4 Haugh of Blackgrange 19 Nov (AET, RHD).
S Three Kinbuck 2 Apr. 1 Thornhill Carse 23 Oct. 1 Lecropt Carse 22 and 23 Dec (MVB, PAL, NB).

*BRENT GOOSE *Branta bernicla* (w)
1 dark-bellied bird Skinflats 4 to 8 May (RS, GO, AB).

SHELDUCK *Tadorna tadorna* (b, W)
Forth Est. (WeBS): 702 in Jan, 813 in Feb, 231 in Mar, 2293 in Sep; 1918 in Oct, 977 in Dec.
F Moult flock: 3140 at Kinneil and 183 at Skinflats on 26 Jul; peaking at 3445 at Kinneil and 360 at Skinflats on 11 Aug; with 1216 birds at Skinflats 17 Sep. Other site max.: 107 S Alloa 12 Feb.
C Breeding: 1 Pr. and 8 Y Tullibody Inch 26 Jul. Site max.: 122 Cambus to Alloa Inch 12 Feb; 5 R. Devon, Alva 29 Apr.

WIGEON *Anas penelope* (b, W)
Forth Est. (WeBS): 1794 in Jan, 940 in Feb, 314 in Mar, 100 in Sep; 143 in Oct, 1014 in Nov, 724 in Dec.
F Winter/spring site max.: 120 Blackness 6 Jan; 570 Kincardine Br.-Dunmore and 156 Skinflats 14 Jan. Summer: up to 7 Skinflats throughout. Autumn/winter site max.: 254 Skinflats 19 Nov; 50 Dunmore 29 Dec.
C Winter/spring site max.: 560 Cambus-Alloa 12 Feb. Summer: 3 M Tullibody Inch 4 Jun. Autumn/winter site max.: 560 Cambus-Alloa 18 Nov; 580 Alloa Inch 19 Nov; 35 R. Devon Alva 19 Nov.
S Winter/spring site max.: 210 Thornhill Carse 17 Jan; 194 Gart GP 24 Jan; 100 Killin, L. Tay Jan and Feb; 96 L. Dochart 4 Mar. Winter/spring site max.: 187 Thornhill Carse 24 Nov; 88 L. Dochart 9 Dec; 137 Killin 16 Dec.

GADWALL *Anas strepera* (s, w)
F One Pr. Skinflats 31 Mar and 25 Apr-8 May (GO, RS, AB).
C Cambus Pools: 2 Prs. 2 to 19 Apr; 1 Pr. to 23 May (AET, CJH). Cambus Village Pools: 3 Pr. 25 Apr; 1 Pr. to 11 May (MVB, NB, DAC). 1 Gartmorn Dam 14 May (PMA). 2 Craigrie Pond, Alloa 26 Sep (RLG). 1 Pr. Polmaise Lagoons 19 Oct (DAC).

TEAL *Anas crecca* (b, W)
Forth Est. (WeBS): 1366 in Jan, 1354 in Feb, 869 in Mar, 582 in Sep; 188 in Oct, 898 in Nov, 1962 in Dec.
F Winter/spring site max.: 492 Kinneil 17 Mar; 301 Skinflats 12 Feb. Summer: 13 Skinflats 1 May. Autumn/winter site max.: 100 Carronshore 18 Nov; 615 Kinneil 1 Dec.
C Winter/spring site max: 263 Cambus-Alloa Inches 14 Jan. Summer: 1 Pr. Cambus Village Pool 28 Apr; 2 M there 4 Jun; 1 Pr. Devonmouth Pool 3 May. Autumn/winter site max.: 602 Cambus-Alloa Inches 17 Dec.
S Winter/spring site max.: 83 L. Dochart 4 Mar; 36 L. Laggan, Kippen 18 Feb. Summer: 1 Pr. L. Ard 2 May. Autumn/winter site max.: 37 L. Laggan, Kippen 19 Nov; 41 L. Dochart 9 Dec; 26 Carron Valley Res. 19 Dec.

*GREEN-WINGED TEAL *Anas carolinensis*
F M Grangemouth 17 Dec (JRC). This is the 3rd record for the area since modern recording began in 1974.

MALLARD *Anas platyrhynchos* (B,W)

Forth Est. (WeBS): 317 in Jan, 318 in Feb, 69 in Mar, 199 in Sep; 175 in Oct, 234 in Nov, 404 in Dec. BBS: recorded at 0.98 b/1km, slightly higher than the annual mean.

C R. Devon, Cambus: F with 6 Y 23 May. Cambus Village Pool: F with 14 Y 21 May; F with 2 Y 18 Jul; F with 6 Y 26 Jul. Cambus Pools: F with 8 Y 23 May. F with 1 Y Tullibody Inch 26 Jul.

S Site max.:100 Airthrey Loch 2 Feb; 94 Doune Pools 19 Feb.

PINTAIL *Anas acuta* (W)

Forth Est. (WeBS): 112 in Jan, 54 in Feb, 64 in Mar, 11 in Sep; 5 in Oct, 64 in Nov, 94 in Dec.

F Majority of above at Skinflats with 98 on 14 Jan, 50 on 12 Feb, 64 on 16 Mar, 56 on 6 Nov; 1 Pr. there 28 and 30 Apr. 86 at Kinneil 30 Dec.

*GARGANEY *Anas querquedula*

F M Skinflats 27 Apr to 8 May (GO, AB, RS).

C M Cambus Village Pools 21 and 22 May (AET).

S One Callander, Callander 10 May (RAB). 1 M Gartmore GP 17 May (CJH). These are the 12th to 15th records, respectively, for the area since modern recording began in 1974.

*SHOVELER *Anas clypeata* (p)

F Skinflats: M 15 Mar; 3 (2 M, 1 F) on 2 Apr; 2 on 26 Jul; up to 3 on 29 Aug-8 Sep; 1 M on 4 Oct; up to 7 on 4-8 Nov; 1 M 19 Nov (GO, AB, MVB, ACC, RS). 2 M Little Denny Res 1 Mar (NB). 2 F Kinneil 22 and 26 Oct; 5 there 5 Nov; 2 on 15 Nov (GO, RS).

C One Cambus Village Pools 3 Jul; 2 there 30 Sep (NB, AET).

S One Carron Valley Res 19 Dec (DAC).

POCHARD *Aythya ferina* (W)

F M Skinflats 25 Jan. 5 Kinneil 17 Oct.

C Sixteen Gartmorn Dam 4 Jan.

S Thirty-eight Lake of Menteith 2 Jan. 8 L. Ard 11 Jan. 15 Carron Valley Res and 12 L. Walton, Carron Valley 18 Feb. 27 L. Walton 19 Nov. 2 Airthrey Loch 21 Dec.

*FERRUGINOUS DUCK *Aythya nyroca*

S 2005: 1 M Gart GP, Cambusmore 24 and 25 Sep (GEL). First record for area; accepted by BBRC.

TUFTED DUCK *Aythya fuligula* (B, W)

F Six (3 M, 3 F) Callendar Park Loch 14 Jan. 1 Pr. Union Canal, Falkirk 15 May. 13 (7 M, 6 F) Kinneil 23 and 24 Dec.

C Seven on R. Devon, Menstrie 6 Mar. 104 Gartmorn Dam 18 Mar; 58 there on 18 Oct.

S Summer/breeding: 2 Pr. Swanswater Fishery, Stirling 6 Jun; 1 F with 8 Y Cocksburn Res. 24 Aug; 3 Gartmore GP 20 Jul. Site max.: 28 Lake of Menteith 2 Jan; 50 Airthrey Loch 14 Mar; 28 L.Walton, Carron Valley 18 Feb; 16 L. Lubnaig 26 Feb; 6 Vale of Coustry 25 Mar; 23 Carron Valley Res 7 Oct.

*SCAUP *Aythya marina* (s, w)

F One Pr. Skinflats 6-25 Jan; 1 M there 11 Aug (AB, MVB). 1 Kinneil 10 Feb; F there 19 Mar; 2 M 26 Jul; 6 on 30 Dec (DAC, RHD, MVB). 1 M Airth Shore 5 Mar (RHD). 13 Forth Est. in Dec (WeBS).

C One Devonmouth, Cambus 9 Sep (CJH).

S M Lake of Menteith 16 Jan and 19 Feb (RW, NB). 1 F Hutchinson Loch 11 Nov (CJP). 1 M Airthrey Loch 21 Nov to year-end (BD, CJP).

*LESSER SCAUP *Aythya affinis*

2005: M Blairdrummond 23 Mar to 4 Apr (NB *et al*). Second record for area; accepted by BBRC.

EIDER *Somateria mollissima* (w, s)
F Seventeen Blackness 13 Feb. Grangemouth: 9 on 12 Feb; 15 on 16 Mar; 1 on 19 Nov. Kinneil: 2 on 28 Jan; 6 on 19 Mar; 25 on 24 Oct.
LONG-TAILED DUCK *Clangula hyemalis* (w)
F F/Imm. Skinflats Pools 11 Aug to year-end (GO *et al.*). 1 Forth/Clyde canal, Bonnybridge 17 Dec (AA).
S Pr. Lake of Menteith 21 Jan; 1 M there 19 Feb; 1 Pr. on 29 Oct (NB). 2 E Frew-Gargunnock, R. Forth 30 Oct (ACR).
*COMMON SCOTER *Melanitta nigra*
F One F Kinneil on 9 and 15 Jan, 10 Feb and 19 Mar (AB, DAC, RHD). This is the 9th record since modern recording began in 1974.
*BARROW'S GOLDENEYE *Bucephala islandica*
S One M commuting between the R. Teith and Eas Gobhain, Callander and L. Venachar 19 Nov to year-end (NB *et al.*). This much photographed bird was usually in the company of Goldeneye and was regularly seen displaying to females. This will be the first record for the Upper Forth area and third Scottish (and British) record, if accepted by the BBRC.
GOLDENEYE *Bucephala clangula* (W)
 Forth Est. (WeBS): 91 in Jan, 36 in Feb, 12 in Mar, 30 in Nov, 38 in Dec.
F Site max.: 40 Kinneil 2 Nov; 13 Skinflats 5 Dec.
C Site max.: 48 Cambus - Alloa Inches 14 Feb.
S Site max.: 31 Carron Valley Res 7 Jan; 25 L. Walton, Carron Valley 18 Feb; 137 Lake of Menteith 19 Feb; 118 Cambus weir 17 Mar; 37 Manorneuk, R. Forth 16 Dec.
*SMEW *Mergus albellus* (w)
S Redhead Br. Of Frew-E Frew, R. Forth 30 Jan and 21 Feb; Redhead there 22 Nov and 19 Dec (PAL). Redhead Gart GP 15 Mar, 30 Apr; Redhead there and 9 Dec (NB). Redhead Vale of Coustry 25 Mar (CJM, SRE).
RED-BREASTED MERGANSER *Mergus serrator* (B, W)
 Forth Est. (WeBS): 142 in Jan, 82 in Feb, 41 in Mar, 23 in Sep, 36 in Oct, 97 in Nov, 57 in Dec.
F Site max.: 20 Skinflats 14 Jan; 19 there on 19 Nov. 19 Higgins Neuk, R. Forth 24 Jan. 25 Kinneil 19 Mar. 7 S Alloa 12 Nov. 8 Dunmore 29 Dec.
C Forty-seven Kennetpans 14 Jan. 1 Cambus Pools 24 Jan. 2 Alloa Inch 12 Feb. 7 Tullibody – Alloa Inch 18 Nov.
S One M on Allan Water, BoA 17 Sep. 2 Endrick R. 25 Jan. 1 M Lecropt 25 Mar. 1 M Vale of Coustry 25 Mar. 1 M L Arklet 5 May. 1 L. Tay 16 May. 1 L. Katrine 15 Sep. 1 Airthrey Loch 17 Sep.
GOOSANDER *Mergus merganser* (B, W)
 Forth Est. (WeBS): 7 in Jan, 5 in Feb, 8 in Sep, 4 in Oct, 37 in Nov, 25 in Dec.
F Site max.: 1 Carronshore 4 Jun; 3 Forth/Clyde Canal, Camelon 18 Mar; 5 Skinflats 24 Oct; 5 Kinneil 26 Oct.
C Site max.: 5 Cambus Pools 24 Jan; 20 R. Devon, Cambus 20 Sep; 22 Tullibody Inch 17 Dec.
S Breeding: F with 9 Y on R. Teith, Callander 20 Jun; 9 juvs. L. Arklet 11 Jul. Site max.: 21 R. Forth, Stirling 12 Feb; 11 Allan Water, Dunblane 12 Sep; 22 Airthrey Loch 16 Nov; 7 Carron Valley Res 19 Nov; 9 L. Laggan 19 Dec; 8 L. Venachar 28 Dec.
RUDDY DUCK *Oxyura jamaicensis* (p)
C One Gartmorn 25 Feb (PMA).
S Four (3 M) Lake of Menteith 15 Jan; 2 there 9 Mar (RW, NB).
RED KITE *Milvus milvus* (b ,W)
 Eleven birds recorded on BBS (previous annual range: 0-4 birds).

S Breeding: 24 territories occupied; 17 Prs. laid eggs, 11 successfully fledging 26 Y (DOE). Other sightings: max. 50 at winter roost at Braes of Doune 7 Feb (DOE, DJC, DA); 20 Argaty, Braes of Doune feeding station 19 Feb (KS); 1 Sgiath an Dobhrain, Arivurichardich 7 Jul (JRC).

*MARSH HARRIER *Circus aeruginosus* (p)
F One Darnrigg Moss, Slamannan 29 Apr (TF).
C Juv. Peppermill Dam 8 Sep; roosted on Tullibody Inch 12 Sep and stayed in general area until at least 21 Sep (see Ringing Report for further details).

*HEN HARRIER *Circus cyaneus* (b, w)
F Ringtail Denny Muir 26 Dec (MWD).
C Ringtail Blackdevon wetlands 26 Nov (CJH).
S M Thornhill Carse 17 Jan (ACR). 1 M Kinbuck 18 Feb; 1 M there 9 and 17 Dec (BD, CJP). 1 M Cringate Muir 10 Sep (CJH). Ringtail Argaty, Braes of Doune 1 Oct; M there 10 Dec (DOE). 2 ringtails Flanders Moss; coming into roost at dusk 22 Oct (ACR).

SPARROWHAWK *Accipiter nisus* (B, W)
 Only 1 bird recorded on BBS (annual range: 1-6).
F Records from: Higgins Neuk; Falkirk; Polmont; Bo'ness; Kinneil; Skinflats (all year, no signs of breeding); Larbert; Denny.
C Records from: R. Devon, Dollar-Menstrie (several); Tullibody; Alva Glen; Cambus.
S Records from: Manorneuk, R. Forth; Blairlogie; Airthrey; BoA; Braes of Doune; Dunblane; Sheriffmuir; Callander; Blairdrummond; Thornhill Carse; Vale of Coustry; Crianlarich.

BUZZARD *Buteo buteo* (B,W)
 BBS: recorded at 0.35 b/1km, slightly below the annual mean.
F Breeding: 20 Prs. located; breeding success unknown (AMc).
S Breeding: 131 known territories checked in the Doune and Aberfoyle areas; 115 were occupied by Ad. Prs.; 61 Prs. fledged 101 Y., 34 Prs. failed, 20 Prs. unknown (DOE, DA). Other records: 6 Argaty, Braes of Doune 19 Feb; 5 Polmaise Lagoons 23 Mar; 7 Vale of Coustry 25 Mar; 5 Carron Valley 23 Sep; 5 Airthrey Loch 3 Oct.

GOLDEN EAGLE *Aquila chrysaetos* (b, w)
S One Pr. Coire Charmaig, G Lochay 10 Feb (PWS). 1 Portnellan, Ben More 9 Apr (GR). 1 Imm. Lochearnhead 1 May (FAM). 1 Imm. Argaty 29 Sep and 1 Oct; presumed same bird over Allan valley from BoA 4 Nov (DOE, CJM, CJH).

OSPREY *Pandion haliaetus* (B)
F One Roughcastle, Falkirk 17 Jun (LI).
S Breeding: 15 Prs. laid eggs, 13 successfully fledging 29 Y (DOE, DA, RAB). 2 Lake of Menteith 10 Apr and 29 May; 1 L. Tay between 11 Apr and 2 Jul. 1 Doune 14 Apr; 1 Blairdrummond 14 and 16 Apr. 1 Carron Valley Res between 30 Apr and 17 Sep. 1 L. Rusky 30 Apr. 1 Crianlarich 6 May. 2 Aberfoyle 16 Jun. 1 Callander 4 Sep. 1 > S Slamannan 4 Sep.

KESTREL *Falco tinnunculus* (B,W)
 Eight birds recorded on BBS (previous annual range: 3-13 birds).
F Breeding noted at Skinflats. Other records from: S Alloa; Kinneil; Stenhousemuir; Falkirk; Polmont; Bonnybridge; Denny; Slamannan.
C Records from: Cambus; Tullibody; Alva; Alva Glen; Fishcross; Gartmorn Dam.
S Breeding noted at: Stirling Castle (3 Y); Fallin; Strathyre. Other records: Lecropt; Stirling (King's Park, Polmaise Woods, Swanswater Fishery, and Roadhead Farm); Cambusbarron; Doune; Lanrick; Thornhill Carse; Carron Valley Res; Killin; Crianlarich.

*MERLIN *Falco columbarius* (b,w)
 Breeding: 6 AoT; 3 occupied by Prs.; 1 fledged 3 Y, 1 failed at egg stage, 1 unknown; 3 occupied by singles (CSRSG).
F One Higgins Neuk 11 Jan (AET)
S One Cromlix 22 Jan (CJP). 2 Sheriffmuir 5 Jul (ACC); 1 M L. Arklet 2 Oct (DJC).

PEREGRINE *Falco peregrinus* (B, W)
F One S Alloa 1 Jan. 1 Carronshore 5 Jan. 1 Higgins Neuk 24 Jan. 1 Torwood 21 Jan. 1 Kinneil 7 Sep. 1 S Alloa 17 Sep and 16 Oct. 1 Skinflats 6 Oct; 2 there 12 Nov.
C One Alloa 13 Apr. 1 Cambus Pools 20 Aug.
S Single birds at: Argaty, Braes of Doune 6 Jan, 22 and 24 Feb; Vale of Coustry 25 Mar; Fallin 17 Apr; Doune 20 Aug; Carron Valley Res 23 Sep.

RED GROUSE *Lagopus lagopus* (B, W)
 BBS: only 1 recorded, very low compared to annual mean.
S One Taobh na Coille, Strath Gartney 4 Jun (AG). 1 Cringate Muir 10 Sep (CJH).

*BLACK GROUSE *Tetrao tetrix* (B, W)
S CSBGCG counts: 11-12 Comer-Corriegrennan-L. Ard; 2 Kinlochard-Achray Forest; 4-5 Glenny-Menteith Hills-Callander; 12-13 G. Finglas-Brig O'Turk; 15 Ardchullarie-Keltie-Braes of Doune; 1 Balquhidder and G Buckie; 13-15 Campsies; 61-69 Carron Valley and Gargunnock-Touch. Two Braes of Doune 19 Feb; 4 nearby 1 May (KS, DOE). 1 L. Arklet 5 May (DAC). 2 M Bracklinn, Callander 30 Apr (DOE); 2 Sron Eadar a' Chinn, Callander 19 May (JRC). 11 (10 M) at Carron Valley lek 19 Nov (DAC). 4 Carron Valley Res 19 Dec (DAC).

GREY PARTRIDGE *Perdix perdix* (B, W)
 Five birds recorded on BBS (previous annual range: 0-8 birds).
F Skinflats: 1 Pr. Feb-May; max. 12 on 10 Sep (GO, DAC, RS, MMcG). 6 Higgins Neuk 1 Jan. 7 Powfoulis 26 Nov (AB).
C R. Devon, Alva: 1 Pr. Mar-May; max. count was coveys of 11 and 4 on 3 Oct (DAC). 2 Gartmorn 3 Jun (ACR).
S One Pr. Bolfornought, Stirling 19 May (RHD). 2 Chartershall, Stirling 14 May; 1 there 25 Jun (GF). 2 Swanswater Fishery, Stirling 6 Jun (ACC). 8 Mains of Throsk, Stirling 17 Sep (RHD). 9 Pleanmill 20 Oct (RHD). No records received for the Carse of Stirling.

*QUAIL *Coturnix coturnix*
S One calling Craigton Fm., Ashfield 14 Jun (BD).

PHEASANT *Phasianus colchicus* (B, W)
 BBS: recorded at 0.8 b/1km, slightly above the annual mean. Very large numbers released on shooting estates, otherwise widespread but in small numbers.

WATER RAIL *Rallus aquaticus* (b, w)
F One Kinneil 2 Jan (RS). 1 Callendar Park Loch, Falkirk 25 Feb (JF).
C One Cambus Pools 12 Feb and 30 Apr (RLG, PMA).

MOORHEN *Gallinula chloropus* (B,W)
F Site max.: 18 Callendar Park, Falkirk 14 Jan; 11 Millhall Res, Polmont 12 Feb; 12 Carronshore 5 May; 19 Lock 16-R Carron, Forth/Clyde Canal 19 Dec.
C Site max.: 7 Gartmorn Dam 11 Sep.
S Breeding: 2 Prs. bred Airthrey with 4 Y 8 Jun; 1 Ad. and 2 Y Polmaise Lagoons 26 Jul. Site max.: 20 Airthrey Loch 3 Nov.

COOT *Fulica atra* (B, W)
C Site max.: 80 Gartmorn 4 Jan.
S Breeding: 1 Pr. Gartmore GP 17 May; 4 broods (4, 2, 2, and 1 Y) Airthrey 8 Jun. Site max.: 95 Lake of Menteith 21 Jan; 40 Aithrey 22 Dec.

OYSTERCATCHER Haematopus ostralegus (B,W)

Numbers on BBS were slightly above the 2005 figure but at 0.80 b/lkm still 11 % below the mean (annual range: 0.41-1.64 b/lkm). Almost all the records came from farmland habitat (1.42 b/lkm). Webs estuary peaks were 163 Jan and 231 Dec.

F 72 Kinneil 19 Mar with 114 there 18 Sep; 61 Skinflats 16 Mar were the peak counts early in the year. 26 returned Skinflats 20 Jun with 71 on 26 Jul, 80 on 2 Aug and 60 on 8 Oct. 4 Haircraigs 1 Jun.

C Return inland: 1 Silverhills Pond, Kersiepow 14 Jan. 1 R. Devon, Tillicoultry 19 Feb. Several similar counts in the Cambus area in Mar and May with a peak of 35 on 21 May. 2 ads. and 2 chicks Castlebridge Business Park, Forestmill 5 Jun.

S Return inland: 15 Vale of Coustry and 4 Gart GPs 24 Jan. 1 Doune 7 Feb; 2 Auchlyne, Killin 4 Mar; 2 L. Dochart 11 Mar. Spring peaks were 82 Drip 17 Feb; 63 Ashfield 11 Mar; 80 Kepdarroch, Thornhill Carse 10 Mar; 27 L. Dochart 21 Mar; 52 W side L. Tay 23 Mar and 50 Craigforth, Stirling 1 Apr. Pr. on nest Gartmore GP 17 May. Pr. hatched 1 egg in garden of Barbush, Dunblane 3 Jul.

*AVOCET Recurvirostra avosetta

F 5 Skinflats 20 Apr (GO). This is the fourth year in a row that Avocets stopped over at this site. 5th record for the area since modern recording began in 1974.

*LITTLE RINGED PLOVER Charadrius dubius

F Ad. Skinflats 24 Apr (GO, AB). This is the 10th record for the area since modern recording began in 1974.

RINGED PLOVER Charadrius hiaticula (b,W)

WEBS estuary peaks were a very low 6 in Jan and 58 in Oct.

F Much smaller numbers than in 2005. 8 Kinneil 19 Mar. 1 Skinflats 24 Apr with 2 there 30 Jun and 1-3 birds 6-11 Sep. The peak counts in autumn were 18 R. Carronmouth, Grangemouth 17 Sep and 14 Kinneil 18 Sep.

S 9 Gartmore/Gart GPs 22 Feb.

GOLDEN PLOVER Pluvialis apricaria (B,W)

WebS estuary peaks were much lower than in the last 2 years with 54 Feb and 834 Oct.

F Another poor year. 12-15 roosting on former peat works, Darnrigg Moss 3 Jan was the only record from the winter/spring period. 5 Skinflats 28 Jul were the first back on the estuary with 20 there 22 Aug. Numbers remained low there with 135 on 17 Sep before climbing to a peak of 710 on 8 Oct, thereafter dropping to 360 on 19 Nov, 240 on 1 Dec and 100 on 9 Dec. Numbers were similarly low at Kincardine Br. with 50 there 1 Oct and Kinneil with 260 on 1 Dec.

S 34 Blairdrummond Carse 26 Apr. 1 Taobh na Coille, Strath Gartney 4 Jun. 1 Flanders Moss 12 Nov.

GREY PLOVER Pluvialis squatarola (W)

Another poor year.

F 22 Kincardine Br. 12 Feb. 8 Skinflats 25 Feb.

LAPWING Vanellus vanellus (B,W)

At 1.12 b/lkm numbers on BBS were 58 % higher than in 2005 and 33 % above the mean (annual range: 0.23-1.72 b/lkm). Most of the records came from farmland habitat (1.91 b/lkm) and unlike in 2005 some were recorded on mountain and moorland (0.35 b/lkm). WebS estuary peaks were 866 in Jan and 2925 Sep.

F 430 Skinflats 12 Feb was the largest flock from early in the year with none reported from Kinneil. 68 included a downy chick Skinflats 20 Jun. Numbers gradually rose to peaks of 869 on 17 Sep, 966 on 8 Oct and 1020 on 1 Dec. The largest flock of the autumn/winter period at Kinneil was 1053 on 18 Sep, after

which numbers dropped to 678 on 17 Oct and 540 on 1 Dec. 100 on 1 Oct was the only flock reported from Kincardine Bridge.

C The largest flock from early in the year was 250 Alloa 1 Mar. 3 ads. and 1 chick Cambus Pools 21 May. Ad. and 3 chicks Balhearty Fm., Sheardale 11 May. 20 Grassmainston, Gartmorn 28 May included 2 prs. with 4 chicks each. 18 R. Devon, Alva/Menstrie 26 Jun included 2Y. 63 Tullibody Inch 4 Jun rose to 358 on 26 Jul and 800$^+$ on 21 Sep. 100 Blackgrange, Cambus 17 Sep. 200 Alloa 25 Sep.

S 150 Airthrey 1 Mar. F on nest Gartmore GP 17 May. 12 returned Auchlyne, Killin 3 Mar; 50 Kilbryde, Braes of Doune 7 Mar and 10 Glen Dochart 11 Mar. 130 Flanders Moss 12 Nov.

KNOT *Calidris canutus* (W)
WeBS estuary peaks were 2854 in Feb and 910 in Dec.

F Smaller numbers than last year. The peaks of the winter/spring period were 2750 Kincardine Bridge 12 Feb and 1260 Kinneil 16 Mar. 31 there on 26 Jul rose to a peak of 560 on 1 Dec. Elsewhere 1 Skinflats 26 Apr with 1-2 birds in Jun, 21 on 17 Sep and 90 on 19 Nov.

*SANDERLING *Calidris alba*
F 1 Skinflats 6 and 7 Sep (GO).

*LITTLE STINT *Calidris minuta*
F 1 Skinflats 21 Sep with 2 there 23 Sep (GO) and 1 on 7 Oct (RS).

CURLEW SANDPIPER *Calidris ferruginea* (p)
As in 2005, there was a constant trickle of birds migrating through the Skinflats/Kinneil area on autumn passage. 4 on WeBS estuary Sep.

F 4 Skinflats 5 Sep with 7 there 6 Sep, 14 on 7 Sep, 8 on 8 Sep and 1 on 15 Sep. 3 birds on 17 and 22 Sep and 8 Oct. Singles Kinneil 15 and 18 Sep (GO, RS, AET, MVB, AJ, CJP).

Autumn passage, area summary (minimum number/half month)			
Sep		Oct	
15	4	3	0

DUNLIN *Calidris alpina* (b?,W)
WeBS estuary peaks were 5506 Feb and 5058 Dec.

F 3270 Skinflats 14 Jan with 2610 there 12 Feb and 2760 on 16 Mar. The only count at Kinneil during the winter/spring period was a very low 180 on 29 Jan. 56 Skinflats 21 May; 380 on 17 Sep, 1790 on 19 Nov and peaked at 2720 on 17 Dec. Very low numbers were at Kinneil, with 100 on 5 Nov and 340 on 1 Dec.

S 1 Taobh na Coille, Strath Gartney 13 May. 1 W side L. Tay 16 May with 20 there 2 Jun.

RUFF *Philomachus pugnax* (p)
F One to two immature birds overwintered at Skinflats where they were seen 14 Jan, 28 Feb, 9, 16 and 31 Mar (GO, MVB, AB). Autumn passage did not start until Sep when a single was present at Skinflats between 1st and 15th. It then increased to a good showing of 14 on 17th when a single was also at Kincardine Bridge, then dropped to 8 on 22nd, 6 on 23rd, 5 on 22nd, 6 on 23rd and 25th with 1 on 5th and 6th Oct, 2 on 7th Oct. Overwintering birds were seen on 12th Nov and 30th Dec (GO, AB, RS, AET, DOE, AJ).

Autumn passage, area summary (minimum number/half month)							
Aug		Sep		Oct		Nov	
0	0	1	14	2	1	1	0

JACK SNIPE Lymnocryptes minimus (w)
F 3 Kinneil 2 Jan with 1 there 9 Jan. 3 Skinflats 11 Feb with 7 there 25 Feb (RS, GO).
 In the autumn/winter period 1 Skinflats 6 Oct, 2 there 12 Nov and 1 on
 saltmarsh there 1 Dec. 2 Braeface Pond, Banknock 1 Nov. 1 St. Helen's Loch,
 Bonnybridge 1 Dec (GO, CJP, RS, MVB, NB).
S 1 L. Rusky 21 Jan. 2 Netherton Marsh, BoA 18 Feb. 1 R. Forth, Teith confl.-Allan
 Water confl. 18 Feb with 3 there 15 Oct and 19 Dec. 2 Curling Pond, Cromlix
 (NB, DT, MA).
SNIPE *Gallinago gallinago* (B,W)
 Estuary WeBS: 1 in Jan, 16 in Sep and 1 in Nov.
 Only 10 birds were recorded on BBS transects (annual range: 3-17 birds).
F 40 Braeface Pond, Banknock 1 Nov.
C 1 W Gogar, Menstrie 16 Mar. 10⁺ Castlebridge Business Park, Forestmill 2 Nov
 with 5 there 1 Dec.
S 30 Netherton Marsh, BoA 15 Jan. Single W side L. Tay 11 Apr, 6 May and 1 Jun.
 1 drumming Drumloist, Braes of Doune 12 May. 1 chipping Arie Dam,
 Callander 3 Jun. 5 L. Venachar 28 Dec.
WOODCOCK *Scolopax rusticola* (B,W)
 Grossly under-recorded during the breeding season.
F 1 Dunmore Wood 7 Jan (MVB).
S 2 Ardeonaig, L. Tay 10 Jan. 1 L. Ard Forest 2 Feb. 2 R. Forth, Br. of Frew-East
 Frew 21 Feb. Singles R. Forth, A91-Fallin 11 Mar; Polmaise Wood, Stirling 18 Mar
 and 26 Dec; Cromlix 19 Mar. Singles W side L. Tay 19 Apr, 8 May and 1 Jun; Lake
 of Menteith and R. Forth, Br. of Frew-E. Frew 22 Nov and L. Laggan, Kippen 19
 Dec (PWS, DJC, PAL, DJ, CR, NB, RHD, JPH, PAL, DAC).
BLACK-TAILED GODWIT *Limosa limosa* (W)
 WeBS estuary peaks in each winter were 334 Jan and 345 Sep.
F Present throughout the year in the Grangemouth area. Monthly peaks at
 Kinneil: 156 Jan (9th), 109 Mar (17th), 6 Apr (6th), 26 May (4th), 219 Jul (26th),
 248 Aug (11th), 328 Sep (18th), 160 Oct (17th), 56 Nov (18th), 20 Dec (9th). Much
 smaller numbers at Skinflats. Monthly peaks there: 37 Jan (27th), 120 Feb (28th),
 100 Mar (15th), 366 Apr (26th), 42 May (1st), 5 Jun (8th and 29th), 188 Jul (23rd),
 4 Aug (22nd), 23 Sep (15th), 18 Oct (6th), 49 Nov (19th) and 92 Dec (1st).
 Elsewhere 1 S Alloa 1 Jan, 5 there 2 Feb, 1 on 16 Oct and 2 on 12 Nov. Single
 Higgins Neuk 11 Jan and R. Forth, Bandeath 26 Jul.
C Small numbers continue to be found upstream of Kincardine Bridge, especially
 in spring. 25 Kennetpans 14 Jan. 31 Cambus Village Pools 26 Apr with 6 there 3
 May, 5 on 22 May, 17 on 25 May, 7 on 4 Jun and 2 on 28 Jul. 12 Cambus Pools 11
 May with 5 there 22 May. 53 Tullibody Inch 17 Dec.
BAR-TAILED GODWIT *Limosa lapponica* (W)
 WeBS estuary peaks in each winter were higher than in 2005: 205 Feb and 144 Dec.
F Numbers were again erratic at Kinneil, generally low with some isolated and
 much larger peaks: 75 on 29 Jan, 40 on 19 Mar, 200⁺ on 24 Oct, 40 on 5 Nov and
 178 on 1 Dec. As usual very few at Skinflats: singles on 30 Jun and 26 Jul, 10 on
 17 Sep and 1 on 19 Nov.
C 31 Kennetpans 14 Jan.
WHIMBREL *Numenius phaeopus* (p)
F Spring: 9 The Rhind, Alloa 30 Apr. 3 Fallin 7 May with 8 there 13 May; 1 >S over
 Little Drive, Bo'ness 28 May (AET, RHD, RS). Autumn: singles >W Skinflats 30
 Jun, 3 >W 13 Jul, single 20 Jul with 3 there 19 Aug, 2 on 7 Sep and 1 on 11 Sep
 (AB, GO, CJH, AET). Single Kinneil 23 Jul with 2 there 16 Aug and singles 15 Sep
 and 24 Oct (RS, RDZ, ACR). 1 Higgins Neuk 8 Oct (MVB).

Autumn passage, area summary (minimum number/half month)									
Jun		Jul		Aug		Sep		Oct	
0	1	3	2	0	5	3	0	1	1

CURLEW *Numenius arquata* (B,W)

At 0.96 b/lkm BBS numbers were at their highest level since recording began locally (annual range: 0.42-0.98 b/lkm). This was 85 % higher than in 2005 and 25 % higher than the long-term mean but numbers tend to fluctuate annually with no clear pattern. They occurred primarily on mountain and moorland habitat (1.28 b/lkm), followed by farmland (0.91 b/lkm) and conifer/moorland edge (0.71 b/lkm). WeBS estuary peaks were 828 Jan and 963 Sep.

F　362 Skinflats 4 Jan with 424 there 12 Feb and 334 on 16 Mar. 20 returned 25 Jun building up to 382 on 8 Oct, 100 on 4 Nov and 487 on 17 Dec. Low numbers at Kinneil during the winter/spring period with 40 on 29 Jan and 30 on 19 Mar. 486 had returned by 26 Jul with 541 on 11 Aug, 471 on 18 Sep, 300 on 5 Nov and 10 by 9 Dec. Elsewhere 220 Blackness 6 Jan. 50 Kincardine Br. 1 Oct.

C　111 The Rhind 14 Jan. Flocks of 203 Cambus area 7 Mar with 217 there 11 Mar, 121 on 23 Oct, 100 there 25 Nov and 150 on 16 Dec. 197 Kennetpans with 194 there 16 Mar and 134 on 17 Sep.

S　Spring return in Mar: 3 Auchlyne, Killin and 14 Thornhill Carse 10th; 22 Drip Carse 22nd; 29 W side L. Tay 23rd and 30 Lecropt 25th. Snow led to influxes of 200 at Manor Powis, Menstrie and 250 West Gogar, Menstrie 16 Mar with 100 still Manor Powis 13 Apr. 300 Bolfornought, Forthbank 23 Mar. 112 Hollow Burn, Fallin 5 Apr. During breeding season reported from Drumloist, Braes of Doune and Braeleny. 260 Cambus Pools 17 Dec.

*SPOTTED REDSHANK *Tringa erythropus* (p)

F　Summer-plumaged bird Skinflats 2 and 3 May (RS, GO).

REDSHANK *Tringa totanus* (B,W)

Recorded in very low numbers (4) on BBS (annual range: 0-4 birds). WeBS estuary peaks were 2493 Jan and 2693 Dec.

F　1118 Kinneil 17 Mar with 475 on 26 Jul, 923 on 11 Aug, 800 on lagoon 7 Sep and 1713 on 18 Sep. 1068 Skinflats 14 Jan with 907 there 12 Feb, 771 on 16 Mar, 750 on 17 Sep, 798 on 8 Oct, 1253 on 19 Nov and 692 on 17 Dec. Elsewhere 30 Kincardine Br. 1 Oct.

C　107 R. Forth, Cambus to Alloa with 69 there 12 Feb, 50$^+$ on 18 Nov and 80 on 17 Dec. 17 Cambus Pools 28 Apr with 1 singing at nearby Blackgrange 30 Apr.

S　1 W side L. Tay 26 Mar was the first back. 7 Allan Water, Cambushinnie-Ashfield 20 Mar. 2 Wood Lane, Blairdrummond Carse 26 Apr with 2 there 22 May. 1 Lecropt 15 May. 1 Bolfornought, Forthbank 20 May.

*GREENSHANK *Tringa nebularia* (p)

WeBS estuary counts: 2 in Jan, 1 in Feb, 4 in Sep, 2 in Nov and 2 in Dec.

F　Skinflats: 1-2 birds during period 6 to 26 Jan, 11, 12 and 25 Feb and 9 Mar. A single on 31 Mar and 2 birds on 18 Apr may have been passage rather than wintering birds (AB, GO, MVB, DAC, CJP, RS). Autumn return started with 1-2 birds 25, 29 and 30 Jun, 19, 21 and 28 Jul. 2 birds on 3, 11 and 13 Aug were followed by 3 on 22 Aug (ACC, GO, AB, AET, GO). Up to 3 birds were seen during period 4 to 23 Sep (MVB, GO, MMcG, AET, RS). Up to 3 birds overwintered in the Skinflats/Kinneil area: 1-2 were seen 12, 15, 19 and 26 Nov with 1-3 birds during period 1 to 30 Dec (CJP, MVB, GO, AB, ACC, DAC). Kinneil: autumn passage started with singles on 26 Jul and 12 Aug with an excellent 10 on 15 Sep (RS) and 2 on 18 Sep (MVB, DAC, CJP, RS). Elsewhere 1 Dunmore 17 Sep (RHD)

C 1 R. Devon, Cambus 20 Aug and 3 Sep. 1 R. Forth, Cambus 20 Aug (different bird) (AET).

S 1 L. Dochart 21 Apr. 1 W side L. Tay 27 Apr (JPH).

Autumn passage, area summary (minimum number/half month)							
Jun		Jul		Aug		Sep	
0	2	0	3	3	8	13	2

GREEN SANDPIPER *Tringa ochropus* (p)

This species now occurs as a wintering bird and a passage migrant.

F Overwintering birds were at Larbert House Loch 14 Jan and Kinneil 27 Jan (MA, GO). In autumn singles were seen at Kinneil on 22 Aug, 5, 6, 7, 15 and 18 Sep and at R. Carron, M876-Larbert 19 Sep (AB, GO, RS, AET, AB). Overwintering birds during the autumn/winter period were at Kinneil 17 Oct, in a flooded pool along the Carronshore to Skinflats path 18 Nov and on R. Carron 17 Dec (MA, RHD, AB).

S 1 Allan Water, Kinbuck 19 Mar (AW).

COMMON SANDPIPER *Tringa hypoleucos* (B)

Recorded in low numbers (8) on local BBS squares, at exactly the annual mean value range: 7-11 birds).

F Spring passage: singles R. Carron, Carronshore 23 Apr and Skinflats 1 May. Autumn passage: 1-2 birds Skinflats 30 Jun, 6 and 19-26 Jul with 4 birds there 23 Jul and 1 on 19 Aug. At Kinneil: 2 birds on 23 Jul with 1 there 26 Jul. A very late bird there 5 Nov. Elsewhere 4 birds R. Carron, Carronshore 9 Jul (AB).

C Spring passage: 2 R. Devon, Cambus 21 May. Autumn passage: 9 Tullibody Inch 26 Jul and 1 Gartmorn 3 Aug.

S Spring arrival in April: 1 L. Dochart 21st was the first back, followed by 1 W side L. Tay 23rd, 2 Allan Water, Dunblane 24th, 1 Bows, Braes of Doune 29th and 2 Tigh Mor, Trossachs 30th. During the breeding season reported from: Crianlarich, Gartmore GP, Keltie Water and Braeleny, R. Dochart and L. Katrine. 8 Gart GPs 9 Jul. Singles R. Forth on Teith-Allan confl. stretch 17 Sep and on Br. Frew-E. Frew stretch 19 Sep.

Autumn passage, area summary (minimum number/half month)					
Jul		Aug		Sep	
0	1	3	15	1	1

*TURNSTONE *Arenaria interpres* (W)

WeBS estuary counts: 12 in Feb, 15 in Mar.

F 4 Carronmouth, Grangemouth 14 Jan with 12 there 12 Feb. 10 Bo'ness 17 Mar. Singles Kinneil 17 Mar and 1 Dec (MVB).

*ARCTIC SKUA *Stercorarius parasiticus* (p)

F Only 1 record: 2 >W Skinflats 6 Oct (GO).

*LITTLE GULL *Larus minutus*

F Two (1st summer) Skinflats 29 Jun; 1 there 30 Jun to 1 Jul; moulting ad. 13 Jul (GO, AET, RS). 2 Carriden 2 Oct.

*MEDITERRANEAN GULL *Larus melanocephalus*

The recent increase in the number of sightings parallels similar trends in neighbouring areas (e.g. Lothians). The sightings below represent the 5th to 11th records; some may refer to the same birds.

F One Kinneil 14 Jan; a 1st winter bird there 4 Apr; ad. 17 Nov and 17 Dec. Ad. Skinflats 19 Jul; a 2nd winter bird there 4 Nov; 2 (ad. and 2nd winter) 12 Nov (JRC, CJP, SRG, AET).

BLACK-HEADED GULL *Larus ridibundus* (B,W)
 Forth Est. (WeBS): 1313 in Jan, 595 in Feb, 250 in Mar, 1192 in Sep, 401 in Oct, 539 in Nov, 968 in Dec. BBS: recorded at 0.92 b/1km, below the annual mean.
F Three thousand one hundred estimated flying to roost over Kincardine Br. 1 Dec. 790 Skinflats 4 Nov.
C Seven hundred Gartmorn Dam 26 Jan. 554 Cambus Pools 11 Mar. 600 Alloa Inches 18 Dec. 2500 Menstrie 4 Dec.
S Breeding: 6 ON Gart GP, Cambusmore 20 May; 1 ON Gartmore GP 17 May. Other records: 200 Airthrey Loch 20 Feb; 1500 Kings Knott, Stirling 11 Dec. 1082 Carse of Cambus, Doune 17 Dec.
*RING-BILLED GULL *Larus delawarensis*
F Ad. Kinneil intermittently 26 Sep to 23 Dec (RS, GO) may have been the returning bird from 2005. This is the 2nd record for the area since modern recording began in 1974 and has been accepted by SBRC.
COMMON GULL *Larus canus* (B,W)
 Forth Est. (WeBS): 181 in Jan, 54 in Feb, 79 in Mar, 142 in Oct, 211 in Dec. BBS: recorded at 0.82 b/1km, below the annual mean.
C One hundred and fifty Cambus Pools 24 Jan.
S Breeding: 6 ON Gart GP, Cambusmore 20 May; 1 ON Gartmore GP 17 May. Other records: 688 L. Watson, Doune 19 Mar; 457 Thornhill Carse 24 Nov; 100 Airthrey Loch 1 Dec; 2500 Drip Carse 15 Dec.
LESSER BLACK-BACKED GULL *Larus fuscus* (b,S)
F Colony on industrial rooftops alongside the Carron at Grangemouth: at least 40 chicks visible 29 Jun. 200 Skinflats 22 Jul and 19 Aug.
C Seven Ad. Blackdevon Wetlands 21 Nov.
S Eighty-three Blairdrummond Carse 22 May.
HERRING GULL *Larus argentatus* (b,W)
 Forth Est. (WeBS): 89 in Jan, 419 in Feb, 20 in Mar, 215 in Sep, 400 in Oct, 31 in Nov, 382 in Dec.
F Colony on roofs alongside Carron, Grangemouth: at least 16 chicks on 29 Jun.
*ICELAND GULL *Larus glaucoides*
F One Kinneil 14 Jan; a 1st winter bird there 17 Dec (JRC) and a 2nd winter bird there 26 and 27 Dec (GO). Two Airth shore 19 Nov (Forth estuary WeBS). These are the 18th to 21st records, respectively, for the area since modern recording began in 1974.
GREAT BLACK-BACKED GULL *Larus marinus* (S,W)
F Largest flocks reported: 10 Avonmouth 3 Jan; 10 Skinflats 4 Nov.
*KITTIWAKE *Rissa tridactyla* (P,w)
F One hundred and twenty Skinflats 23 Sep, flew off west (GO, RS).
SANDWICH TERN *Sterna sandvicensis* (P)
 Forth Est. (WeBS): 281 in Sep, 4 in Oct.
F Monthly site max. Skinflats: 20 on 25 Jun; 1 on 13 Jul; 27 on 11 Aug; 4 on 10 Sep. Kinneil: 8 on 26 Jul; 12 there 31 Aug; 56 on 17 Sep; 1 there 20 Oct. 139 Kincardine Br. 17 Sep; 20 there 1 Oct. 18 Carriden 18 Sep. 1 E past Bo'ness Harbour 15 Oct.
C Two at Tullibody Inch 4 Jun was a very early date (AET). 11 (2 J.) Cambus 20 Aug. 15 Kennetpans 17 Sep. 3 Dunmore 8 Oct.
S One over Fallin 10 Jun was another early date; 11 there 4 Aug; 45 on 17 Aug (RHD).
COMMON TERN *Sterna hirundo* (B)
F Skinflats: 2 on 4 May; 15 on 7 May; 26 on 23 May; 10 on 25 Jun; 17 on 26 Jul; 3 on 19 and 22 Aug; 6 on 11 Aug. 4 Carron, Grangemouth and 3 Kincardine Br. 17 Sep.

C Four on Forth, Cambus 20 Aug.
S Five Fallin 16 Aug; 4 there 17 Aug.
*ARCTIC TERN *Sterna paradisaea*
F One Skinflats 21 May (RS) is the 13th record since modern recording began in
 1974.
GUILLEMOT *Uria aalge* (W)
 Forth Est. (WeBS): 24 in Sep, 1 in Oct, 8 in Dec.
F One Kincardine Br. 17 Sep; 30 there 1 Oct (MVB; ACC). 12 > W Skinflats 23 Sep;
 3 there 6 Oct; 4 on 17 Dec (GO, RS). 2 S Alloa 16 Oct; 3 there 22 Oct (RHD). 1
 Kinneil 24 Oct (RHD).
C Ten Cambus 23 Sep (RDZ). 1 Dunmore 8 Oct (MVB).
S One Arnprior, R. Forth 25 Sep (BM). 1 R. Forth, Stirling 30 Sep (PM).
*RAZORBILL *Alca torda* (w)
F One Skinflats 6 Oct. 2 S Alloa 22 Oct (GO, RHD). 3 Forth Est. 12 Dec (WeBS).
S One L. Katrine 15 Sep (DR).
*LITTLE AUK *Alle alle*
F Two Kinneil 5 Nov (JRC). This is the 7th record for the area since modern
 recording began in 1974.
FERAL PIGEON *Columba livia* (B,W)
 Numbers dropped slightly from 1.61 b/lkm on local BBS transects in 2005 to 1.43
 in 2006 but were still 13 % above the long-term mean (annual range: 0.58-
 2.19 b/lkm). Unsurprisingly, they occur at the highest rate in the urban/
 suburban habitat category, with 4.08 b/lkm compared to 2.28 on farmland.
C 100 Blackgrange, Cambus 16 Dec.
F 300 Skinflats 9 Dec.
STOCK DOVE *Columba oenas* (B,W)
 Recorded in fairly low numbers on BBS transects, with 8 birds in 2006 (annual
 range: 1-14 birds). All birds were registered on farmland.
F 14 Kinneil 14 Mar and 13 there 18 Sep. 1-5 birds Skinflats Mar to Sep. 3
 Bandeath, Fallin 2 Jul and 4 there 18 Jul.
C 2 Alloa Inches area 30 Apr with 11 there 23 Dec. 1-2 birds Woodland Park, Alva
 23 Aug and 15 Oct and singles Cambus Village Pools 22 May and 4 Jun.
S 8 Gargunnock 23 Feb. 11 Argaty, Braes of Doune 12 Apr. 6 Wood Lane,
 Blairdummond Carse 23 Apr. Also reported from Drumvaich, Braes of Doune
 10 Mar; Cambuskenneth 12 Apr; Hollow Burn, Fallin 29 Apr; Keir, Dunblane 1
 Jul and Lake of Menteith 9 Jul.
WOODPIGEON *Columba palumbus* (B,W)
 Recorded on BBS transects at 3.45 b/lkm which is 4 % above the mean. It was
 recorded from all four habitat types, being most numerous on farmland at 5.32
 b/lkm and conifer woodland/moorland edge at 4.00 b/lkm.
C 100 R. Devon, Alva 8 Jan. Ca. 600 25-Acre Wood, Fishcross 17 Jan. 100
 Blackgrange, Cambus 17 Sep.
S Ca. 1,000 Vale of Coustry in rape stubble 22 Feb. 340 Argaty, Braes of Doune 16
 Sep. 100 L. Rusky 26 Nov.
COLLARED DOVE *Streptopelia decaocto* (B,W)
 Greatly under-reported. No significant records were received this year.
 Numbers on BBS continued to increase from the all-time low in 2004 to 0.48
 b/lkm, which is the their highest value recorded so far, 78 % above the mean
 (annual range: 0.17-0.48 b/lkm). Recorded in the greatest numbers in urban/
 suburban areas at 2.37 b/lkm with 0.66 b/lkm on farmland.
CUCKOO *Cuculus canorus* (B)
 Occurs in low numbers on BBS transects. The total of 18 birds in 2006 was the

highest to date (annual range: 6-18 birds). Recorded mostly in the conifer and moorland habitats.
Spring arrival: Tyndrum Community Woodland 21st Apr was 8 days earlier than in 2005 (Flanders Moss). This was followed by birds at Kirkton Farm, Crianlarich 27th; Mid Lundie, Argaty 28th; Bows, Braes of Doune 29th and Brig o' Turk and Blackwater Marshes, L. Venachar, both on 30th.

C Singles Cambus Pools 11 May and R. Devon, Alva 4 Jun.
F 2 Darnrig Moss 9 May with 1 there 1 Jun. Single California 11 Jun.
S Single west end of L. Tay 6 May and other dates in May and Jun. 6 Crianlarich area 6 May with 1 there 4 Jun. 2 Gartrenich, Aberfoyle 9 May with 3 there 7 Jun and 2 nearby at Cobleland 16 Jun. Single L. Katrine 9 May. 3 Cromlix Moor 10 May. Singles Sheriffmir 12 May, Menteith Hills 14 May, Blairdrummond 22 May. 1 Callander 17 May, 2 Sron Eadar a' Chinn, Callander 19 May and 1 nearby at Tom Dubh 24 May. 2 prs. Flanders Moss 22 May. Singles Glen Lochay 31 May; Argaty, Braes of Doune 1 Jun and Allt na Ceardaich, Killin 3 Jun.

BARN OWL *Tyto alba* (b,w)
Following the comparatively large number of sightings over the last two years, there were only eight sightings this year, mainly from the core area (i.e. SE Stirlingshire/Clackmannanshire boundary and Falkirk).

F Two Champany, Bo'ness 12 Feb (RS). Single Grangemouth Ind. Est. 8 and 9 Nov (GO).
S Three prs. during the breeding season Doune Lodge, Braes of Doune; single Hill of Row, Dunblane 27 Oct (DOE). Casualties were found on the A81 at Douchlage, Buchlyvie 3 Jun (JT); on the M9 near Stirling (DJC) and on the A811 at Cambusbaron 9 Dec (JT).

TAWNY OWL *Strix aluco* (B,W)
F Single calling most nights in Jan Strathavon Fm., Slamannan.
C One to two birds calling Tait Place, Tillicoultry on several dates in Jan to Apr and Jul to Sep. Singles calling Cambus distillery 3 Sep and Gartmornhillwood, Gartmorn Dam 22 Sep with 2 birds there 18 Nov. 1 dead on A80, Falkirk boundary 4 May. 2 Bo'ness 13 Jul.
S Single flew across A84 Drumvaich, Braes of Doune 20 Jan. Pr. calling to each other Strathyre 6 Feb. Singles west end of L. Tay 8 May and 1 Jun; Crianlarich 4 Jun; Airthrey L., BoA 20 Jul and Ochiltree, Dunblane 9 and 15 Aug. Pr. calling to each other Newton Crescent, Dunblane 1 Oct. Singles Flanders Moss car park 22 Oct and Castle Craig, Stirling 22 Nov. Road casualties A91 at Springkerse 31 Jan and A9 N of Dunblane 18 May.

*LONG-EARED OWL *Asio otus* (b,w)
F Single Skinflats 22 Apr (GO).
C Single flushed by 2 Buzzards Cambus 10 Apr (DAC).
S Single Wester Moss 11 May believed to have bred (RHD). Fledged young found dead Doune Lodge, Braes of Doune (DOE).

SHORT-EARED OWL *Asio flammeus* (b,W)
For this rather local breeder, a more systematic survey of known breeding areas and potential breeding sites would be of value. Two birds were recorded on BBS transects.

F Single Kinneil 15 Jan with 2 there 5 Nov and singles 12 Nov and 24 Dec (AB, JRC, CJP, GO). Single high W Skinflats 8 Oct (MVB). Single mobbing Hen Harrier Denny Muir 26 Dec (MWD).
C Single between R. Devon and Melloch Wood 21 Mar (DE). Only 3rd record in Clackmannanshire since 1996.

***NIGHTJAR** *Caprimulgus europaeus* (b)
S The breeding site at L. Ard Forest remains occupied. 1 bird was churring and wing-clapping 15 Jul (JW).

SWIFT *Apus apus* (B)
With 0.45 b/lkm numbers recorded on BBS transects were 10 % down on 2005 and 8 % down on the mean (annual range: 0.15-0.98 b/lkm). Birds were recorded at greatest density (2.24 b/lkm) in urban/suburban areas.
Spring arrival: 1 Alloa 1 May was 3 days later than in 2005 (Alloa). This was followed by one Carron, 3 Slamannan and Doune and 11 Dunblane all on 3 May, singles R. Devon at Menstrie/Alva, Strathyre and 4 Blairdrummond all on 4 May; 6 BoA 5 May; 2 Larbert and 4 Falkirk on 6 May and 4 Skinflats 7 May.
Autumn departure: 6 Dunblane 5 Aug; 1 Stirling 10 Aug; 1 Falkirk 17 Aug and 1 Kincardine Br. 28 Aug, which was 9 days later than in 2005 (Killin).
C 20 hawking Cambus Pools 7 Jul; 29 Dollar 16 Jul; 50 Tillicoultry 22 Jul.
S Between 5 and 37 BoA 16 May to 26 Jul with screaming (17 birds) only noted 17 Jul. 25 Aberfoyle 16 Jun.

KINGFISHER *Alcedo atthis* (b,w)
There were four records from the breeding season but no confirmation of breeding.
F Single Higgins Neuk 1 Jan. 5 R. Carron, Larbert-Carron 15 Jan. Singles R. Carron at Camelon cemetery 31 May and at Carron Works 15 Oct; Kinneil 15 Nov and 23 Dec; R. Carron at Carronshore 27 Dec.
C Two R. Devon, Devonside to Harviestoun, Tillicoultry 17 Jan and 2 Devonside 27 Feb. Single R. Devon nr. Menstrie/Alva 19 Apr.
S Singles Endrick Water 4 Feb; Kirkton, Crianlarich 4 Jul; Airthrey L., BoA 20 Jul; Cambusmore 7 Sep. 3 R. Forth, Teith to Allan confluence 17 Sep. 4 R. Teith, Wester Row to Forth confluence 22 Oct. Singles R. Teith, Carse of Lecropt 25 Oct and Callander 31 Dec.

GREEN WOODPECKER *Picus viridis* (B,W)
More records away from SE needed to establish true status. Three birds were recorded on BBS transects.
F Singles Strathavon Fm., Slamannan 2 and 9 May; Plean CP 4 May; Carron House, Carronshore 4 Jun; Bo'ness 5 Aug and Torwood 19 Nov.
C Heard calling Tillicoultry on several dates Feb-Apr, Jul and Oct. Singles Dollar Glen 18 Mar and 30 Apr; Birkhill, Gartmorn 2 Apr; Alva Glen 17 May and Woodland Park, Alva 31 May. Ad. and 3 juvs. R. Devon, Alva 2 Jul.
S Singles west end L. Tay 19 Mar; Polmaise Woods, Stirling 31 Mar; Argaty and Kilbryde, Braes of Doune 29 Apr; Bracklinn, Callander 30 Apr; Strathyre 23 May; Tom Dubh, Callander 24 May; Cobleland, Aberfoyle 16 Jun; Menteith Hills 18 Jun; Keir, Dunblane 29 Jul; Airthrey L. 4 Aug and Stank Glen, Ben Ledi 4 Sep.

GREAT SPOTTED WOODPECKER *Dendrocopus major* (B,W)
Recorded in small numbers (6) on BBS, which is slightly above the long term average (annual range: 0-7).
F Two Dunmore Wood 29 Jan with one there 9 Apr. Pair Plean CP 20 Mar with one there 21 Sep. Singles Haircraigs 9 Apr; Jaw, Slamannan 9 May; Garvald, Carron Glen 13 May; Denny 27 Jun; Torwood 29 Jun; Lock 15, Forth and Clyde Canal 18 Sep; Skinflats 24 Nov.
C Singles Tait Place, Tillicoultry 5 Jan, 30 May (F) and 14 Oct with 3 (1F) at nearby Harvieston Home Fm. 22 Jul. Singles Kennetpans 14 Jan; Dollar Glen 5 Feb; NE Tullibody 9 Feb with one there boring holes in telegraph pole 4 Apr. Single Dollar Glen 18 Mar. Single Gartmorn Dam 23 Mar with 3 involved in a territory dispute there 10 Apr and 1 nearby 25 Apr. 3 (2 juvs.) Woodland Park, Alva 31 May. Singles Aberdona 10 Jul; Castlebridge Business Park, Forestmill 19 Jul; R.

Devon, Menstrie/Alva 13 Aug, 25 Aug and 3 Nov. Singles Cambus Pools 29 Aug and 2 at nearby Blackgrange 17 Sep.

S Singles Argaty, Braes of Doune 6 Jan; drumming Lake of Menteith 1 Feb; west end of L. Tay 19 Mar; Crianlarich 6 May; nested Mid Torrie, Callander 20 May; Tyndrum community woodland 30 May. Two Airthrey 16 Jun; juv. Ochiltree, Dunblane 7 Jul. Single Glen Finglas 24 Dec.

*HOOPOE *Upupa epops*

S Thornhill Muir Fm. 7 Jun (photographed by MT). This is the third record for the recording area, the first having occurred in Menstrie in 1896, the second in Gargunnock in 1984.

SKYLARK *Alauda arvensis* (B,W)

Recorded on BBS at 1.94 b/lkm, 10 % above the long-term mean (annual range: 1.25-2.71 b/lkm). Most frequent on mountains and moorland (3.16), then farmland (1.64).

The first singing bird was at Kersiepow, Alva 14 Feb

F 40 Skinflats 16 Mar with 75 there 8 Oct.

C 20 East Birkhill, Forestmill 30 Nov.

SAND MARTIN *Riparia riparia* (B)

Numbers continue to vary widely on local BBS transects. After very low numbers in 2003 and 2004, numbers increased fivefold in 2005, then almost doubled again in 2006. The rate of 0.53 b/lkm is 71 % above the long-term mean (annual range: 0.02-1.32 b/lkm). Recorded predominantly on farmland with lower numbers in mountain and moorland.

Arrival seems to have been much later than in previous years. The first birds were noted 20 Mar at Gartmorn 29th (3 days later than in 2005 (Stirling and Killin)) with no further report until 3 Doune 9 Apr, when birds are usually widespread. Departure also seems to have been later: 60 Skinflats 5 Sep were followed by 1 L. Venachar 13 Sep (20 days later than the main departure in 2005 (Fishcross)).

C Ca. 92 AOT Devonvale, R. Devon 23 May.

S 150 Glen Finglas 15 Apr; 100 Blair Drummond 16 Apr; ca. 50 Cambusmore/Gart GP 30 Apr. Ca. 20 AOT R. Dochart 1 Aug. 256 nest holes Cambusmore/Gart GP 6 Sep.

SWALLOW *Hirundo rustica* (B)

Following the 2005 high, numbers increased further in 2006 to 3.05 b/lkm, 31 % above the long-term mean (annual range 1.65-2.87 b/lkm). Recorded in all habitats with the greatest frequency in farmland at 5.46 b/lkm.

Spring arrival: 1 Carronshore 31st Mar was 3 days earlier than in 2005 (Carron). This was followed by singles Alva 1st Apr, Airthrey 7th, BoA 10th, Alloa 13th. Widespread from mid-month.

Autumn departure: 4 Alloa and 4 The Forest 21st Sep; 19 R. Forth Cambus-Alloa 22nd; 30 King's Park, Stirling 22nd with 3 there 29th. 6 R. Devon, Alva 24th. 86 Doune Ponds 1st Oct; 9 Dunmore 8th and 2 Carronshore 16th were 17 days earlier than in 2005 (Skinflats).

F 6 prs. nested Strathavon Fm., Slamannan but many fledglings predated by Magpies. 80 Skinflats 5 Sep.

C 100 Gartmorn Dam 11 Sep.

S 60 L. Venachar 13 Sep; 50 Ballochruin Pond, Killearn 15 Sep.

HOUSE MARTIN *Delichon urbica* (B)

Numbers were slightly higher than in 2005 but at 0.61 b/lkm were the 3rd lowest so far, being 30 % below the long-term mean (annual range: 0.25-1.7 b/lkm). Unlike 2005 was most commonly recorded in the urban/suburban habitats (1.32 b/lkm).

Arrival in Apr: single Blairdrummond 14th was 7 days later than in 2005 (also there). This was followed by single King's Park, Stirling 16th and 6 R. Carron, Carronshore 23rd.

Departure in Sep: single Gartmorn Dam 11th; 5 L. Venachar 13th; single Killearn 15th; 35 Dunblane 16th; 4 Cambus 17th and 13 Dunblane 1st Oct, which was 9 days earlier than in 2005 (also there).

F 32 Roughcastle, Falkirk 17 Jun.

C 1$^+$ AOT Coalsnaughton centre.

S 7 around nest boxes Univ. of Stirling 4 May; 32 Cobleland, Aberfoyle 16 Jun. 2 prospecting Coneyhill, BoA, mid-Jun.

TREE PIPIT *Anthus trivialis* (B)

No birds were recorded on BBS for the 3rd year in a row.

Arrival in April: 2 School Wood, Clackmannan 17th were 5 days later than in 2005 (Dunblane). This was followed by singles Tyndrum community woodlands 28th and Tigh Mor, L. Achray 29th; 2 Carron Res. and 3 Drumloist, Braes of Doune 30th.

C 2 singing Gartmorn Dam 28 May.

S 2 Lundie, Braes of Doune 4 May; single Crianlarich, 3 Flanders Moss and 6 Duke's Pass, Aberfoyle all 3 May; 2 Inversnaid 30 May. Singles Glen Lochay 3 May and west end L. Tay 4 Jun. 3 Cobleland, Aberfoyle, 18 Jun.

MEADOW PIPIT *Anthus pratensis* (B,W)

At 4.14 b/lkm was virtually identical to the 2005 figure (4.16) and only 1 % below the long-term mean (annual range: 2.71-6.21 b/lkm). Continues to be scarce mid-winter.

F 20 Skinflats 19 Feb and 19 Dec. 30 Dunmore Wood 9 Apr.

S Ca. 50 Cambusmore/Gart GP 6 Sep. 7 in 2.5km Cringate Muir 10 Sep.

*ROCK PIPIT *Anthus petrosus* (w)

At traditional sites along Falkirk shore.

F 8 S Alloa 1 Jan (RHD). 1 Blackness 6 Jan (CJH).

GREY WAGTAIL *Motacilla cinerea* (B, w)

Recorded in low numbers (10) on BBS; the rate this year of 0.07 b/lkm is 17 % below the long-term mean. 74 % were recorded on farmland with the remainder occurring on mountain and moorland.

F Regular visitor to Strathavon Fm., Slamannan during winter. Ad. and 3 juvs. R. Carron, Carronshore 9 Jul.

C M R. Devon, Menstrie 6 Mar. Prs.Cambus 10 Apr and 13 Jul. Pr. Dollar Glen 30 Apr. 3 Woodland Park, Alva 31 May. Single Harviestoun Home Fm., Tillicoultry 22 Jul. Pr. R. Devon, Menstrie 15 Sep. Single Gartmorn 23 Sep. Male Cambus 28 Dec.

S 3 prs. Allan Water, Dunblane 24 Apr with 3 birds there 2 May, 6 (4 juvs.) 15 Jun and 4 birds 12 Sep. Pr. L. Katrine 9 May with 3 birds there 15 Sep. 4 Cobleland, Aberfoyle 16 Jun. Single Polmaise lagoons 21 Sep. M Carse of Lecropt 23 Dec.

PIED WAGTAIL *Motacilla alba* (B, w)

Numbers on BBS dropped a little this year to 0.31 b/lkm, which is 24% below the mean (annual range: 0.21-0.77 b/lkm). Recorded in all habitats, with the highest density occurring on farmland at 0.41 b/lkm.

Remains scarce in winter: three Jan records (4 in 2004 and 2005) but all from one location: Tait Place, Tillicoultry 1st, 5th and 8th. Six Feb records (2 in 2004 and 1 in 2005): singles Tullibody 1st; Kersiepow, Alva 14th; Tillicoultry 18th; Killin 18th with 5 there 20th, 23rd and 25th; Coalsnaughton 19th and 4 birds Skinflats 19th. Six Nov records from 3 locations (4 in 2004 and 6 in 2005): Castlebridge Business Park, The Forest 1st and 3 birds there 4th; single The Rhind, Alloa 18th with 3

birds there 25th and 2 Carse of Cambus, Doune 28th. Seven Dec records (10 in 2004, 6 in 2005): 3 Castlebridge Business Park, The Forest 1st with a single there 14th. 6 Skinflats and 1 The Meadows, Callander 9th; singles Kersiepow, Alva and Cambus Village Pools 11th; single Rossburn Lane, Blairdrummond Moss 20th.

F Single White Wagtail (*M.a. alba*) Skinflats 31 Mar, with 2 there 24 and 25 Apr, 3 on 28 Apr and 1 on 3 May.

C Two White Wagtail (*M.a. alba*) Cambus Village Pools 26 Apr.

S 12 King's Park, Stirling 12 Aug with 90 there 29 Sep and 100 on 3 Oct. Addition to 2005 report:

F 51 (presumed roost) Falkirk 8 Jan.

*WAXWING *Bombycilla garrulus* (w)

C 27 Cambus Pools 15 Jan (PMA).

S 10 Torbrex, Stirling and a single at the reliable site of Stirling Royal Infirmary 27 Jan (AET, AB). Single Callander library 25 and 26 Nov (RAB, DOE, JT, MMcG).

DIPPER *Cinclus cinclus* (B,W)
As usual, recorded in low numbers on BBS with 3 birds (annual range: 1-11).

F 2 Carron Works, R. Carron 17 Sep with 1 there 8 Oct and 3 on 17 Dec. Single Carron Glen 25 Apr.

C Two Cambus Pools 15 Jan. One singing R. Devon, W. Sheardale 21 Jan. Single R. Devon, Tulligarth 31 Jan. 16 R. Devon, Dollar-Tillicoultry 27 Feb. 2 R. Devon, Alva 18 Mar. 1 Gartmorn Dam 23 Mar. One carrying nest material Dollar Glen 16 Apr. One Woodland Park, Alva 31 May.

S Two (1 singing) Allan Water, BoA 12 Jan. 4 Endrick Water 4 Feb. 4 Allan Water, Dunblane 20 Feb. 2 L. Dochart 11 Mar with 1 there 1 Aug; 1 west end L. Tay 19 Mar. Single Tyndrum community woodland 21 Apr; pair Sheriffmuir 24 Apr and 2 Broomridge, Bannock Burn 27 Apr. Singles Crianlarich 6 May; Aberfoyle 11 May; Sron Eadar a' Chinn, Callander 19 May; Cambusmore 7 Sep. 2 L. Earn 16 Oct and Callander 31 Dec.

WREN *Troglodytes troglodytes* (B,W)
Widespread and common. Under-recorded.
Occurs on BBS with 2.29 b/lkm, which is an 18 % drop since the high last year and is 6 % above the long-term mean (the annual range is rather narrow at 1.53-2.78 b/lkm). Density is at its highest in coniferous woodland (4.57) but this species is recorded at high densities in all habitats, apart from mountain and moorland.

F 18 on transect at Roughcastle, Falkirk 17 Jun.

S 11 on transect at Hollow Burn, Fallin 29 Apr. 13 on transect at Cobleland, Aberfoyle 16 Jun.

DUNNOCK *Accentor modularis* (B,W)
Widespread and common. Under-recorded.
Dropped by 24 % from its highest ever figure in 2005 to 0.58 b/lkm in 2006 (annual range: 0.34-0.76), which is 16 % above the mean. Numbers in the urban/suburban category (2.11) were 3 times higher than in farmland and 7 times higher than in conifer woodland and moorland edge habitat.

S 7 ringed Strathyre garden 27 Jan. 10 on transect at King's Park 21 Mar with 13 there 20 Apr. 1 on fatball Coneyhill, BoA 12-21 Jul.

ROBIN *Erithacus rubecula* (B,W)
Under-recorded. The BBS rate of 1.41 b/lkm is virtually the same as in 2005 and 1 % above the long-term mean (annual range: 0.92-1.43). Found in all habitats but at greatest density in coniferous woodland (4.57 b/lkm) and urban/suburban (2.50 b/lkm) with only 1.52 b/lkm in farmland.

C 12 Gartmorn Dam 4 Jan. 15 Blackgrange, Cambus 16 Dec.

S 10 Airthrey 10 Feb. 17 King's Park, Stirling 8 Mar. 14 Hollow Burn, Fallin 15 Apr.
 16 Cobleland, Aberfoyle 16 Jun; 10 Allan Water, Dunblane 12 Sep.
REDSTART *Phoenicurus phoenicurus* (B)
 Occurs in very low numbers on BBS transects with only 3 birds this year.
 Recorded for the first time in 2003 (annual range: 2-5).
 Arrival in Apr: 1 west end L. Tay 23rd was 4 days later than in 2005 (Aberfoyle).
 This was followed by 3 (1M, 2F) Tigh Mor, L. Achray 29th and 2M Brig o' Turk
 30th. (JPH, FAM, MVB)
F F Skinflats 18 Oct (GO).
S M Brig o' Turk/Glen Finglas 21 May. 4 (2M) Bracklinn, Callander 22 May. Singles
 L. Tay 29 May and 1 Jun; Glen Lochay 31 May; Allt na Ceardaich 3 Jun and M
 Lanrick 25 Jun. F Lake of Menteith 9 Jul. M Doune Lodge, Braes of Doune 27
 Aug (RHD, DOE, JPH).

WHINCHAT *Saxicola rubetra* (B)
 Occurred at its highest number on BBS transects with 26 birds (annual range:
 2-26 birds). With 0.19 b/lkm was 90 % above the long-term mean.
 Spring arrival has been remarkably consistent over the last four years. A single
 Doune 29th was 1-2 days earlier than between 2003-2005. This was followed by
 M Dumyat; M L. Arklet and pair Skinflats all on 5th May; 3 Sheriffmir 12th;
 Sron Eadar a' Chinn, Callander 19th; M L. Arklet and F Inversnaid 21st.
 Autumn departure: 3 Skinflats 13 Aug and M Glinns Road, Kippen 1 Sep was 7
 days earlier than the bulk of 2005.
F F Skinflats 8 Jun and in company of 2 imms. there 9 Jun.
S Singles Glen Lochay 31 May; Braeleny, Callander (singing) and Allt na
 Ceardaich, both 3 Jun.

STONECHAT *Saxicola torquata* (b,w)
 After last year's high, the 20 birds recorded on BBS transects were the highest
 to date, having risen steadily from 0.01 b/lkm in 1997 to 0.15 b/lkm this year. As
 would be expected, they were mainly found in mountain and moorland habitat
 with very small numbers on farmland.
F 1-3 birds Skinflats Jan and Apr to Dec with ad. and 2 juvs. there 6 Jul and 4 well
 grown juvs. 29 Aug. 1-2 prs. Kinneil Sep, Oct and Dec. 1-2 birds S Alloa Jan, Oct
 and Nov. M Union Canal, Tamfourhill 18 Feb. Single California 11 Jun. 8
 Slamannan-Fannyside 13 Oct. M St Helen's Loch, Bonnybridge 1 Nov.
C M E of Coalsnaughton 10 May with a pr. there 27 Jun. 2 prs. Blackdevon
 wetlands 26 Nov.
S 1-3 birds Auchlyne, Killin Feb-Mar. Pr. Carron Valley Res. 18 Feb with a M there
 19 Dec. 1-2 birds Sheriffmuir area Apr-Jun and Aug-Sep with 6 there 15 Sep. Up
 to 2 prs. Polmaise lagoons Aug-Dec. 2 Gartrenich, Aberfoyle 9 May with 1 there
 7 Jun. 2 prs. and 3 juvs. Flanders Moss 22 May with a single there 23 Oct. 2 Tom
 Dubh, Callander 24 May with 1 there 26 Jun. During breeding season also
 reported from Brig o' Turk/Glen Finglas (F with nest material), L. Arklet and
 Braeleny, Callander. In winter (Sep-Dec) also reported from Cringate Muir; L.
 Walton; Severie, Braes of Doune; Townhead, N Third and Lower Greenyards,
 Forthbank.

WHEATEAR *Oenanthe oenanthe* (B)
 The 16 birds recorded represent 0.12 b/lkm, 20 % down on 2005 and 14 % below
 the long-term mean (annual range: 0.07-0.25 b/lkm). The vast majority occurred
 in mountain and moorland habitat.
 Spring arrival in Apr: prs. Strathavon Fm., Slamannan and Muirpark 3rd were
 13 days later than in 2005 (Arnprior). This was followed by M Bows 9th and

single at South Alloa 16th.
Autumn departure: 2 Skinflats 6 Sep and F West Jawcraigs Slamannan 13 Oct was 39 days later than in 2005 (Kinneil).

F Migrants: M South Bellsdyke, Skinflats Village 1 May. Pr. Skinflats 5 May and M there 8 Jul.

C Migrants: Single Balhearty Fm., Coalsnaughton 20 Apr and F The Rhind, Alloa 30 Apr. 3 Gartmorn 12 May.

S 2 Kirkton Fm. (hill ground) 19 Apr; 2 Wood Lane, Blairdrummond Carse 26 Apr. Pr. Kinbuck Bridge 4 May nested in rabbit burrows. Prs. Flanders Moss 6 May. Singles Sheriffmuir 12 May and Arie Dam, Callander 3 Jun.

*RING OUZEL *Turdus torquatus* (b)

S One Sron Eadar a' Chinn, Callander 19 May (JRC). 2F, 1M Trossachs 14 Jun (DJC).

BLACKBIRD *Turdus merula* (B,W)

Recorded on BBS at 2.36 b/lkm, the same as the long-term mean. Annual numbers have been in a very narrow range of 1.82-2.72 b/lkm. As usual, the urban/suburban habitat was most favoured by this species with 5.66 b/lkm but again this is the lowest rate since BBS began. This is followed by a density of 3.59 b/lkm on farmland.

C 12 M W of Tillicoultry 26 Dec.

S 1 singing Coneyhill, BoA 25 Feb. 40 Airthrey 14 Mar with 20 there 31 May, 2 Jun, 15 Nov and 25 on 22 Dec. 25 King's Park, Stirling 28 Apr with 26 there 31 May, 29 on 5 Jun, 21 on 1 Nov and 2 on 15 Dec. A pair in Fallin had a 1st brood 8 Apr, 2nd brood 14 May, 3rd brood 22 Jun and a possible 4th brood 30th Jul.

FIELDFARE *Turdus pilaris* (W)

Spring departure: no April sightings were received, the last 2 birds being seen at Skinflats 31 Mar and a very late bird Polmaise 14 May, which was 15 days later than in 2005 (Flanders Moss).
Autumn arrival in October: 60 Flanders Moss and Glenhead, Denny 22nd were 2 days later than in 2005 (Denny). This was followed by 10 L. Rusky 23rd, 50 Doune 28th, 25 SW Blackdevon wetlands 14 SW Dunblane 29th, and 100+ Thornhill Carse 30th.

F 120 SW Little Denny Res. 7 Jan. 50 Glenhead, Denny 8 Jan. 240 Skinflats 1 Dec.

C 50 R. Devon, Alva 19 Nov. 80 R. Devon Menstrie/Alva 8 and 17 Dec with 200 there 21 Dec.

S No counts were received from the Carse of Lecropt, which traditionally holds large flocks. 150 Thornhill Carse 17 Jan with 120 there 15 Feb, 118 on 10 Mar, 130 on 24 Nov and 65 on 28 Dec. 60 Argaty, Braes of Doune 28 Feb. Ca. 300 head of L. Lubnaig and 87 Auchlyne, Glen Dochart 4 Nov. 76 King's Park, Stirling 7 Nov with 60 there 15 Dec. 100 Airthrey 14 Nov. Ca. 180 L. Coulter 1 Dec.

SONG THRUSH *Turdus philomelos* (B,W)

Under-recorded. Recorded at 0.65 b/lkm, a drop of 17 % on the previous year (annual range: 0.46-0.82 b/lkm) but slightly (2 %) above the 9-year mean. It was found most often in the urban/suburban category (1.45 b/lkm).
As usual few winter records. Jan: singles R. Devon, Menstrie/Alva 6th, 8th and 25th. Single Ochiltree, Dunblane 3rd to 11th Feb and 26th Nov. Feb: singles Tullibody and Auchlyne, Glen Dochart 9th; Kinneil 10th; Coneyhill, BoA 13th (singing).

F 8 Roughcastle, Falkirk 17 Jun.

C 5 Woodland Park, Alva 31 May. 8 Blackgrange, Cambus 14 Oct.

S 6 Airthrey and 7 Gartmorn Dam 23 Mar. 10 King's Park, Stirling 31 May. 8 Cobleland, Aberfoyle 16 Jun.

REDWING *Turdus iliacus* (W)

Spring departure: 12 Argaty, Braes of Doune 5 Apr was 8 days earlier than in 2005 (Tyndrum).

Autumn arrival in Oct: unspecified numbers Springkerse, Stirling and Tullibody (heard) 12th were 4 days later than in 2005 (Braes of Doune). This was followed by 30 Doune 13th. Good flocks in several localities from 20th.

F 100 Skinflats 4 Nov and 9 Dec.

C 100 R. Devon, Alva 29 Jan with 70 there 12 Feb, 250 on 20 Oct and 350 on 28 Nov.

S No counts were received from the Carse of Lecropt, which traditionally holds large flocks. 230 Kilbryde, Braes of Doune 7 Mar. 100 Flanders Moss and 400 L. Rusky 23 Oct. 175 in 6 flocks SW Dunblane 28 Oct. 200 passing Airthrey throughout 30 Oct with 100 here 7 Nov. 100 Aberfoyle Forest Park 15 Oct. 120 Airthrey 22 Dec.

MISTLE THRUSH *Turdus viscivorus* (B,W)

Greatly under-recorded. Recorded at 0.22 b/lkm on BBS, 12 % less than last year but still 16 % above the mean (annual range: 0.07-0.30 b/lkm). Most prominent in the mountain, moorland and conifer habitats (0.64 b/lkm).

F Singing Plean CP 21 Jan. 20 Skinflats 4 Nov.

S Singing Coneyhill, BoA 22 Jan. 70 (2 flocks) Carron Valley Res. 7 Oct. 15 Airthrey 3 Nov.

*GRASSHOPPER WARBLER *Locustella naevia* (b)

Eight birds recorded on BBS was the highest to date (annual range: 1-4 birds). Spring arrival in Apr: W side L. Tay 27th was 4 days later than in 2005 (Skinflats). This was followed by singles at R. Devon, Menstrie/Alva and Skinflats 28th and Hollow Burn, Fallin 29th, 2 Skinflats 29th, singles at Blackgrange, Polmaise, Carron Res., Cromlix and Blackwater Marshes, L. Venachar all on 30th.

F Single Darnrig Moss 5 May and 13 Jun.

C Singing Blackgrange, Cambus 29 Jul.

S Singles Yellowcraig Wood, Airthrey 5 May; Flanders Moss 6 May; 3 W side L. Tay 8 May and 1 Jun; 2 Gartrenich, Aberfoyle 9 May. Singles Hollow Burn, Fallin 14 May; Tyndrum community woodlands 30 May. Also present during breeding season at Lundie, Braes of Doune (no date given).

SEDGE WARBLER *Acrocephalus schoenobaenus* (B)

A total of 7 birds were recorded on BBS locally this year (annual range: 4-17). Spring arrival: 1 Wood Lane, Blairdrummond Carse 26 Apr was 4 days earlier than in 2005 (Alva/Menstrie). This was followed by singles Skinflats 27 Apr, R. Devon, Alva/Menstrie 28 Apr, Cambus Pools and Blackwater Marshes, L. Venachar 30 Apr. 1 singing Skinflats 5 May; single Darnrigg Moss, Slamannan; 3 Flanders Moss 6 May.

Autumn departure in Aug: 2 Blackgrange, Cambus 12th and 1 R. Devon, Alva 13th was 24 days earlier than in 2005 (Tullibody Inch).

F Single Skinflats 20 Jun gathering food with 4 there 22 Jul. Single Shieldhill, Falkirk 26 Jun and 1 Jul.

C 11 R. Devon, Alva/Menstrie in 400 m patch 12 May with birds present there 20 May, 4 Jun, 26 Jun (feeding Y) and 2 Jul. Single Cambus Pools 23 May with 3 there 11 May and 4 at nearby Blackgrange 29 Jul. 2 Gartmorn 3 Aug.

S During breeding season reported from Hollow Burn, Fallin; Polmaise lagoons (6 ads., 2 juvs.); Drumoist and Argaty, Braes of Doune; Aberfoyle and W side L. Tay (May, Jun and Jul).

WHITETHROAT *Sylvia communis* (B)

The BBS rate of 0.27 b/lkm was 4 % higher than in 2005 and 23 % higher than

the long-term mean (annual range: 0.09-0.32 b/lkm).
Spring arrival: 1 Skinflats 26 Apr was 4 days earlier than in 2005 (Cowie and Alva/Menstrie). This was followed by 1 singing Cambus and single R. Devon, Alva/Menstrie 28 Apr.; single Hill of Row, Dunblane; 2 Skinflats and 3 (incl. F building nest) Hollow Burn, Fallin all on 29 Apr; singles Alloa 3 May and Darnrig Moss, Slamannan 5 May.
Autumn departure: 2 Blackgrange, Cambus 12 Aug; 5 R. Devon, Alva 13 Aug. A family there 23 Aug was 16 days earlier than in 2005 (Dunblane).

F 4 Carron Glen 13 May. 6 Roughcastle, Falkirk 17 Jun. 8 Skinflats 25 Jun with ad. gathering insects there 29 Jun, 5 on 22 Jul.

C 7 R. Devon, Alva/Menstrie in 400 m patch 12 May with 3 there 20 May, 4 on 4 Jun, 1 feeding Y 26 Jun. Singing Cambus 11 and 23 May with imm. at nearby Blackgrange 29 Jul. 5 Gartmorn 26 Jun and 3 on 3 Aug.

S 3 Aberfoyle 11 May; 6 Cobleland, Aberfoyle 16 Jun.

GARDEN WARBLER *Sylvia borin* (B)
Recorded in very low numbers on BBS transects. This year's total was 4 birds (annual range: 0 -6).
Spring arrival in May: singles R. Devon, Menstrie/Alva and Argaty, Braes of Doune 4th were 2 days later than in 2005 (Fallin). This was followed by 1 Gartmorn 7th, 2 Doune 9th, singles Fallin Bing 11th and L. Katrine 13th.
Autumn departure: 1 Blackgrange, Cambus 12 Aug was 17 days earlier than in 2004 (Blairdrummond).

C 3 Woodland Park, Alva 31 May. One Gartmorn 3 Aug.

BLACKCAP *Sylvia atricapilla* (B)
The above average rate since 2002 continued with 0.19 b/lkm on BBS transects, 6 % higher than last year and 27 % higher than the long-term mean (annual range: 0.07-0.19 b/lkm). In a reversal from last year, the highest rate occurred in the urban/suburban habitat with 0.79 b/lkm, followed by 0.29 b/lkm in the mountain, moorland and conifer edge habitats, a reflection of the high variance in squares surveyed in each category between years.
Winter records: M in Stirling garden 2 Jan with F there in Feb. Single Alva 1 and 9 Feb. In second part of year: M Airthrey 6 Nov, 2M there 7 Nov, M 15 Nov and 7 Dec. 2 in BoA garden from 15 Nov. M Skinflats 2 Dec.
Spring arrival in April: 6 M Blairdrummond 6th were 4 days earlier than in 2005. This was followed by 2 Hollow Burn, Fallin 15th; King's Park, Stirling 16th. Reported from several localities in SW of recording area from 24th.
Autumn departure: 2 Alva 17th Aug; singing bird Skinflats 13th Sep was 15 days later than in 2004 (Blairdrumond) but 4 days earlier than in 2003 (Lecropt).

F 4[+] singing Plean CP 4 May. 5 Hollow Burn, Fallin 14 May.

C 7 Gartmorn 14 May.

S 5 Airthrey 28 Jul.

WOOD WARBLER *Phylloscopus sibilatrix* (B)
Under-recorded. Unlike in previous years, no birds were recorded on BBS.
Spring arrival: singles Tigh Mor, Trossachs and W end of L. Tay 29 Apr were a day earlier than in 2005 (Crianlarch). This was followed by 3 singing Little Drum Wood, Brig o'Turk 30 Apr; 2 singing L. Katrine and 1 Darn Walk, Dunblane 3 May; 3 Glen Finglas 6 May where 1 also 21 May.

S Recorded on several dates in May until 1 Jun at west end of L. Tay. 3 singing David Marshall Lodge, Aberfoyle 17 May; 2 Glen Lochay 27 May with 1 there 31 May. 1 Inversnaid 30 May; 1 Allt na Ceardaich, Killin 3 Jun.

CHIFFCHAFF *Phylloscopus collybita* (B)
Overall numbers on BBS were small with a total of 11 birds only (19 in 2005).

Spring arrival: much later than last year. One Skinflats 31 Mar was 7 days later than in 2005 (Blairlogie and Falkirk). This was followed not until 11 Apr by a single at Bantaskine, Falkirk, then singles Blairdrummond 14 Apr; Bellsdyke Rd., Larbert 15 Apr and Dunmore Wood 16 Apr.
Autumn departure: juv. Carron Valley Res. 17 Sep; Newton Crescent, Dunblane 23 Sep and a late bird singing King's Park, Stirling 4 Oct was 8 days later than in 2004 (Blackness).

F One singing Falkirk Tunnel 21 Apr with 2 there 24 Apr. 2 singing Plean CP 4 May. Singles singing Carron Glen 13 May and R. Carron, Camelon 31 May. Singles Carron House, Carronshore 4 Jun; Torwood 29 Jun and singing Grangemouth Golf Course 17 Jul.

WILLOW WARBLER *Phylloscopus trochilus* (B)
After the steady decline since 1997, there was a 20 % increase in numbers this year with 1.47 b/lkm. This is still 18 % below the long-term mean and 48 % below the 1997 figure (range: 1.23-2.84). As before, the highest rate occurred in the conifer and moorland habitat with 3.29 b/lkm, almost twice that in farmland.
Spring arrival in Apr: 1 Yellowcraig Wood, Airthrey 14th was 11 days later than in 2005 (Fallin and Flanders Moss). This was followed by birds at Hollow Burn, Fallin 15 Apr with 7 there 29 Apr; Blairdummond and Dollar Glen 16th with birds reported from many locations thereafter.
Autumn departure in September: 1 Gartmorn 11th was followed by singles Blackgrange, Cambus and Skinflats 17th, which was 19 days earlier than in 2005.

C 6 Cambus Pools 30 Apr with 4 there 7 Aug and 18 ringed at nearby Blackgrange 12 Aug. 9 Gartmorn 15 May and 26 Jun with 14 there 3 Aug. Family R. Devon, Alva/Menstrie 3 and 25 Aug. 8 Alva Glen, 12 Aug. 8 R. Devon, Alva 13 Aug.

S 6 singing Airthrey 20 Apr with 3 (1 juv.) there 8 Aug. 8 Wood Lane, Blairdrummond Carse 24 Apr. 6 King's Park, Stirling 25 Apr with 7 there 23 May and 6 on 10 Aug. 16 Polmaise Woods, Stirling 6 May. 14 Crianlarich 6 May; 6 Cambusbarron 6 May; 6 Swanswater Fishery, Stirling 6 Jun.

GOLDCREST *Regulus regulus* (B,W)
Under-recorded. No notable records were received.
After the high of 2005, numbers (0.65 b/lkm) dropped by 39 % to just above the mean (+5 %) (annual range: 0.18-1.07). The highest density (4.64 b/lkm) occurred, not surprisingly, in the conifer and moorland category.

SPOTTED FLYCATCHER *Muscicapa striata* (B)
Recorded in very low numbers on BBS with the 5 birds this year, like last year, equalling the mean (annual range: 2- 12). Remains scarce with reports from 20 locations received.
Spring arrival in May: single L. Katrine 9th was 5 days earlier than in 2005 (G. Dochart). This was followed by singles Dollar Glen 21st, Burnbank Wood, Blairdrummond; 2 Westerton Fm., Dollar and 4 Linnbank Fm., Dollar 22nd, single Gartmorn 25th (also there 27 Jun); Tullich, G. Lochay 27th and Tyndrum community woodlands 30th.
Autumn departure: singles Skinflats 22 Aug and 1 Sep were probably passage birds.

F Single Jawparks Fm., Slamannan 9 May.

S Present in June Allt na Ceardaich 3rd; west end L. Tay 4th; Allan Water, Dunblane 15th; R. Teith, Callander 20th. Pr. Lake of Menteith 9 Jul; single Doune Lodge 22 Jul; 2 ads. with 4 juvs. King's Park, Stirling 10 Aug and single Sheriffmuir 20 Aug.

*PIED FLYCATCHER *Ficedula hypoleuca* (b)
S M Little Drum Wood, Brig o'Turk 30 Apr. Single Glen Lochay 9, 27 (in song) and 31 May. 1 singing David Marshall Lodge, Aberfoyle 17 May. M Bracklinn, Callander 10 Jun.

LONG-TAILED TIT *Aegithalos caudatus* (B,W)
 Numbers on BBS fluctuate markedly (annual range: 0.03-0.38b/lkm) due to the small number of birds involved (11 this year).
F 11 Callander Estate, Falkirk 12 Feb.
S 2 at 580 m asl. Taobh na Coille, Strath Gartney 13 May. 12 Keirhead, Thornhill 23 Oct.

COAL TIT *Periparus ater* (B,W)
 Widespread but under-recorded. After the very high 2005 BBS rate, the 0.53 b/lkm represents a drop of 42 % (annual range: 1.2-2.51 b/lkm), 18 % below the mean. With 3.79 b/lkm is 15 times more frequent in coniferous woodland than farmland (0.25 b/lkm).
F 25 Roughcastle, Falkirk 17 Jun.
S 16 Strathyre during garden ringing session 27 Jan. 53 Cobleland, Aberfoyle 16 Jun.

BLUE TIT *Cyanistes caeruleus* (B,W)
 Under-recorded. After last year's high, the BBS rate of 2.21 b/lkm was 12 % lower but still 23 % above the long-term mean (range: 1.20-2.51). Is most frequent on farmland (3.65 b/lkm), then urban/suburban areas (3.26 b/lm).
F 77 Roughcastle, Falkirk 17 Jun.
C 18 R. Devon, Alva 5 and 8 Jan. 16 Gartmorn 25 Feb.
S 20 Strathyre during garden ringing session 27 Jan. 20 King's Park, Stirling 17 Feb. 20 (several families) Airthrey 16 Jun. 33 Cobleland, Aberfoyle 16 Jun. 57 Fintry 19 Jun.

GREAT TIT *Parus major* (B,W)
 Under-recorded. This year's figure of 1.20 b/lkm is up 5 % on 2005 and 52 % above the long-term mean (range: 0.23-1.72). Is most frequent in urban/suburban areas (1.97 b/lkm), then farmland (1.81 b/lkm).
C 14 Woodland Park, Alva 5 Jan. 10 Gartmorn 24 Jan. 10 R. Devon, Alva 29 Jan and 17 Dec.
S One in juv. plumage on feeder 2 and 3 Feb Springwood Ave., Stirling. One singing Coneyhill, BoA 26 Feb, 13 and 14 Oct. 22 King's Park, Stirling 27 Feb.

NUTHATCH *Sitta europaea*
S Single Aberfoyle 13 Oct (AS) is the 5th record for our area following the first record in 1999.

TREECREEPER *Certhia familiaris* (B,W)
 Under-recorded. Recorded in very low numbers on BBS. This year's total of 9 birds was the highest so far (annual range: 2-9).
C 3 old road Alva-Menstrie 8 Apr. 3 E of Gartmorn 25 May.
S 4 Cobleland, Aberfoyle 17 Jun. 4 Airthrey 16 Aug.

*GREAT GREY SHRIKE *Lanius excubitor*
F 2 Skinflats 23 Sep (RS) was the 19th record for the recording area.
S 1 Townhead Fm., North Third Res. 21, 28 and 29 Oct (DB) was the 20th record for the recording area.

JAY *Garrulus glandarius* (B,W)
 Recorded in very low numbers on BBS generally with 8 this year locally (annual range: 1-11 birds).
F Singles Dunmore Wood 21 Jan. 2 Bonnyfield, Haircraigs 2 Feb. 2 Denny 29 Apr. 4 Roughcastle, Falkirk 17 Jun. 3 Torwood 19 Nov. Single Callendar Estate,

Falkirk 16 and 30 Dec.

C Single Gartmorn 24 Jan and 22 Sep. 2 calling The Forest, Gartlove 25 Jan and one there 1 Dec. Singles Cambus 21 Mar; E of Clackmannan 29 Mar; Alloa 7 Apr; 2 School Wood, Clackmannan 17 Apr. Singles Dollar Glen 30 Apr; Coalsnaughton 23 Oct

S In autumn/winter: 4 Glen Lochay 10 Jan; singles Auchtubh and Stronachvar, Balquhidder 11 Jan with 1 Balquhidder Station 9 Dec. 1 Plean CP 21 Jan with 2 there 3 Nov. Singles Lake of Menteith 21 Jan, 19 Feb and 1 Oct. 3 Innishewan, Glen Dochart 9 Feb with 1 L. Dochart 9 Dec. 2 Auchlyne, Killin 10 Mar; 1 W side L. Tay 19 Mar. 2 Carron Valley Res. 23 Sep, 7 Oct and 19 Nov. 6 L. Rusky 23 Oct with 1 there 26 Nov and 20 Dec. 1 Doune Ponds 25 Oct; 1 S of Doune 24 Nov. 1 Callander holiday park 22 Nov. In breeding season: 1 Cambusbeg, Callander 30 Apr; 4 Cromlix Moor 10 May with 2 there 13 Jul; 1 Cambusmore carrying food 20 May with family of 3 there 1 Aug; 1 Glen Lochay 31 May; 2 Cobleland, Aberfoyle 17 Jun; 1 Tom Dubh, Callander 26 Jun; 1 Cushenquarter, Plean 24 Jun

MAGPIE *Pica pica* (B,W)

Recorded in a fairly narrow range on BBS, the 2006 rate of 0.58 b/lkm is 21 % higher than last year and 14 % above the mean (annual range: 0.31-0.63 b/lkm). Most numerous in urban/suburban habitat with 3.03 b/lkm compared to 0.72 in farmland.

No records received from the Airthrey roost. Continues to be very scarce NW of Dunblane. Abundant around Stirling but is not as frequent in the west; large groups now widespread in Falkirk

F 17 near Falkirk Wheel 18 Feb. 10 Haircraigs 20 Mar and 3 Sep.

C 10 R. Devon, Alva 8 Jan.

S 12 Newton Crescent, Dunblane 7 Apr. Pr. nested Mid Torrie Fm., Callander 20 May. 2 Tom Dubh, Callander 24 May and 26 Jun. Pr. and 3 juvs. Severie, Braes of Doune is the first time breeding has been recorded there. 1 L. Rusky 23 Oct. 10 Airthrey 23 Nov (presumably not roost count).

JACKDAW *Corvus monedula* (B,W)

Under-recorded. After last year's high, there was a 14 % drop, still 12 % above the mean (annual range: 2.11-3.27 b/lkm). Recorded at 4.88 b/lkm on farmland and 4.08 b/lkm in urban/suburban squares, the latter less than half that of 2005.

C Ca. 35 prs. collecting nest material Tillicoultry quarry 10 Apr.

S Roost flights S over Coneyhill, BoA late Jan to late Mar, with maxima of 250 birds on 25 Jan and 80 on 16 Feb, down to 35 on 22 Mar. At the end of the year there were maxima there of 125 on 23 Oct, 240 on 1 Nov and 150 on 16 Nov. 200 Airthrey 2 Feb. 120 around King's Park, Stirling 7 Dec. 200 Thornhill Carse 28 Dec.

ROOK *Corvus frugilegus* (B,W)

The 2nd most frequent species on BBS. The BBS figure of 2.80 b/lkm represents a 47 % drop on last year and a 35 % drop on the long-term mean (annual range: 2.08-6.74 b/lkm). Numbers vary quite widely from year to year depending upon how many large post-breeding feeding assemblages are encountered

Systematic counts of known rookeries (e.g. BoA, Gartmorn, Forth and Clyde Canal, Lake of Menteith, etc.) needed.

S 400 Thornhill Carse 17 Jan. 300 Airthrey 2 Feb. Major roost flights over Coneyhill, BoA observed 10 Feb to 23 Mar. 5 rookeries noted in late Apr in Dunblane: 29 nests Strathmore Ave., 100 nests Holmehill, 16 nests Victoria Hall, 75 nests Kippendavie, 53 nests Duthieston House (MVB). 252 King's Park, Stirling 7 Dec. Ca. 1,500 Longbank, Doune 16 Dec. Major roost flights of Rooks and Jackdaws observed over Coneyhill, BoA in Jun and Nov to Dec, with maxima of 520 on 5 Jun and 2,000 on 10 Nov.

CARRION CROW *Corvus corone* (B,W)
 After last year's high, BBS numbers dropped 12 % to 5.48 b/lkm, still 43 % above the long-term mean (annual range: 2.18-6.22 b/lkm). Most frequent on mountain/moorland habitat (7.88 b/lkm), then farmland (5.21 b/lkm).
F 33 Bo'ness 17 Mar. 30 Skinflats 22 Jul with 42 there 11 Aug.
C 50 R. Devon, Alva 8 Jan. 30 Cambus Pools 15 Jan with 40 at nearby Blackgrange 17 Sep. 67 Colsnaur Hill 31 May with 60 there 4 Jul. 40 Woodland Park, Alva 26 Sep.
S 30 Airthrey 23 Feb. 1 Coneyhill, BoA 26 and 28 Feb had white wings. 267 on carse at King's Park Stirling 21 Dec.

*HOODED CROW *Corvus cornix* (b, w)
 A single bird was recorded on BBS transects this year. More records are needed to determine true status in NW of recording area.
F Singles at Harvies Maling, Denny 1 Mar; R. Carron, Grangemouth 12 Jul; Skinflats 2 Nov are unusual locations (NB, AE, GO).
S In core range: pr. L. Doine, Balquhidder 11 Jan and 4 Mar. 10 and 15 hybrids Glen Dochart 11 Jan. Hybrids Achmore, Killin and Crianlarich (paired with a Carrion Crow) both 11 Jan. 1 L. Voil, Balquhidder 9 Feb was paired with a Carrion Crow; 1 Tulloch, L. Voil 4 Mar was paired with a hybrid; 1 Rhuveag, L. Voil 4 Dec. 23 and 25 hybrids Glen Dochart 9 Feb with pr. at L. Iuhhair 4 Mar, 1 L. Dochart 4 Mar (paired with a Carrion Crow) and 1 and 3 hybrids Dochart Haughs 16 Dec. Singles Crianlarich 6 May and W side L. Tay 1 Jun. Outside usual range: 2 Wester Borland, Thornhill 12 Nov.

*RAVEN *Corvus corax* (B,W)
 A total of 29 birds were recorded on BBS, more than twice the previous highest number (annual range: 1-14). Unlike last year when all records came from the coniferous habitat category, was most frequent in mountain and moorlnd (0.47 b/lkm), than conifer/moorland (0.36 b/lkm) with small numbers in farmland. A Doune Lodge roost count of 90 on 22 Jan was smaller than in 2005. There were again a number of reports from south/southwest of the core Callander-Doune-Dunblane area.
F 1 Strathavon Fm., Slamannan 27 Jan and pr. there most days in Dec.
C 2 over Castlebridge Business Park, The Forest 28 Aug.
S From core area: pr. L. Doine, Balquhidder 11 Jan. Nests with 4 Y Argaty, Braes of Doune 14 Apr and 3 Y Drumloist, Braes of Doune 30 Apr. 5 Crianlarich 6 May. 3 Cromlix Moor 10 May. 1 Sron Eadar a' Chinn, Callander 19 May. 2 Newton Crescent, Dunbane 1 Jun.7 Arie Dam, Callander 3 Jun. 2 Taobh na Coille, Strath Gartney 4 Jun. 1 Tom Dubh, Callander 26 Jun. 7 Sgiath an Dobhrain 7 Jul. 2 Cromlix Moor 13 Jul. 3 Ochiltree, Dunblane 20 Aug and 1 there 19 Oct. 2 Doune Ponds 6 Sep. 3 Cambusmore 7 Sep. 1 L. Katrine 15 Sep. 2 Kinlochard 16 Oct. 1 L. Rusky 29 Oct. 3 Severie, Braes of Doune 19 Nov. 2 L. Dochart 9 Dec. 1 L. Venachar 28 Dec. Outside of the core area: 1 Gogar Loan, Menstrie 10 Apr. 2 Cambusbarron and 2 Polmaise Woods, Stirling 6 May. 1 Mine Wood, BoA 6 Jul. 2 Airthrey 15 Sep and 1 there 21 Dec. 3 Flanders Moss 22 Oct with 1 there 23 Oct and 12 Nov. 5 Cambus 19 Nov. 1 Carron Valley Res. 17 Dec.

STARLING *Sturnus vulgaris* (B,W)
 Greatly under-reported. The most abundant species on BBS. This year's rate of 5.61 b/lkm was 10 % lower than in 2005 and 5 % below the mean (annual range: 4.06-10.71 b/lkm). Numbers vary greatly from year to year depending upon how many large post breeding feeding assemblages are encountered. They were 2.6 times more frequent in urban/suburban settings (21.97 b/lkm) than on farmland (8.30 b/lkm).

F 300 Kincardine Br. roost 5 Jan with 100 there 1 Oct and 130 on 1 Dec. 200 Haircraigs 5 Jun. 500 Glenhead, Denny 18 Dec.

C 100 Blackgrange, Cambus 4 Oct.

S 100 Airthrey 8 Jun. 300 N Third Res. 24 Oct. 2,500 in pre-roost flight over mouth of Bannock Burn 25 Nov. 250 King's Park, Stirling 7 Dec. 400 in roost exit flight to W at Craig Forth, Stirling 9 Dec.

HOUSE SPARROW *Passer domesticus* (B,W)

Under-recorded. With 2.10 b/lkm on BBS squares, this species was recorded at its highest ever level. This represents an increase of 17 % on last year and is 31 % above the long-term mean (range: 1.22-2.08). The urban/suburban abundance (6.58 b/lkm) was exactly twice that recorded on farmland (3.29 b/lkm).

S 40 Argaty, Braes of Doune 6 Jan with 50 there 5 Oct. 30 Kinlochard 16 Oct.

TREE SPARROW *Passer montanus* (B,W)

Occurs in very low numbers on BBS transects with 16 birds this year being the highest to date by far (annual range: 0-7). All the birds were found on farmland (0.22 b/lkm).

Fewer records this year than in 2004-05 but the species still seems to be more widespread than in preceding years.

F Small numbers most months in Skinflats area with maxima of 40 on 23 Jul, 22 on 26 Jul, 38 on 14 Sep and 25 there at Brackenlees Fm. 26 Nov. 25 Fallin 13 Oct. 2-10 birds Kendushill Fm., Maddiston Feb to Oct.

C 2$^+$ Linn Mill 17 Jan. 15 Fishcross 15 Jan with 9 at nearby Maggie's Wood Flood 12 Feb. 1 Cambus Pools 24 Jan. 1 R. Devon, Alva 18 Mar and 17 Dec. 2 Longriggs, Coalsnaughton 10 May. 2 Gartmorn 10 and 12 May and 27 Jun. 25 Westhaugh, Alva in game crop 11 Dec. 6 S Alloa 16 Oct with 3 there 22 Oct and 1 on 9 Nov.

S 18 Hilton Fm., Cowie 1 Feb. 15 Arneive Fm., Thornhill Carse 10 Mar with 7 at Nether Carse 24 Nov. 1 Lecropt 25 Mar. 4 Hollow Burn, Fallin 15 Apr with 10$^+$ there 14 May. 4 Wood Lane, Blairdrummond Carse 26 Apr. 3 Carbrook Mains, Plean 29 Apr with 2 there 24 Jun. Singles Cambusbarron 19 May and Upper Taylorton 20 May. 25 Fallin 13 Oct.

CHAFFINCH *Fringilla coelebs* (B,W)

Numbers on BBS squares increased to 5.25 b/lkm, the highest figure to date (range: 3.46-5.15). This is 15 % higher than last year and 23 % above the long-term mean. Numbers were highest in conifer woodland and its moorland edge at 13.10 b/lkm, almost twice that recorded on farmland (6.93 b/lkm).

S 500 Lerrocks, Braes of Doune 5 and 24 Jan with 250 there 5 Oct and 350 on 15 Dec. 500 Westerton, Braes of Doune 5 Jan. 760 Glenhead, Braes of Doune 8 Feb with 600 there 2 Apr. 410 Doune 10 Jan. 190 Waterside, Kinbuck 11 Mar with 400 at nearby W Cambushinnie 15 Nov and 800 there 25 Nov (MVB). 8 Taobh na Coille, Strath Gartney at 580m asl. 13 May. Ca. 400 Milton of Cambus 25 Oct. One singing Coneyhill, BoA 13 Feb.

*BRAMBLING *Fringilla montifringilla* (W)

F 1 Kinneil 17 Oct. 2 Strathavon Fm., Slamannan 27 Dec (GO, TF).

C M Newrowhead, Clackmannan 17 Apr (RHD).

S Singles (M and F) Ochiltree, Dunblane on several dates in Jan, Mar and Apr with 19 there 12 Mar (NB). 1 Keir roundabout, Dunblane 20 Jan.1 High Street, Dunblane 5-25 Feb with 2 there 26 Feb-25 Mar (CJP). 2 Lerrocks, Braes of Doune 22 Jan with 4 at nearby Glenhead 8 Feb and 10 on 2 Apr. 5 Waterside, Kinbuck 11 Mar (MVB). F Springwood Ave., Stirling 15 Mar (CJM). 3 Ashentree Fm., Thornhill Carse 3 Apr (RHD). 2 L. Rusky 23 Oct. 1 Deanston Fm., Doune 12 Nov (JT).

GREENFINCH *Carduelis chloris* (B,W)

 Under-recorded. No large flocks reported this year. After last year's high, numbers (0.67 b/lkm) dropped by 37 % to 8 % below the mean (range: 0.42-1.07 b/lkm). This species favours urban/suburban habitats occurring at 1.71 b/lkm (much lower than in 2005), followed by farmland (1.05 b/lkm).

F 17 Polmont, Falkirk 17 Sep.

C 50 Gartmorn 11 Sep.

S 40 Springwood Ave., Stirling 6 Jan. 28 King's Park, Stirling 10 Feb.

GOLDFINCH *Carduelis carduelis* (B,W)

 At 0.51 b/lkm this species was recorded at its highest level on BBS squares so far. This is 38 % higher than in 2005 and 65 % above the mean (range 0.12-0.40 b/lkm). Found in greatest abundance on farmland (0.81 b/lkm), then in urban/suburban (0.66) and conifer/moorland (0.43 b/lkm). Again no significant flocks reported from the Doune-Dunblane area.

F 35 Back Falkirk 6 Apr. 30 Skinflats 18 Apr. Roost of 50-60 birds Strathavon Fm., Slamannan Nov to Dec.

C 30 R. Devon, Alva 13 Aug.

S 25 Sheriffmuir Inn 15 Sep.

SISKIN *Carduelis spinus* (B,W)

 Recorded in low numbers (27) on BBS. At 0.20 b/lkm was 29 % lower than in 2005 and 43 % lower than the long-term mean (annual range: 0.10-0.75 b/lkm). Recorded predominantly in conifer/moorland edge habitats (0.93 b/lkm), where more than four times as frequent as on farmland (0.18 b/lkm).

F 28 Polmont, Falkirk 28 Jan. 5 singing Dunmore Wood 16 Apr.

S 70 Newton Crescent, Dunblane 17 Sep with 33 there 21 Oct. Ca. 20 R. Balvag Bridge, Balquhidder 4 Dec; ca. 30 Strathyre 4 Dec. 40 Carron Valley Res. 19 Dec. 20 Airthrey 22 Dec. 175 Callander 31 Dec.

LINNET *Carduelis cannabina* (B,W)

 With 114 birds recorded, more than three times as frequent as the previous highest rate (annual range: 5-35 birds). This represents a 17-fold increase compared to last year and is 259 % above the long-term mean. Recorded predominantly on farmland (1.55 b/lkm), then mountain/moorland (0.05 b/lkm). Medium-sized flocks were again present in the Doune and Dunblane areas. No reports from the Carse of Lecropt.

F 30 Skinflats 6 Jan with 120 there 8 Oct, 60 on 1 Dec and 110 on 9 Dec. 20 Kinneil 5 Nov.

C 170 R. Devon, Alva 6 Jan with 250 there 28 Nov, 100 on 8 Dec and 120 on 21 Dec. 57 Longcarse, Tullibody Inch 14 Jan. Ca. 150 in set-aside Westhaugh, Alva 7 Apr. Ca. 200 W Fishcross in wild bird cover 4 Nov.

S 270 Glenhead, Braes of Doune 2 Apr. 220 Stonehill, Dunblane 15 Sep. 280 W Cambushinnie, Kinbuck 27 Oct with 200 there 15 Nov.

TWITE *Carduelis flavirostris* (b,W)

 21 birds recorded on BBS this year compared to none last year, yielding a rate of 0.15 b/lkm.

F 50$^+$ Kinneil 2 Jan with 20 there 12 Nov. 20 Skinflats 25 Feb with 40 there 12 Nov, 60 there on saltmarsh 1 Dec and 40 on 9 Dec. 74 Higgins Neuk 17 Dec.

S 180 Glenhead, Braes of Doune 8 Feb with 1 there on 2 Apr and 4 at Mid Lundie on 16 Jul. 80 Ashentree Fm., Thornhill Carse 3 Apr. 3 Garrison Fm., Inversnaid 23 Apr with 6 there 21 May. 2 Wood Lane, Blairdrummond Carse 26 Apr. 5 Braes of Balquhidder 4 May. 2 Sron Eadar a' Chinn, Callander 19 May and 7 Jul. 1 W side L. Tay 21 May. 3 Braeleny, Callander 3 Jun.

LESSER REDPOLL *Carduelis cabaret* (b,W)
 Recorded in low numbers on BBS with 4 birds this year compared to 12 last year (annual range: 2-27).
C 16 W of Tillicoultry 26 Dec. During breeding season: 5 Birkhill, Gartmorn 8 and 10 Apr.
S 25 Carron Valley Res. 7 Jan. 24 Ochiltree, Dunblane 14 Nov with 85 there 26 Nov. Ca. 30 Callander 19 Nov. During breeding season recorded from: Cromlix (6), Tyndrum community woodland, W side L. Tay, Glen Lochay and Glen Finglas where one collected nest material 21 May.

*COMMON CROSSBILL *Loxia curvirostra* (b,W)
 Occurs in very low numbers on BBS transects with 8 birds recorded this year compared to 4 last year (annual range 0-11). Found only in coniferous/moorland edge habitat with 0.57 b/lkm.
C 4M, 1F Birkhill, Gartmorn 2 Apr, 1 M there 8 Apr (RHD) with pr. and juv E Gartmorn 10 May (DAC). 17 School Wood, Clackmannan and 1 Hillfoot Hill, Dollar both 17 Apr (RHD).
S 8 Carron Valley Res. 8 Jan and 19 Nov (DAC, GO). Single Sheriffmuir 26 Feb (CJP) with 6 there 9 Dec (EMH). 5 Lake of Menteith 9 Jul (DOE). 18 L. Rusky 30 Oct (RS) with 3 there 23 Oct (JT). 3 Hutchinson L. 11 Nov (CJP). 6 Lanrick 19 Nov (DOE). 10 Lerrocks, Braes of Doune 15 Dec (MVB). 2 Cromlix 17 Dec (CJP).

BULLFINCH *Pyrrhula pyrrhula* (B,W)
 Occurs in low numbers on BBS with 7 birds this year compared to 6 last year (annual range: 1-13). This year it was only recorded on farmland and not in coniferous woodlands as in 2005.
C During breeding season reported from: Birkhill, Gartmorn; Cambus Pools and Alva Glen.
S 6 Marl Loch, Braes of Doune 29 Jan. 8 Keir, Dunblane 23 Jan. 6 King's Park, Stirling 1 Dec. 10 Airthrey 21 Dec. During breeding season reported from: Fallin; Coneyhill, BoA; Aberfoyle and G. Lochay.

*SNOW BUNTING *Plectrophenax nivalis* (W)
S 1 Stob Binnein 3 Jan (MML). 25 Allt a Chaol Ghlinne, Tyndrum 6 Mar (JPH).

YELLOWHAMMER *Emberiza citrinella* (B,W)
 The BBS rate of 0.63 b/lkm represents the highest figure since recording began locally. Numbers were up by 2 % compared to last year and were 62 % higher than the mean (range: 0.08-0.61 b/lkm) with all the birds being recorded on farmland (1.20 b/lkm).
C During breeding season reported in Gartmorn area Apr, May and Jun. 10 Blackgrange, Cambus 16 Dec.
S 50 South Mid Frew feeding station, Thornhill Carse 10 Jan. During breeding season reported from: Hollow Burn, Fallin; S Alloa; Lower Greenyards, Forthbank where 15 on 26 Dec; Flanders Moss; Glen Lochay; Blairdrummond; Longbank, Doune. 25 Glenhead, Braes of Doune 16 Sep. 15 Polmaise 26 Dec.

REED BUNTING *Emberiza schoeniclus* (B,W)
 With 61 birds, numbers on BBS were almost twice as high as the previous highest number (annual range 11-35 birds). This represents a 450 % increase on 2005 and is 114 % above the mean. It was recorded at its highest levels on mountain and moorland squares (0.60 b/lkm), then farmland (0.48 b/lm).
F 8 Kinneil 19 Mar. During breeding season reported from Shildhill, Falkirk and Skinflats where 59 at Orchardhead 1 Dec and 31 on 26 Dec.
C 12 R. Devon, Alva 6 Jan. During breeding season reported from: Cambus Pools; R. Devon, Alva and Gartmorn. 8$^+$ roosting Castlebridge Business Park, The

Forest 1 Dec. 20 Blackgrange, Cambus 16 Dec.
S 18 L. Arklet 2 Feb. During breeding season reported from: Carron Valley Res. and Arie Dam, Callander. 15 Lower Greenyards, Forthbank 26 Dec.

ESCAPED SPECIES

SWAN (CHINESE) GOOSE *Anser cygnoides*
This is the first time this species has been reported from our recording area.
S Airthrey throughout the year (CJP, AET). This bird has been present since at least 2003.
BAR-HEADED GOOSE *Anser indicus*
This is the first time this species has been reported from our recording area.
S Wester Borland, Thornhill with Pink-footed Geese 25 Oct (JT).
EGYPTIAN GOOSE *Alopochen aegyptiacus*
The long-staying bird that was first discovered on the Forth on 22 Jan 2003 was present until Sep.
F R. Forth, Bandeath 2 Jul (AET), then Skinflats on 4, 8, 13, 15 and 18 Sep (MVB, RS, AET, GO, DOE, AB).
C Cambus 11 May (DAC).
WOOD DUCK *Aix sponsa*
The long-staying male from 2004 was still present in Jan.
S Castle Business Pk., Stirling on 5, 14 and 27 Jan (AET, RS).